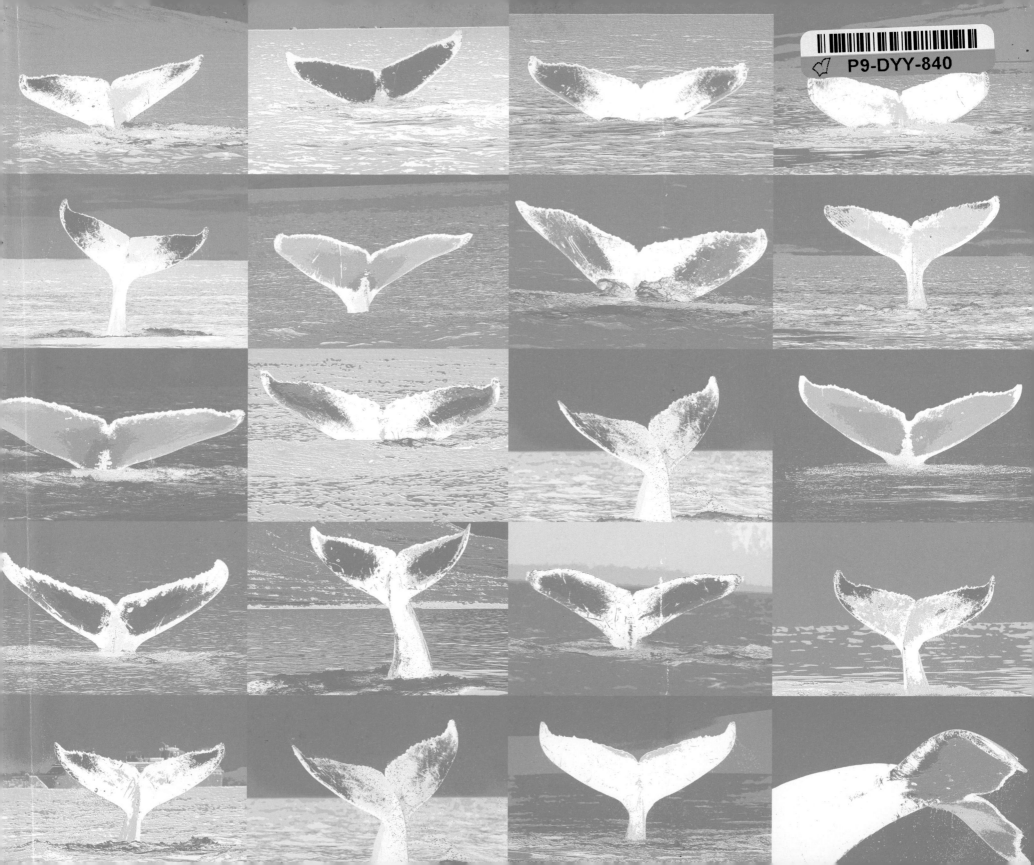

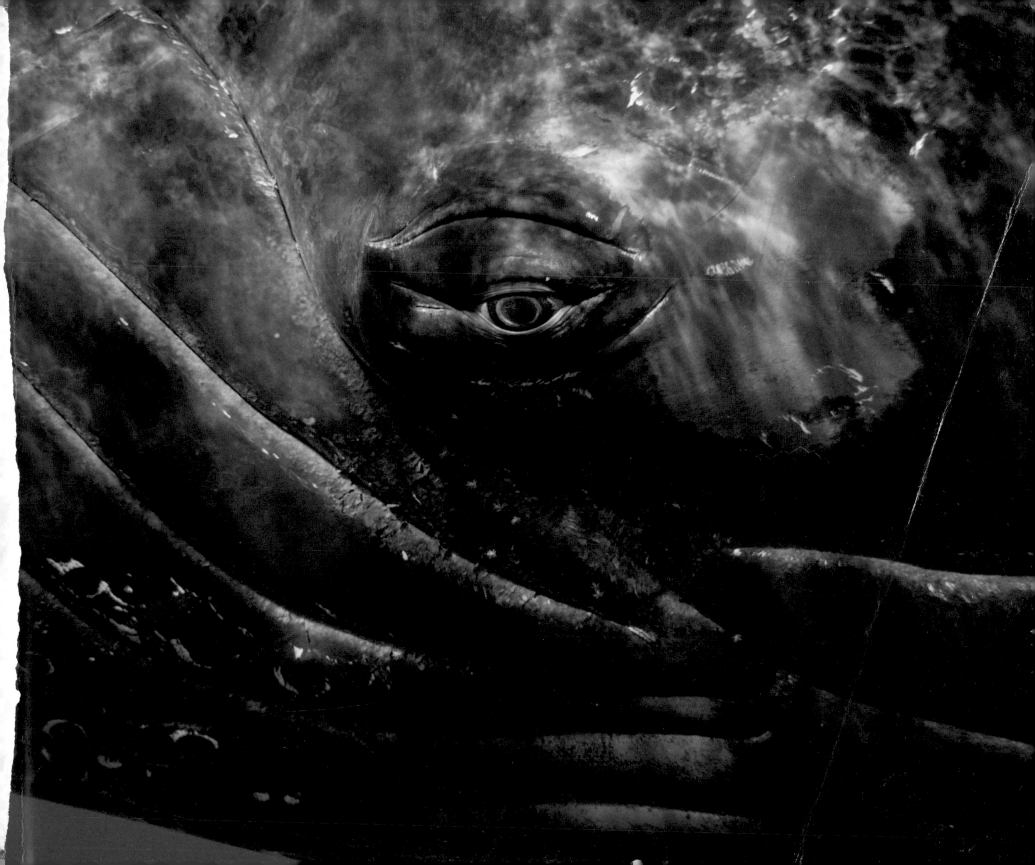

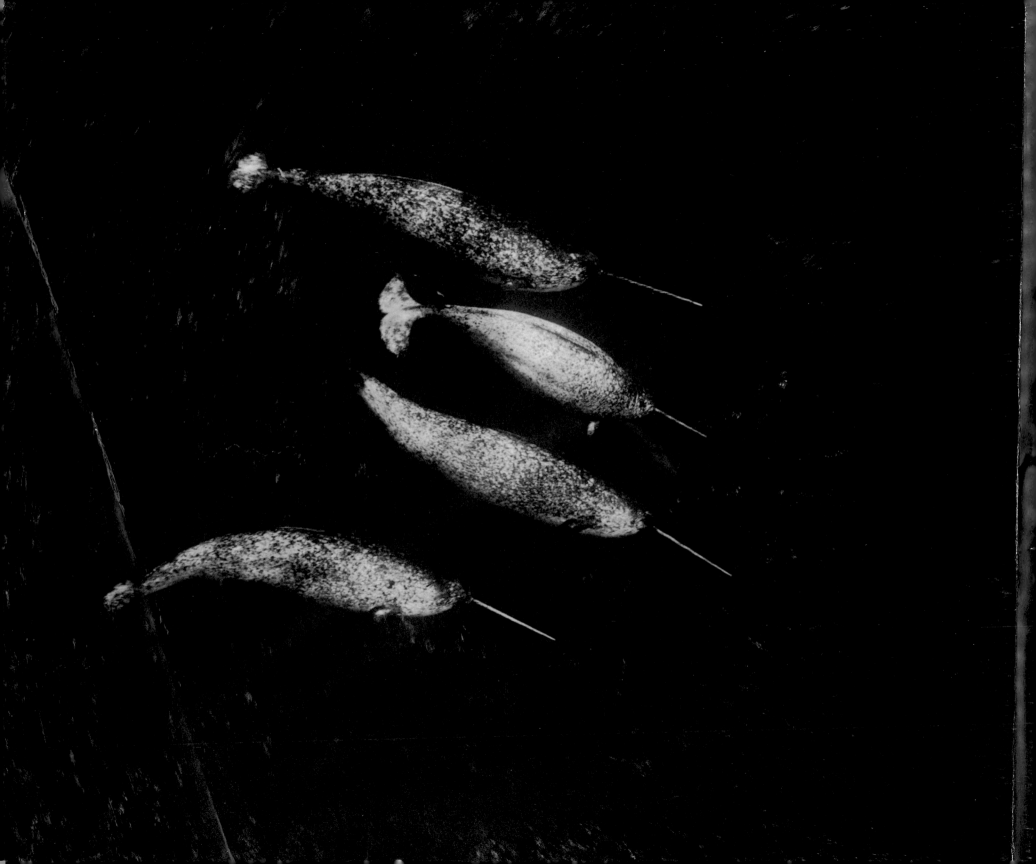

AMONG GIANTS
A Life with Whales

Charles "Flip" Nicklin

WITH K. M. KOSTYAL

FOREWORD BY DR. JAMES DARLING

THE UNIVERSITY OF CHICAGO PRESS
CHICAGO AND LONDON

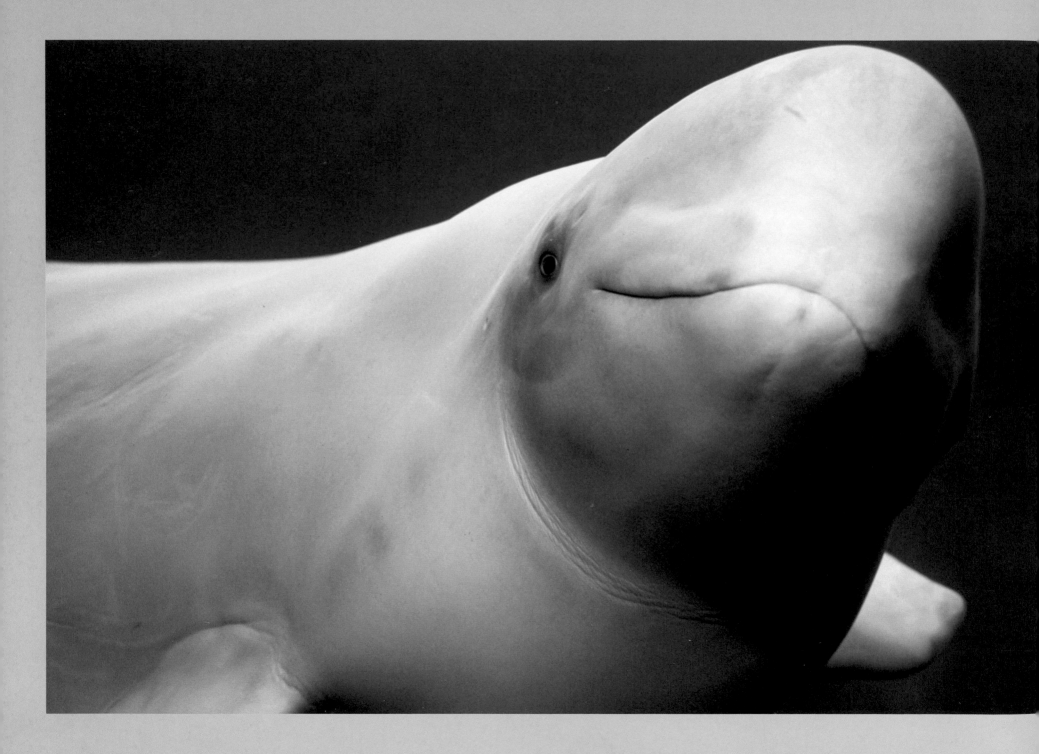

DEDICATION

To my mother, Gloria, and my wife, Linda,
with more love than I can express

BELUGA WHALE (*Delphinapterus leucas*)
POINT DEFIANCE ZOO, TACOMA, WASHINGTON 1992

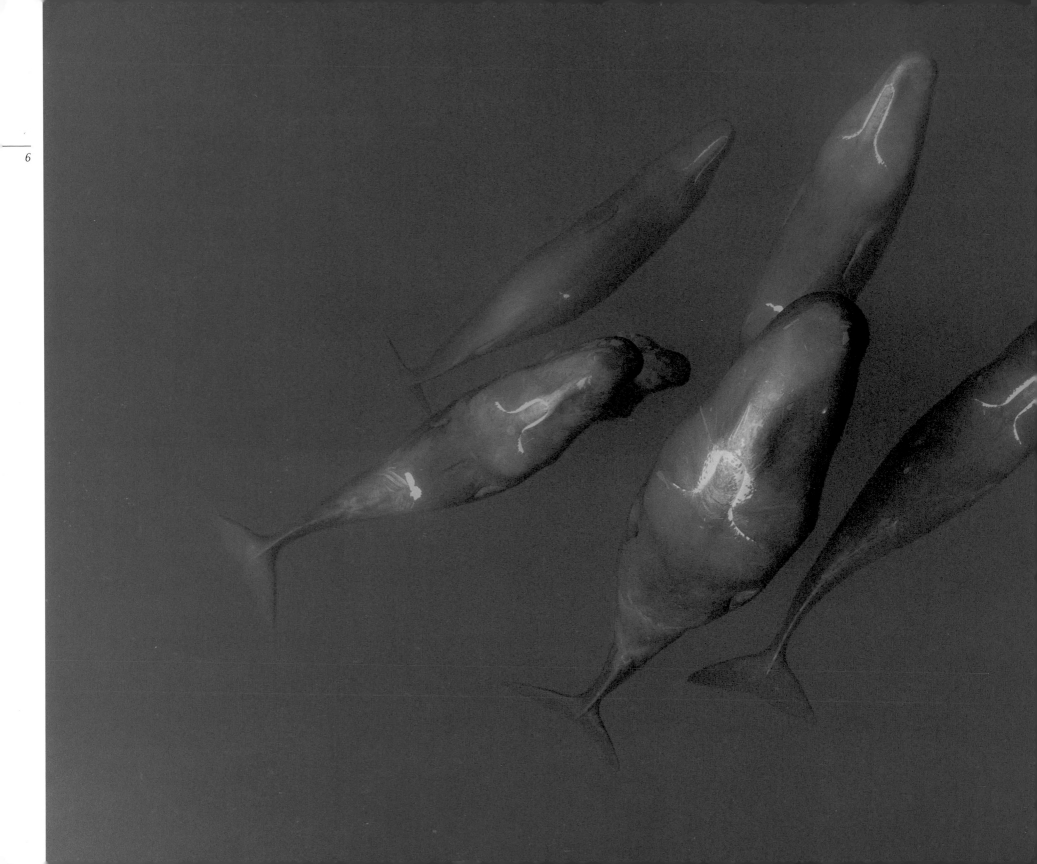

SPERM WHALE *(Physeter macrocephalus)* DOMINICA 1993
Returning to the surface after a long, deep dive, these whales
positioned themselves so they could focus their sonar on me.

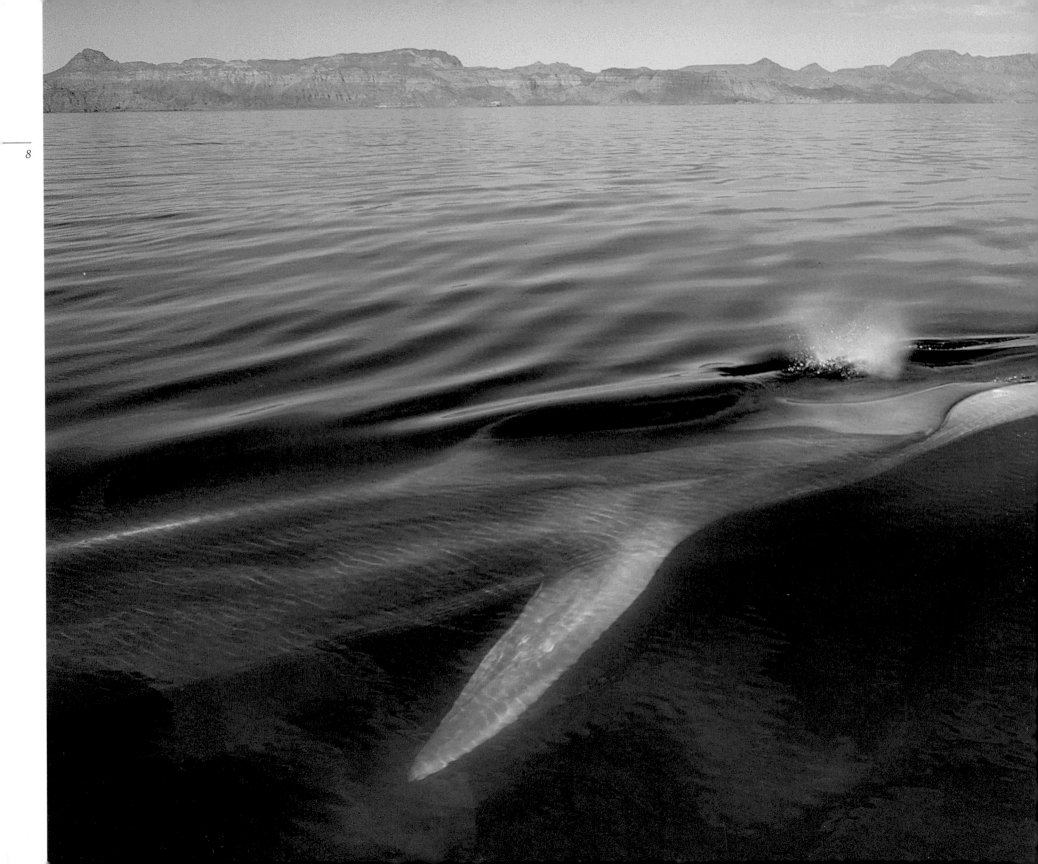

FIN WHALE (*Balaenoptera physalus*) BAJA CALIFORNIA 1988
*Fin whales were heavily hunted in the early to mid-20th-century
days of mechanized whaling, but the whales we saw off Loreto,
Mexico, were surprisingly curious.*

HUMPBACK WHALE (Megaptera novaeangliae) MAUI 2006
My protégé, Jason Sturgis, shooting behavioral footage of
a yearling humpback and its mother

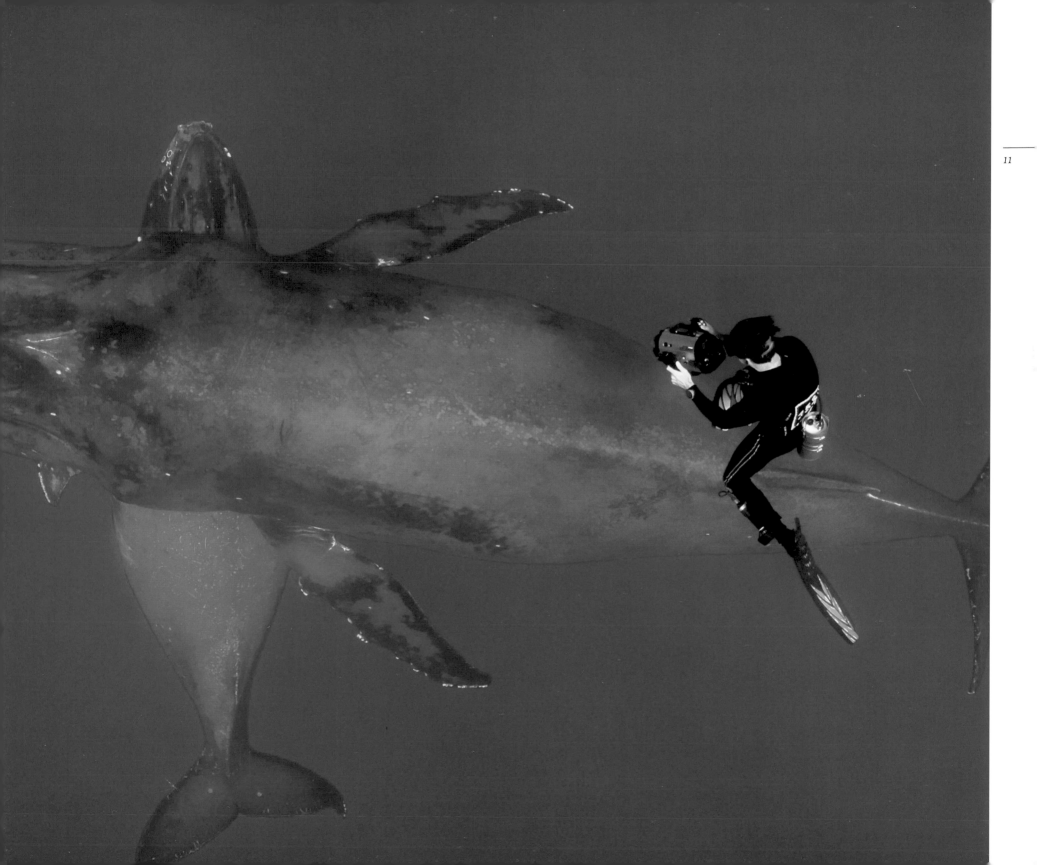

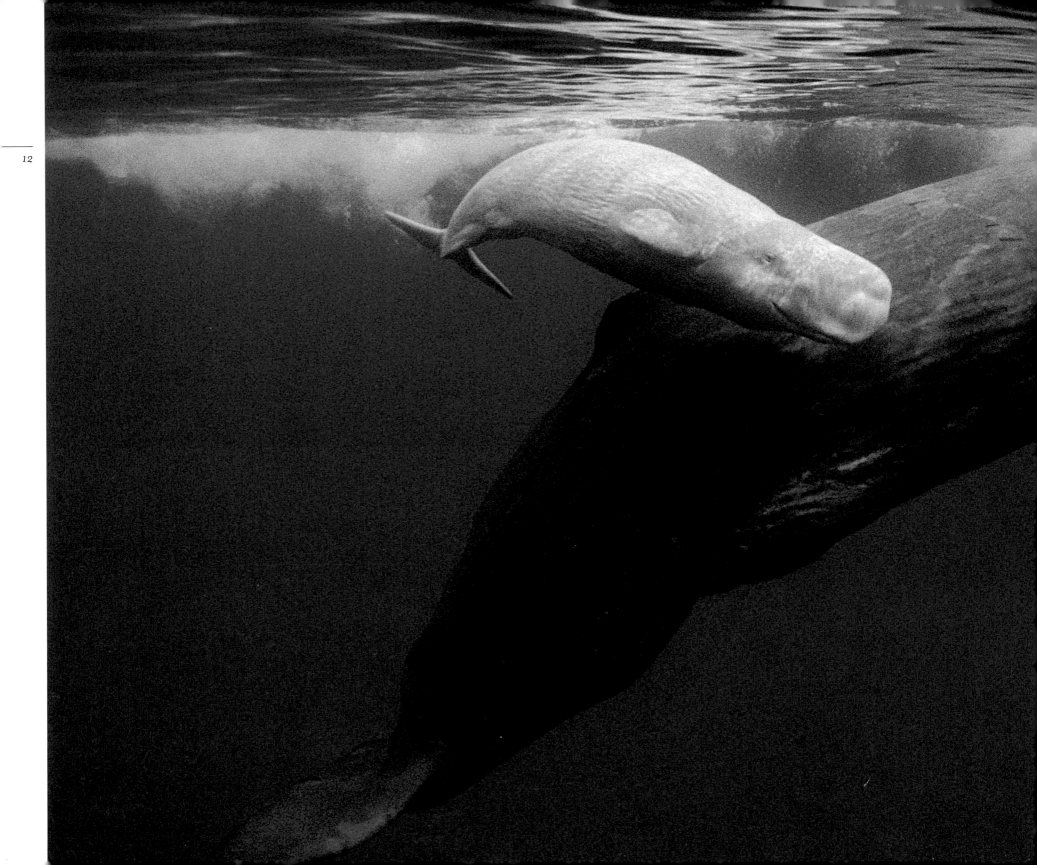

SPERM WHALE *(Physeter macrocephalus)* AZORES 1995
A very young—and rare—white sperm whale with its mother.
Sperm whale females spend their lives in family groups,
helping each other care for the young.

BOTTLENOSE DOLPHIN *(Tursiops truncatus)* DOLPHIN QUEST, HAWAII 1995
Four captive bottlenose dolphins in a man-made lagoon on the Big Island of Hawaii

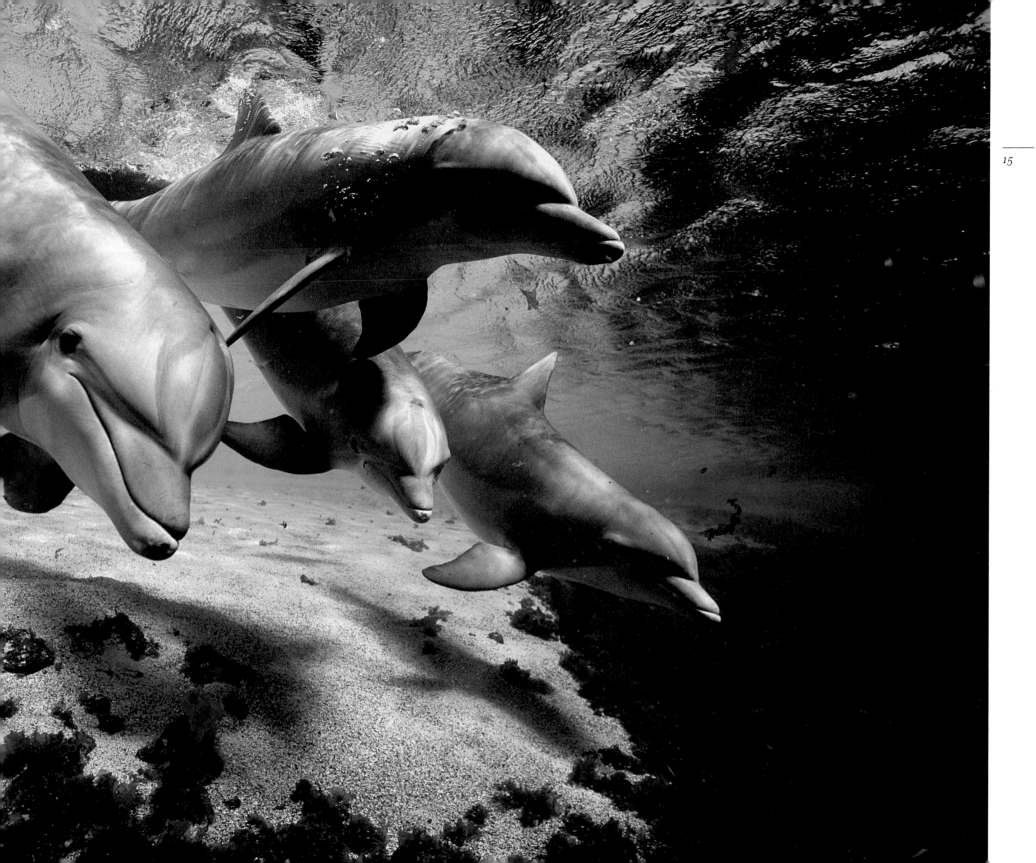

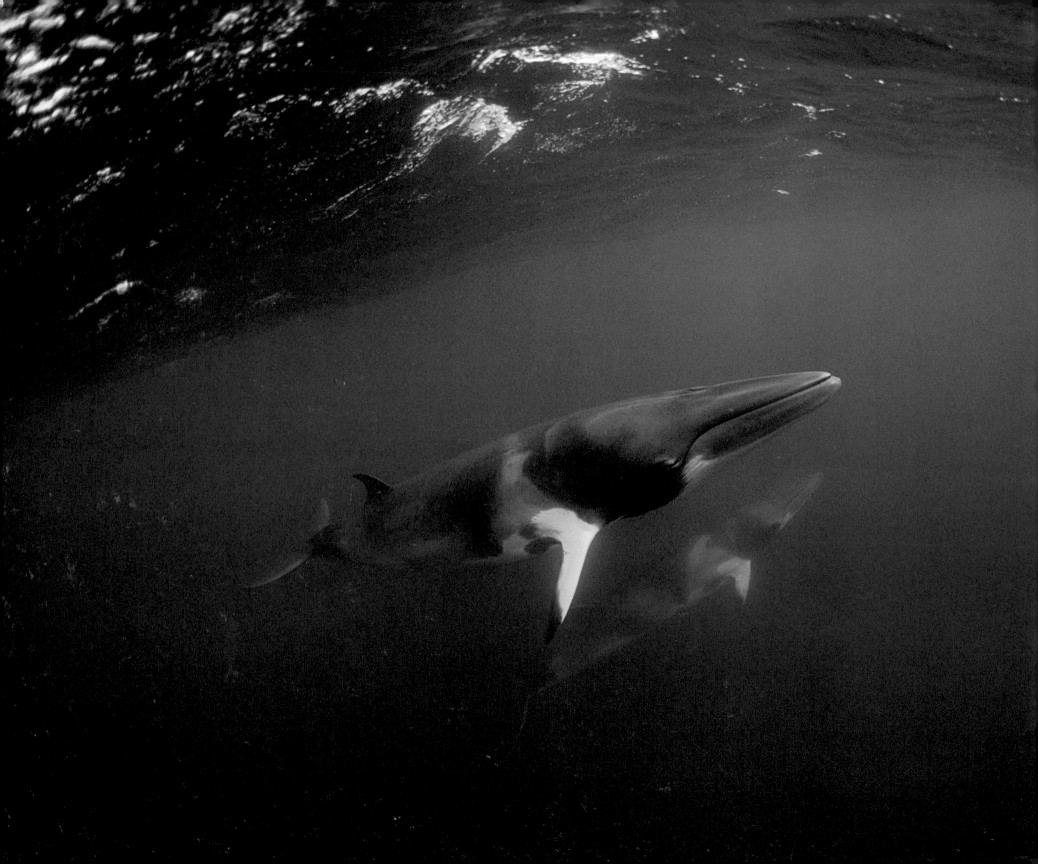

CONTENTS

FOREWORD *Dr. Jim Darling* 19

INTRODUCTION MY FATHER RODE A WHALE 23

CHAPTER 1 COMING OF AGE 29
 Jim Darling on Humpbacks 55

CHAPTER 2 NEW ERA OF DISCOVERY 59
 Hal Whitehead on Sperm Whales 87

CHAPTER 3 LIFE IN THE HIGH ARCTIC 91
 Glenn Williams on the Canadian Arctic 117

CHAPTER 4 TROUBLE IN THE OCEAN 121
 Jon Stern on Minke Whales 148

CHAPTER 5 IMAGING THE FUTURE 153
 Bruce Mate on Technology 177
 Kathy Moran on Flip Nicklin 183

184 PHOTO NOTES

186 ACKNOWLEDGMENTS

188 RESOURCES AND BIBLIOGRAPHY

190 INDEX

192 CREDITS AND COPYRIGHT

DWARF MINKE WHALE
(*Balaenoptera acutorostrata*)
GREAT BARRIER REEF, AUSTRALIA 2000
*Minkes are currently the most hunted
whales, in spite of the 1986 international
moratorium on commercial whaling.*

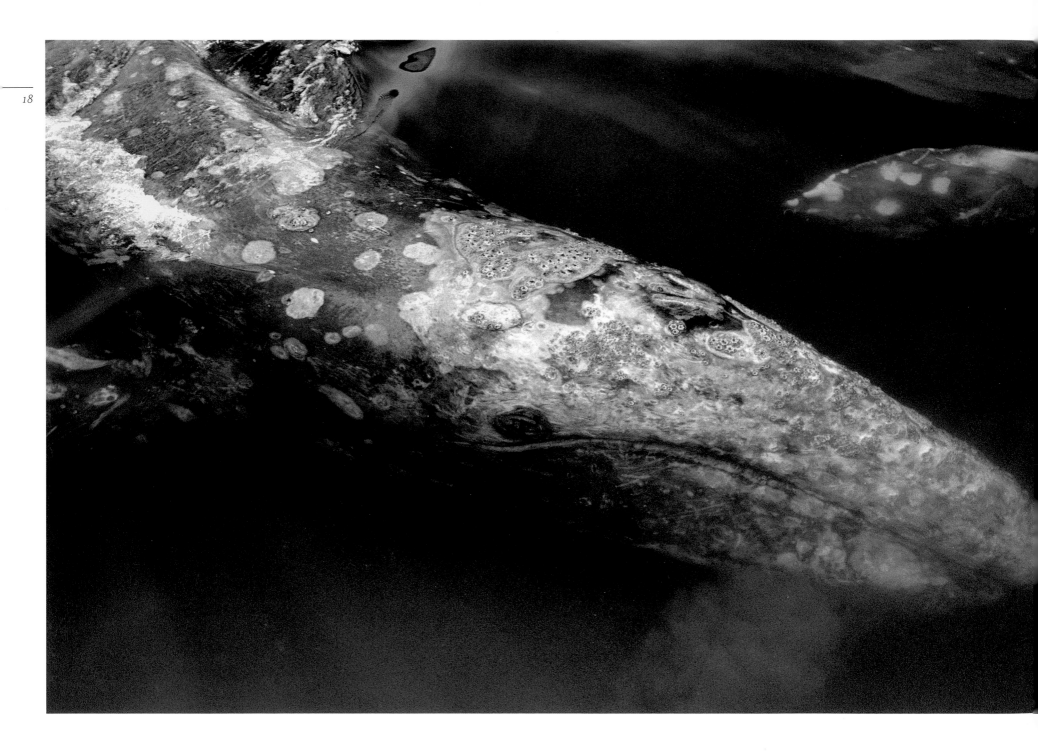

FOREWORD

LOOKING BACK, it is curious how it all came together. It was 1979 and I was on Maui for the third year in a row, doing whale research by photo-identifying individual humpbacks and describing their behavior in general. While I was there, I became the research contact for a group working on an IMAX film on humpbacks. I knew the underwater cameraman, Chuck Nicklin, from a few years earlier, when he was on Maui working on a *National Geographic* whale story. This time, his son Flip had come along as the still photographer for the film. Somewhere along the line—on a dock or across two boats at sea—Flip and I were introduced. I'm not sure how much would have come of this introduction if it hadn't been for a whale named Frank.

Since then things have changed so much that it's hard to put this into perspective, but at that time, in the 1970s, working closely with living whales at sea, much less singing humpbacks, was a very young art. In the couple of years before I met Flip, our research team had learned to isolate which whale was singing out of a crowd of dozens and move in close enough to make good recordings. But at that time we had never seen a singer underwater—in fact, it never occurred to me that we *could* see one underwater. Once they dove, we figured they went somewhere deep and dark, while we were stuck on the surface listening on hydrophones until they showed up again.

GRAY WHALE *(Eschrichtius robustus)* TOFINO, CANADA 2000
Gray whales in shallow feeding flats near Vancouver Island

HUMPBACK WHALE (*Megaptera novaeangliae*) MAUI 1998
A friendly singer that spent hours below our boat

One day in mid-March we were working though our daily routine with a singer designated F as in Frank—or "6th whale of the day" in the field notes. As we had learned to do, we glided over the circular slick the whale had made as it dove, dropped a hydrophone over the side, and turned on the recorder. At that point a girl who was a guest on the boat for the day, and who had virtually no experience with whales, looked down into the clear blue Hawaiian water and pointed to a whale below us. Sure enough, there was Frank, just sitting there motionless, maybe 50 feet down, belting out his song. We were so close that the screeches and moans of the song vibrated through the hull of the boat.

After an hour or so of watching and listening, we realized this whale wasn't going anywhere; it was literally stationary, moving only to the surface to breathe once in awhile. I radioed the film crew, and Flip and Chuck got in the water with the singer. To make a long story short, Frank became the star

of an IMAX film. More important, the day taught us one incredible thing: We could find singers underwater, and they would stay in one place for us… and we could learn things that seemed unknowable the day before.

I did not know either of the Nicklins well at this point, but after working closely with them through that day, I had a few impressions. First, they were totally comfortable in the water, so at home in it that it was not limiting in any way. Second was their competence, hidden well behind quips and smiles. And third, they clearly were enjoying the water and the whale and the break-through as much as I was.

A couple of weeks later, when the IMAX shoot was finishing up, Flip and I met over breakfast in the Pioneer Inn, a hangout for the local harbor life and for tourists alike and by then whale central in Lahaina. Flip offered to volunteer with the research project the next season and this seemed like a pretty good idea to me. I don't think either of us had much of a master plan. I knew I could get close to whales. Flip knew he could dive and take pictures. Between us we could learn some things.

It's a little strange writing this now, as these talents aren't very unique today, but at the time only a handful of folks knew how (or were willing) to get within a few feet of wild whales—either to study them or to take pictures. Why I am not sure, but it probably had something to do with the fact that up until that time the entire human-whale relationship had been one of pursuit and death. The idea was still seeping into our collective minds that if you made a careful approach to a whale so as not to frighten it, it might react with curiosity and tolerance rather than flight or an attack.

When Flip came back the next year, we set out to answer the then-key question about singers: Which sex did the singing? The study went like clockwork. I'd find a singer, Flip would slip over the side, free dive under it, and take a photograph of its underside. After a few months, it became clear that humpback singers are males. During his dives, Flip also took a variety of unprecedented photographs of humpbacks. That led to a *National Geographic* story and a career that has spanned 30 years of new insight into whales.

To skip ahead, the initial work Flip and I did together led to many things, far too numerous to mention here. Suffice it to say there were great adventures around the world, many recounted in this book. For three decades researchers chased the science and Flip took the pictures. His pictures have had a huge influence on how we see whales. I mean huge. I mean way beyond the impact of the science. They let us see and imagine a real animal rather than a mythical beast, or a whaling "unit."

Flip is best known for his *National Geographic* photography, but he has made another, less overt contribution that probably only the researchers themselves are aware of. Flip carries with him an overview of what is happening in the world of whale research that is quite unique. Most field researchers, myself included, actually have a relatively narrow view of the overall field. We know our own projects well, often to the point of preoccupation, but usually have limited communication with other whale researchers. And although conferences and papers give us a chance to share research results, they do not convey the day-to-day intrigue, the really interesting thoughts that never get published, all the things that don't work, and much of the insight that comes from our uncountable hours on the water.

Through his weeks, months, and years with researchers all over the world, Flip has a perspective on whale research much broader than many individual scientists. It comes out all the time. I cannot list the number of occasions we'd be out in the boat and he'd say, "You know the minke whale guys in Australia found…" or "Hal's (Whitehead) student thinks…" or "Richard (Sears) saw blue whales doing the same thing…" or "The guys at Cornell found that singers move all the time…" or "You really should give Bruce (Mate) a call before you do that…"

One cannot overestimate how much we collectively—all researchers—have learned about whales in the last 30 or 40 years. It's an explosion of knowledge. The revelations come fast, almost daily, and at times unfold with the excitement of a page-turner. Still, any researcher out there will tell you we are just beginning. We still barely know the majority of the more than 80 species of whales and dolphins, and for the handful we are studying, we are still asking the most basic questions.

Not too long ago a *National Geographic* fact checker called me to check on something written about whales, and I found myself explaining that we really don't know all the answers. After a few minutes of this she realized there actually was not an answer to her question—yet. She said something to the effect, "It's like you guys are on the edge of a huge unexplored continent." This is so true. We have reached its edge and peered inside. That is all. As phenomenal as the photos in this book are, they are just the first tentative steps into the unknown.

—*Dr. Jim Darling*

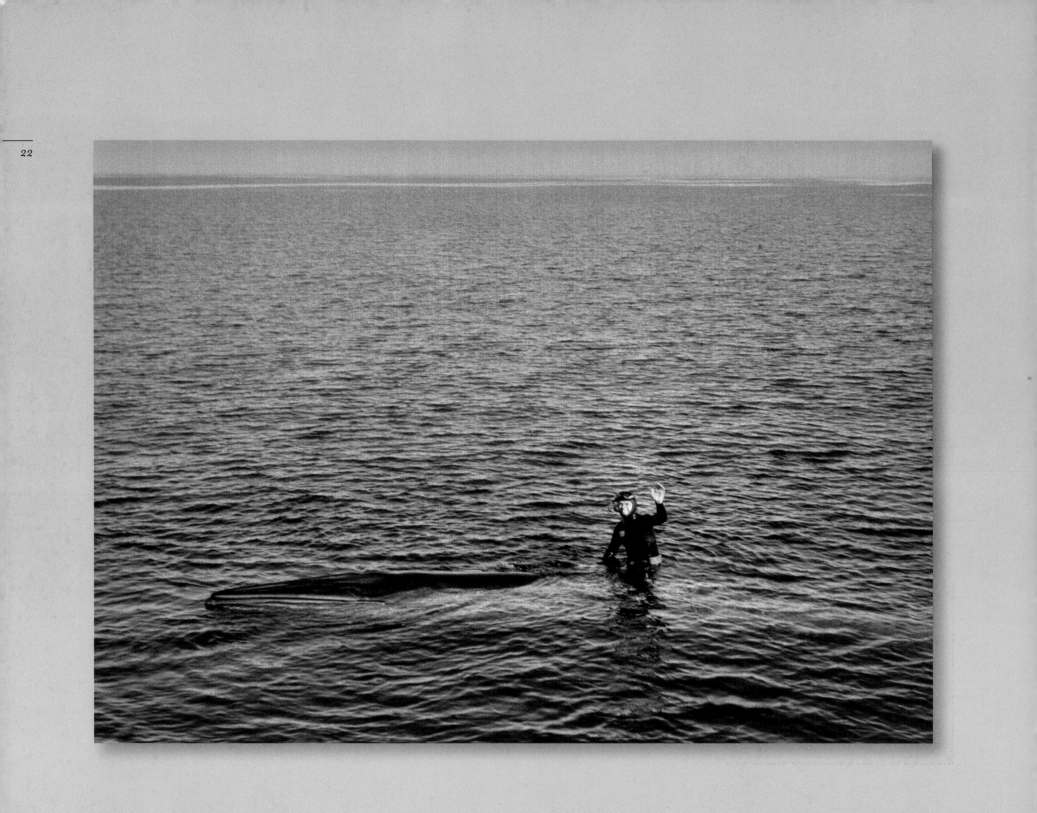

MY FATHER RODE A WHALE

My dad, Chuck, on the back of a Bryde's whale off San Diego, 1963. This picture put him on the road to becoming a famous underwater photographer and cinematographer.

THE DAY MY FATHER, Chuck, rode a whale changed everything. But like most life-changing days, it began like a lot of others. It was the early '60s and Chuck ran a dive shop in San Diego when scuba was a new thing. That particular day he and some buddies were going diving, as they often did. They took a couple of cameras with them, but mostly they were hoping to bring home dinner, maybe a large fish or a lobster.

Once they got out in the ocean, though, they spotted a whale at the surface. When they approached it in their small boat, it didn't move or dive, and as they got closer, they could see that its flukes were being held down by an anchor line to a gill net. They got in and swam up to it. I imagine they had practical concerns, wondering if there were sharks around, if the whale was injured, if it was safe to be near an animal that was so large.

They were divers, hunter-gatherers who were harvesting what the ocean offered and who tended to see the underwater environment in terms of its physical challenges and possibilities. Now all of a sudden here was this big beautiful whale sitting next to them. It didn't do much, didn't seem to react to their presence. They went up to it, took pictures of it above and below water, petted it, swam around it, and eventually Chuck got on the back of the whale. He sat there and waved at the camera—a hero shot.

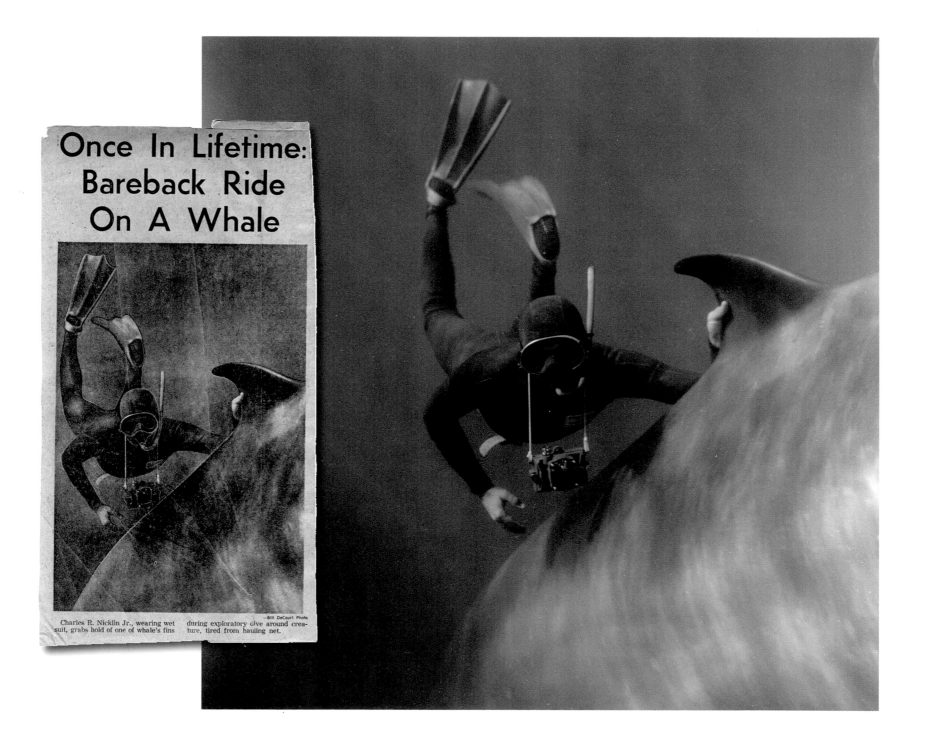

Once In Lifetime: Bareback Ride On A Whale

Charles R. Nicklin Jr., wearing wet suit, grabs hold of one of whale's fins during exploratory dive around creature, tired from hauling net.

—Bill DeCourt Photo

Pictures of Chuck freeing the Bryde's whale and riding it ran in our local newspaper, the San Diego Union-Tribune.

We regularly took photographs to the *San Diego Union-Tribune* from our adventures in the sea—the big catch of the day, things like that. So my dad called a sports columnist at the paper and told him, "We've got a whale of a fish story for you and pictures to go with it." The paper ran the images on the front page. It was a slow news week, and the shot of my dad was picked up by other papers across the country. There followed a flurry of fame that included an appearance on a local late-night TV show with a very young host named Regis Philbin and a spot as a contestant on the then popular game show *To Tell the Truth*.

This all happened in a time before Save the Whales, when whales weren't viewed as much more than commodities. Today, a picture of someone sitting on a whale could get that person arrested, but then most Americans had probably never seen an image of a whale taken up close and in the water. It would be a dozen years more before the first underwater images of humpbacks were circulated from Maui.

I don't think our story, my dad's and mine, would have been quite the same if Chuck had just taken pictures of the whale and himself. But he did more than that. He free dove down to its tail, grabbed the anchor line, pulled it off, and set the whale free. All the stuff we know about whales now we didn't know then. As far as he knew, the whale could have attacked him. But it didn't. It swam away, apparently unharmed. He took a chance and it paid off.

In retrospect, I can see that my dad's encounter with a whale in the wild influenced the direction of my own life. I was looking for adventure, and in many respects I was following my father, taking my place in the world that opened up, for both of us, because of what happened that day. The places we'd go, the people we'd meet, were largely due to that event.

Chuck went on to become an award-winning underwater cinematographer. He worked on a number of whale documentaries and on Hollywood movies, including *The Deep*, *The Abyss*, and even a couple of James Bond films. In his 80s, he's still shooting video, leading diving adventures, and swimming with whales.

As to my story, that's what this book is all about.

BRYDE'S WHALE (*Balaenoptera edeni*) LA JOLLA, CALIFORNIA 1963
A close-up Chuck took of the Bryde's whale

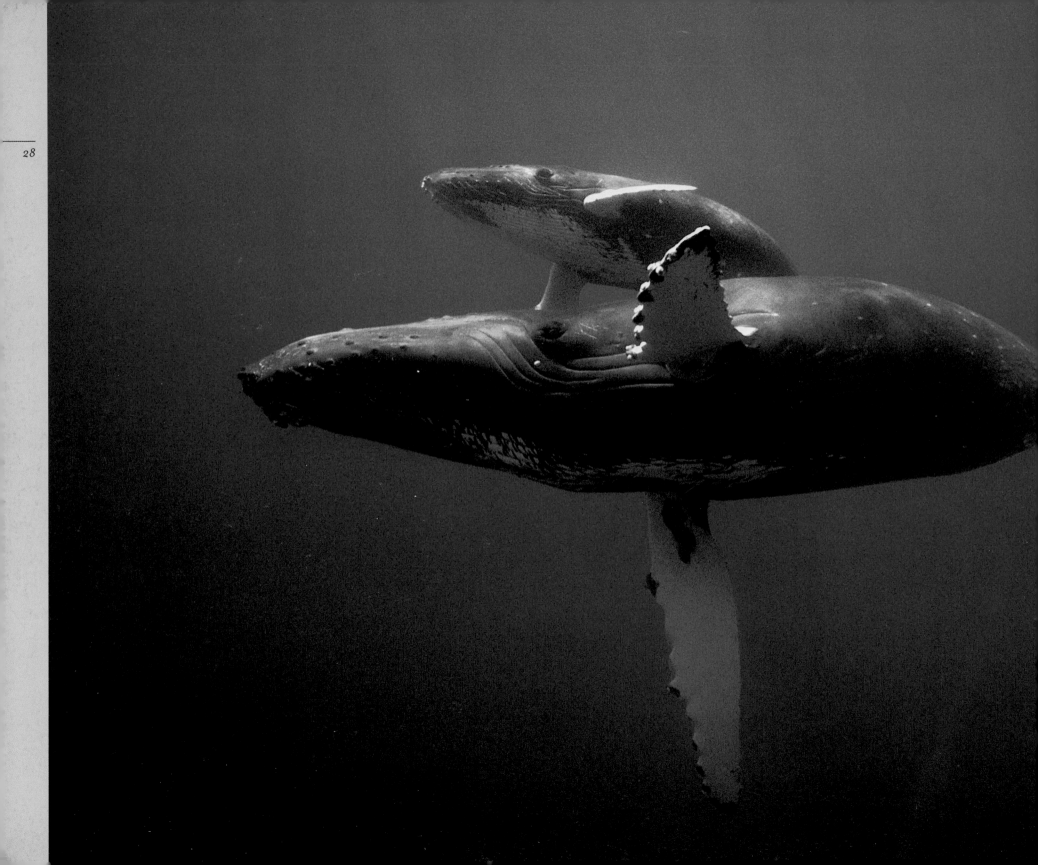

Coming of Age

HUMPBACK WHALE *(Megaptera novaeangliae)* MAUI 1980
Mother and young

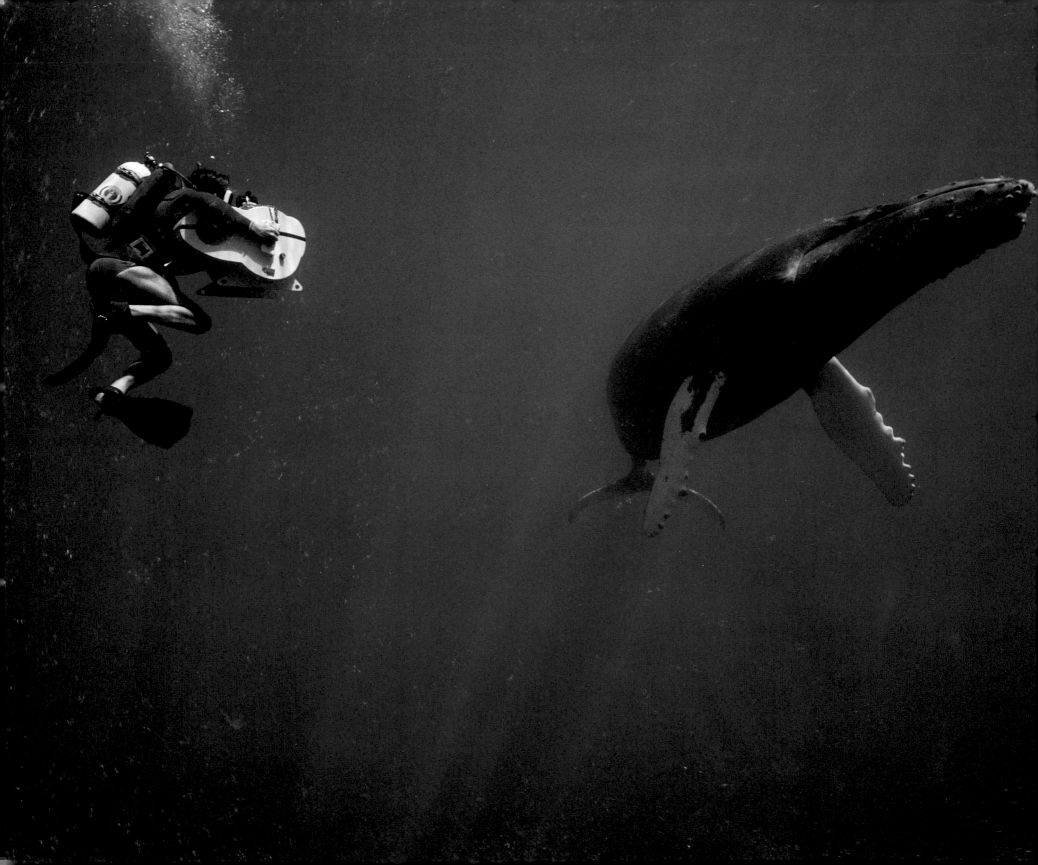

"I wanted to photograph the world I saw when I put my head underwater."

DIVING AND WHALES weave in and out of my family like something embedded in our DNA. My great-great grandfather Philip Crosthwaithe arrived in San Diego, my hometown, on a whaling ship, though that wasn't his intent. He thought he'd signed on for a "fishing trip" to the Grand Banks. But the few-days trip turned into a six-month, life-twisting odyssey around Cape Horn—another kid shanghaied to crew on a whaler.

Whaling was not for Philip, so he jumped ship in San Diego. At that time, in the 1840s, it was a little Mexican town, and Philip eventually married into the prominent Lopez family, becoming a respected town figure himself. In his recollections, he described the waters off San Diego as filled with "great numbers of whales" that "came to deliver their young." Philip's grandsons, my grandfather Charles and his two brothers, returned to the sea, in a fashion. Among their businesses, they had a construction company that built piers along the coast, requiring them to do some hardhat diving. In 1947, the year before I was born, Charles drowned in a diving-related accident.

My family had a grocery store, Chuck's Market, in east San Diego. San Diego was a smaller town then, with a strong Hispanic flavor and presence, and I grew up in a neighborhood full of my Crosthwaithe kin. My great-uncle Marcos, who lived near us, left a big impression on me. He was a tough, beat-up guy, who walked with a cane and had fingers missing, all the result of diving accidents.

My dad, Chuck, with a 300-pound IMAX camera filming a friendly humpback in Maui. This was a rare occurrence at the time and very exciting.

From the time I was an 11-year-old kid, I helped out in my dad's new business, the Diving Locker. Many of the guys who came in were free divers, abalone harvesters, spearfishermen—a rugged bunch. They weren't diving for recreation or glamor, they were diving for dinner. I remember a Greek diver trying to settle his bill at the shop with a jar of pickled octopus.

These characters weren't the only ones hanging around the Diving Locker, whose corporate name was Scientific Diving Consultants. My dad's original partners were all scientists from places like Scripps Institute. They were at least as eccentric as the other bunch. But they weren't after dinner. They were after discovery, a new way to see the oceans now that scuba gear let men swim with some of the freedom of fish. Their talk, their approach to the ocean mingled with the spearfishermen's and hung in the dive shop air. Being around them and watching how Chuck, as I called my dad, had changed his own life made me realize that there were a lot of different ways to live. And being part of the diving world, teaching diving, feeling at home in the water, was becoming part of my identity.

The world of the dive shop gradually got bigger after Chuck rode that whale in 1963. He became one of a very small group of divers who could also claim to be underwater photographers. That's when Bates Littlehales came into our lives. Bates was *the* underwater photographer at *National Geographic* and he wanted to swim with gray whales. He needed to talk to a whale expert, and Chuck qualified. After all, he'd seen a whale up close, underwater, and had even taken pictures of it.

Bates would come out to visit and we'd take him diving. I was in my late teens then, and he became a role model for me. He'd traveled the world and had exciting underwater adventures, but he wasn't full of himself. Just comfortable with himself and easy with me. The first underwater pictures I took were with a Nikonos camera with a fish-eye lens that Bates lent me.

Bates wasn't the only *Geographic* photographer who spent time at the Diving Locker. I also helped a guy named Jonathan Blair with specialty diving, showing him how to function underwater with his hands full of camera gear. When the *Geographic* sent Jonathan to cover the Hawaiian Islands National Wildlife Refuge, he asked me to come along as his "diving and camping assistant." To get in photographic shape for the trip, I went to the Caribbean for a week and did 38 dives. On each dive I shot a roll of film. The first picture I sold was from that trip—a shot of a grouper that ran in a kid's magazine. They paid me ten dollars.

The environmental movement was gaining momentum then, and the

RIGHT: *This picture of an underwater photographer at work was my first published photograph in* National Geographic, *Tanner Banks, off San Diego, 1977.*

OPPOSITE, LEFT TO RIGHT: *Chuck in front of the Diving Locker with the store mannequin, "Jacques." Me at 14 with my spearfishing trophies. Here I am on my first* National Geographic *assignment in Hawaii, 1976, and with NGM photographers Jonathan Blair, right, and Steve Uzzell, middle, on the same assignment.*

Marine Mammal Protection and Endangered Species Acts had been passed a few years earlier. Jonathan's *Geographic* story was going to be a celebration of the wildlife out on the islands—thousands of birds, monk seals, sea turtles, and all kinds of reef life.

For three months Jonathan, Steve Uzzell—a specialist in multimedia shows—and I covered the refuge islands in the remote northwestern part of the archipelago. We used the Coast Guard station on Tern Island as a base, then took little inflatable boats out to other islands in the refuge, some atolls no more than 100 yards by 50 yards. We really had to work to figure out where to pitch our tents because there was so much animal life. Endangered monk seals and green turtles came back and forth at the water's edge, and nests of frigates, boobies, tropicbirds, terns, and albatrosses were everywhere. On one of the larger islands there were an estimated six million birds, and countless bird lice that infested both the birds and us.

During the last few weeks of the assignment, Bates came out to join us. At night he and I would go diving, while Steve and Jonathan kept reminding us to look out for tiger sharks. The talk for the whole three months was of photography, how to see light, even how to "paint" with it. These guys lived and breathed photography. Being around them made me see photography in a whole different way. Both Bates and Jonathan gave me a chance to shoot situations they could easily have handled themselves, and when *Hawaii's Far-flung Wildlife Paradise* came out in the magazine two years later, a couple of my images were in it.

After Hawaii I picked up work here and there. I dove for a scientific consulting company based in Virginia that conducted environmental impact studies on prospective oil leases off California, Texas, and Louisiana. It was a way to make a living and shoot underwater, though some of the water I worked in was dark and dirty. I considered it diving for dollars. No fun. Occasionally, I had to wear a harness, so the guy above on the surface knew where I was. I couldn't avoid thinking that this was the kind of dark-water diving that my great-uncle Marcos had done with my grandfather.

For three years I didn't have a place of my own. I lived on boats on these assignments or slept in back of Chuck's dive shop in a sleeping bag. Or I bunked in with friends and family. I was saving the money I made to buy camera gear. I wanted to photograph the world I saw when I put my head underwater.

Just when I was at a real low point, I got a call from a multimedia company doing some work for Sea World in San Diego. They needed someone to photograph Sea World's new giant shark tank, and it was just what I needed to keep me going. That kind of chance assignment became part of a pattern:

ABOVE: *Green turtle and albatross* OPPOSITE: *Pufferfish*
FRENCH FRIGATE SHOALS, HAWAIIAN ISLANDS NATIONAL WILDLIFE REFUGE 1976
From my first National Geographic *assignment, as an assistant*

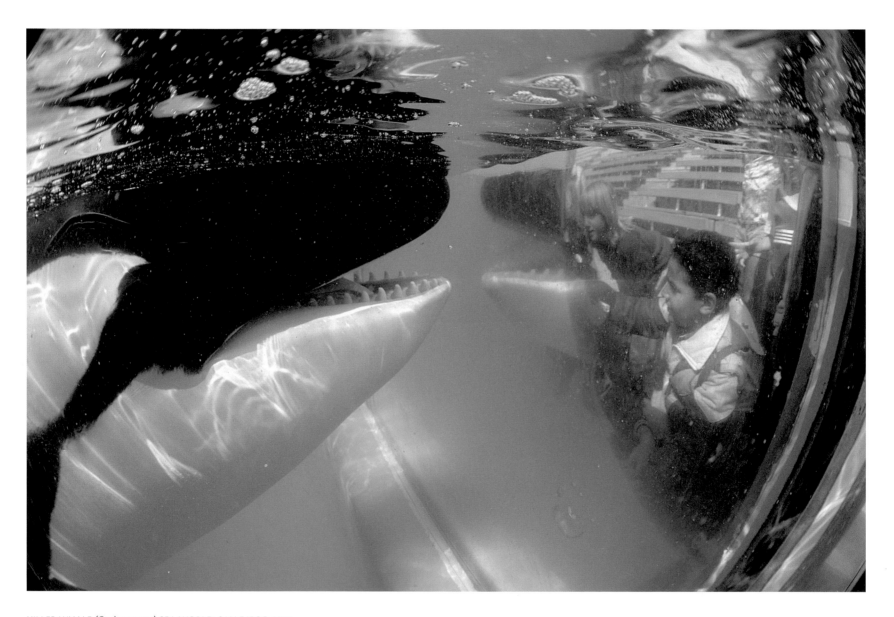

KILLER WHALE (*Orcinus orca*) SEA WORLD, SAN DIEGO 1981
*For all the controversy surrounding captive cetaceans, they offer
the first interaction with marine mammals for many a child.*

Every time I'd be ready to quit trying to be a photographer, something like that would pop up to keep me going. More than the income and experience, photographing captive sharks at Sea World gave me an idea for a *National Geographic* story.

In 1978 I flew to Washington, D.C., and had my first face-to-face contact with the National Geographic Society. I paid for the trip myself, but I told Bates the trip was being paid for by the Virginia-based scientific consulting company. And I told the consulting company the Geographic was paying for the trip. On many levels, that was my first foray into telling a story.

As always, Bates was helpful, encouraging, and ready to show me the ropes. He even arranged for me to meet the legendary NGS director of photography, Bob Gilka. Gilka was the highest life form I could imagine—for decades one of the most powerful people in photography and an advocate for photographers. The people he sent into the field regularly were called Gilka's Gorillas, and a wall at NGS headquarters was devoted to pictures of them in every corner of the world, clowning in tough situations. Like every young photographer, my greatest dream was to get there one day— on Gilka's gorilla wall.

On the day that Bates was going to bring Gilka by his office to meet me, and while I waited for them, I pored over hundreds of 35mm transparencies. They were "out takes" from the Hawaii assignment, spread on a light table. When I heard Bates and Gilka come in, I turned to meet them and knocked about 200 images onto the floor. Gilka said something like, "You look busy. I'll see you later." I figured I'd never see him again.

Gilka's brusqueness was famous, and he cultivated it. The sign outside his door said, "Please wipe your knees before entering." He once famously told an aspiring photographer, "It's good that you're young and strong, because what I'm going to tell you is going make you feel old and weak." The photographer didn't give up, and he's celebrated in the field now. I was determined not to give up myself. I wiped my knees and went in. Gilka sat back in his chair, his glasses low on his nose, listening politely but impassively as I talked on about my experiences so far.

I flew out of D.C. encouraged. I had a few small *Geographic* assignments, some day-long shoots, and others as a photo assistant. I'd also gotten to know other *NGM* photographers, and I'd even met Gil Grosvenor, the editor-in-chief of the magazine. I'd had the audacity to show him a few of my pictures, images I'd be embarrassed to show anyone today, but I was young and knew no better.

I went back to pick-up jobs in San Diego, but every time *Geographic* photographers came through town, I'd help out, officially or unofficially, hoping they'd leave me their extra film so I could keep shooting. In those days before digital photography, film and film developing cost a lot and I knew the more I experimented, the better I'd get. Getting a free "brick" of Kodachrome, a 20-pack carton, helped a lot.

While I was struggling to claw out a foothold in the world of photography, my dad Chuck was becoming more and more well known as an underwater cinematographer. He was shooting documentaries and Hollywood features like *The Deep*. He had always said, "Whatever I do, I'm going to do well. If I had

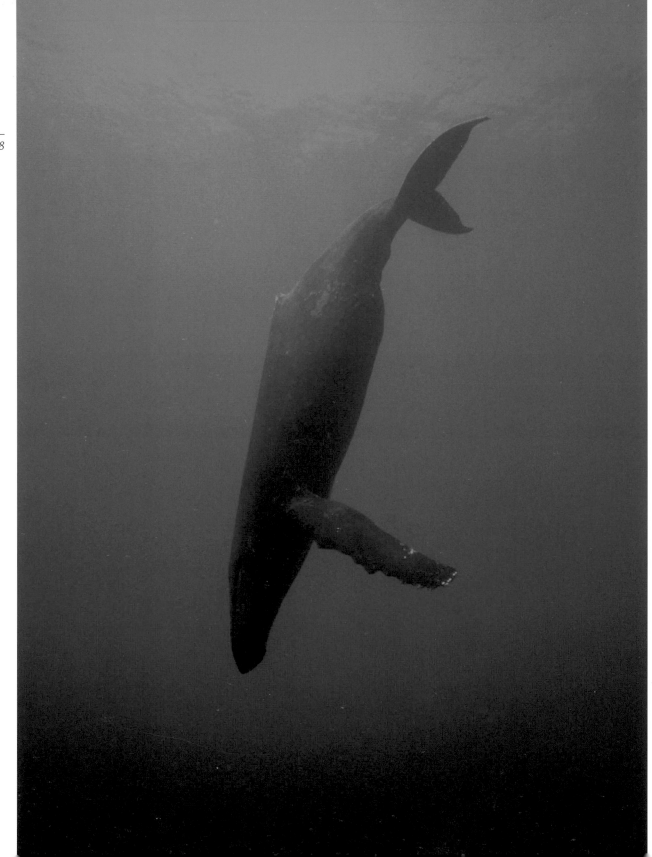

HUMPBACK WHALE
(Megaptera novaeangliae) MAUI 1979
Frank, the first humpback singer we identified by sex

OPPOSITE, LEFT TO RIGHT: *Jim Darling and Greg Silber, humpback researchers on Maui, trying out an underwater hang glider that never worked, 1981; one of the early whale-watching boats working out of Lahaina, Maui, 1981; Jim sorting whale ID shots at his home in Tofino, Canada, 1981; Greg, now with NOAA, and Beth Mathews, just retired from University of Alaska Southeast, recording whale song off Maui, 1981.*

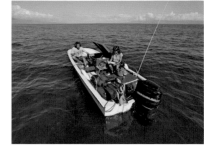

been a street sweeper, I'd have been a famous street sweeper. I'd have named my broom and worn white gloves." In the late '70s he got an assignment to work on an IMAX film, *Nomads of the Deep,* and he brought me on to do stills. Today, there are scores of IMAX theaters all over the world, but at that time "Image Maximum" was the latest, greatest way to push the impact of photography forward. With screens measuring 72 feet across and 53 feet high, IMAX gave audiences the up-close thrill of really "being there"—in the ocean depths, on the mountaintops, wherever the camera took them.

In the winter of 1979 we flew to Maui to shoot humpbacks. Things had tightened up a lot since Chuck rode a whale, and now you needed a federal permit to get near most whales. Chuck went through Roger Payne and got included on Payne's permit. Chuck had worked with Roger in Patagonia in 1972 shooting right whales for the first underwater wild whale story the *Geographic* ever published.

In the late '60s and early '70s, Roger Payne and a colleague had described how humpback whales actually "sing," creating "exuberant, uninterrupted rivers of sound." He'd become a pioneering leader in whale research and conservation, and his album, *Songs of the Humpback Whale,* had captured the public's imagination. So had Joan McIntyre's wildly popular *Mind in the Waters: A Book to Celebrate the Consciousness of Whales and Dolphins.* Suddenly, whales had become iconic gentle giants—wise, mythic creatures. I had been in Hawaii in the late '60s, helping out in a dive shop on the Big Island that Chuck had part ownership in. Maui had been the place to party then. Now, a decade later, it was the place to whale watch.

I remember thinking at the time that it was probably too late to get in on the whole "photographing whales" thing, even though the first picture of humpbacks in the wild had only been published in 1975. The idea that scientific research would keep opening up new ideas, new developments, and even new species to photograph and study changed my thinking, especially after I met Payne's group of graduate students. Just like the humpbacks, they came to Maui each winter. The whales came to mate and calve; the graduate students—more than a dozen young men and women squeezed into one ramshackle, three-bedroom house—spent their time looking for whales.

In those days, there were few cetacean researchers at all, and fewer still doing field research, trying to study marine mammals in the wild. One of them was our main contact and the coordinator in the group, Jim Darling, a grad student at UC Santa Cruz who'd been hired by Payne to make recordings of singing whales.

It's not that easy to work around whales in open water, to position yourself so you don't disrupt or interfere with the whales' behavior but are close enough to shoot it. Jim had a real talent for that. On March 10, 1979, Chuck and I were tagging along behind Jim in our own boat in the waters between Maui and Lanai, where the humpbacks pass through. Then, for the first time, someone on Jim's boat spotted a singer down about 50 feet, hanging there, stationary, as it sang. He called us over to get pictures of the singer that would allow him to "sex" it—identify its sex. The idea was to photograph the whale in order to identify the individual, then photograph its genital area—the female has a single, long genital slit, whereas a male has two slits—to document its sex.

In those days, I could free dive without air down about a hundred feet and stay a minute. That made taking photographs of the whales a lot more feasible, as bubbles from air tanks change the whole human-animal dynamic. Bubbles are part of a humpback's display behavior, so if you go up to one wearing an air tank making a loud bright display, you're communicating something—but you don't know what—to an animal that weighs in at around 40 tons. Not a good idea. Free diving was the way to do this photographic sexing, and as the seasons wore on, I took more and more images for Jim, images that helped him establish that only male humpbacks sing. This was a big jump in understanding whale behavior.

Meeting and working with all these young, smart, passionate biologists was life-changing for me. It was a community I really liked and had had little exposure to. I was beginning to realize that underwater photography could do more than get me published, it could help tell the story of this new, changing field of marine mammal research. Here were a dozen or so graduate students who were taking our thinking on whales from myth and magic to an understanding of them as biological creatures. Before, scientists thought they had to kill a whale to study it, but these guys were studying the animals in the wild and identifying individuals by their distinctive natural markings. Jim asked me to come back the next year and work with them, doing more photography. I agreed.

Suddenly, things were breaking my way. I found out the *Geographic* had approved my shark story idea, only I hadn't been assigned as the primary photographer on the story. Still, I had gotten a piece of the puzzle. I was to photograph shark researchers and their work in various parts of the world. That was fine with me. I had a *Geographic* assignment, and, having worked with Jim and his colleagues on Maui, I realized I liked documenting scientists at work.

I'd also gotten used to the academic budget that the Maui researchers lived on, and it took me a while to realize the *Geographic* was willing to do better than that. One place I landed for the shark story was La Paz, Mexico, near the tip of Baja California, to cover researchers working on hammerhead sharks. The first thing I needed to do was hire a boat and crew, and I found three lobster boats for hire that had been donated by the Cuban government. They'd been painted on one side only, the side facing shore, so prospective clients wouldn't see what bad shape they were in. Only one was functional, and I settled for it. That was Friday, and I expected we'd be on our way,

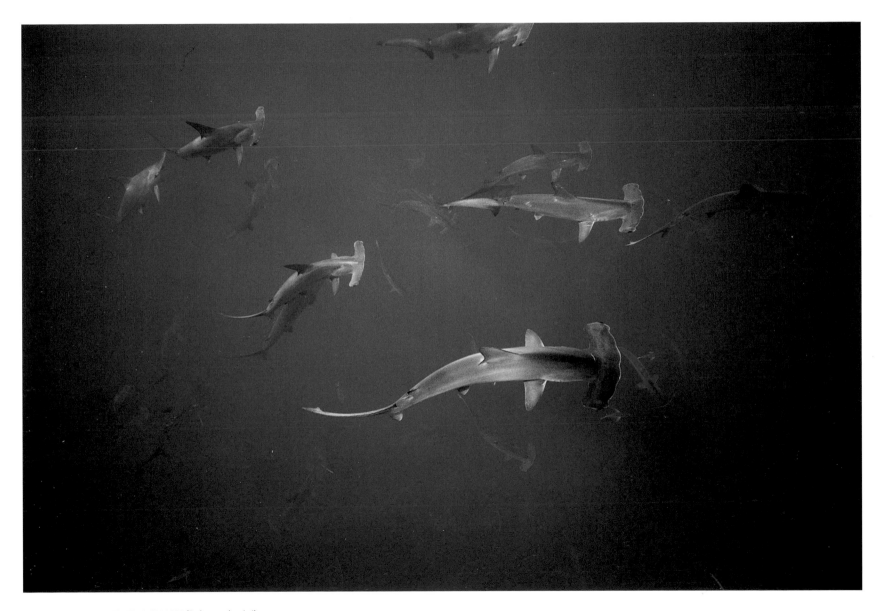

SCALLOPED HAMMERHEAD SHARK (*Sphyrna lewini*)
EL BAJO SEAMOUNT, BAJA CALIFORNIA 1980
The first magazine photograph published of schooling hammerhead sharks

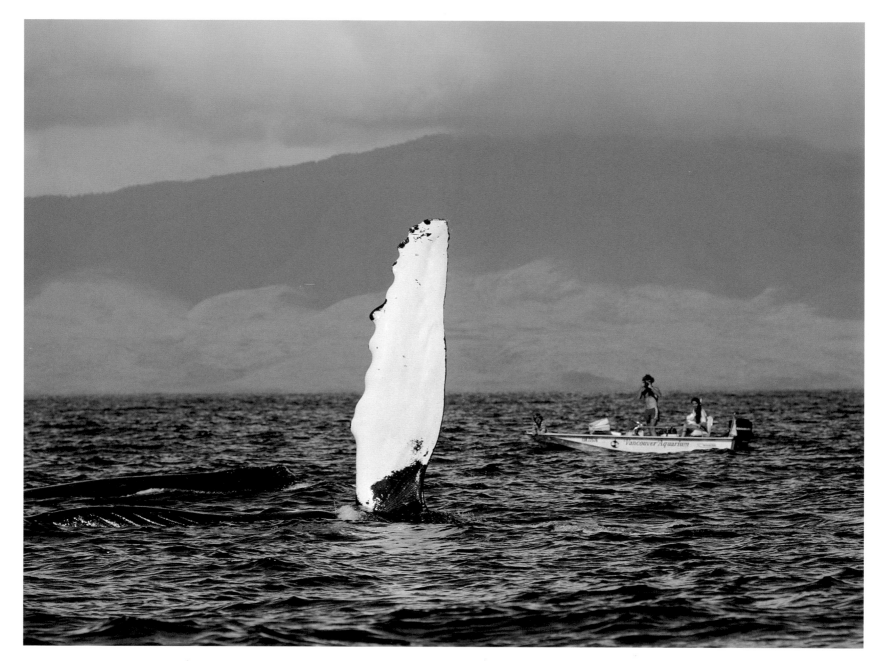

A humpback slaps its pectoral as researcher Graeme Ellis
and his young family observe it from a small boat, Maui, 1981.

RIGHT: *Jim Bird (at scope), Mary Bird (with notes), Karen Miller (surveying), and Margo Rice (with binoculars)—the so-called "Hill People"—track and describe whale behavior from a small hill south of Lahaina, Maui, 1981.*

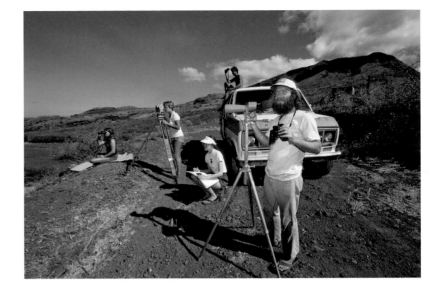

but the captain hid from us till after midnight, because, we later found out, he considered it bad luck to leave on a Friday.

That 60-foot bucket of his was hot and uncomfortable, and the water onboard was dirty. But the captain knew how to find sharks. He took us out to a seamount called El Bajo in the Gulf of California teeming with them—maybe 600 hammerheads, each six to nine feet long, so many that the ocean was dark with them.

The whole premise of the *Geographic* story I was working on revolved around the idea that sharks were, as the title proclaimed, "magnificent and misunderstood." The writer, scientist Eugenie Clark, believed that most were "timid toward man…'chinless cowards.'" That was hardly the image painted in vivid color in *Jaws*, which had come out in 1975. Standing on that old boat in the Sea of Cortes, staring down at the ominous, shifting stain under the sea surface as hundreds of sharks prowled, I certainly had second thoughts about getting in the water. But the fear of not getting the images I'd been sent to get was frankly more threatening. I'd come a long way and spent a lot of effort to find these animals and get to this point. I wasn't going to pass it up.

I slipped off the gunwale into the water and snorkeled toward the fins. As I got closer, I could see a dark shadow in the blue water that gradually separated into hundreds of hammerheads. They kept circling above the seamount, mostly ignoring me, sometimes shifting out of my way. I had to get in close and free dive down among them to get a good picture. It was a delicate balance of art and survival. I took a breath and dove. An image I got of the circling sharks became my first gatefold in the *Geographic*.

That seamount was an amazingly rich site. Besides the sharks, manta rays sailed by me on all sides. I had a whole other *Geographic* story staring at me, but I was too focused on the sharks to see it.

The next winter, I was back on Maui for a few months' work with Jim. I slept on the floor in a cheap condo he had rented, while the bunch of whale researchers working with him lived nearby in a three-bedroom house. None of us was doing this work for the money, that was certain. We were doing it for the thrill of discovery—and adventure.

Every day Jim and I and sometimes a couple of other researchers would go out on a 17-foot Boston Whaler he had for the season. We were looking for stationary humpback singers. We could spot their tails as far as 50 feet

under the surface, since they sang with their tails pointing toward the surface and their heads down. Whenever we found a singer, I would hop in. My job was to sex the singers, so I had to go under the tail. These were free dives down about 70 to 100 feet, but I took a little pony tank of air in case I needed it coming up from those deep dives.

The most important thing for me to do was stay relaxed and not use up a lot of air or unnecessary energy. I'd take a few deep breaths and start kicking down, counting my kicks as a way to keep calm and focused. I needed to get into position beside the whale and not blow bubbles. As I got closer, the singing would grow louder and louder, going past the 70 decibel noise codes and finally topping out at 160 decibels, as loud as the roar of a jet engine. I wasn't hearing it, though, I was feeling it. All my air spaces were vibrating. It was like being inside a drum. I needed to get 10 feet beyond the tail to the genital slit, but whenever I started in that direction, the tail would usually flex up. After a number of these dives I realized the whales were flexing their tails because they felt a bubble or something from my presence, and they were lifting their pectorals and looking back under them to see what was what. In order to do that, they used their tails for purchase. Still, if the tail came down on me, I knew I'd get pounded. Humpbacks may look graceful, even weightless in the water, but just a small bump from one would really hurt.

While I was down there beside those massive creatures, holding my breath, I had to stay very focused on the camera. I was shooting Kodachrome with a pound-and-a-half Nikonos, and it was clumsy to use. You couldn't fiddle with it very easily to change f-stops while you were underwater on a free dive. I'd bracket to make a bunch of exposures, then I'd come up for air, change the f-stop and go down again. Generally I'd make three dives for each animal, concentrating hard on both getting the shot and not knocking myself off. Now cameras have auto focus and auto exposure, but the gear was pretty primitive then. Still, we could take the film into a shop on Maui in the late afternoon and get it the next morning. My images confirmed that all the humpback singers were male.

Sometime during that season, I got a call from Mary Smith, the picture editor at the *Geographic* who worked with researchers. She'd heard I was taking pictures of the humpback research, which the Geographic was helping to fund. She wanted me to know the magazine had proprietary rights to all photography from that research, but she also asked to see my images. I sent her some of the behavioral shots, and she liked them. She told me to keep shooting that season and mail her what I took. I asked the *Geographic* to send me back to Maui the following season and they agreed.

When I came back the next year, I was officially on assignment, my expenses paid. That made life much more comfortable for me, and I could pay my way with Jim and the other researchers instead of being a drain on their strained finances. In April 1982 the first story with my byline, "Singing Whales," appeared in the *Geographic*.

I had set three goals for my career and I was beginning to realize them. First, I wanted to make a living; then, I wanted to make it doing something I wanted to do; and ultimately, I wanted to do something I wanted to do and have that make me a living. I was starting to see a way to do that.

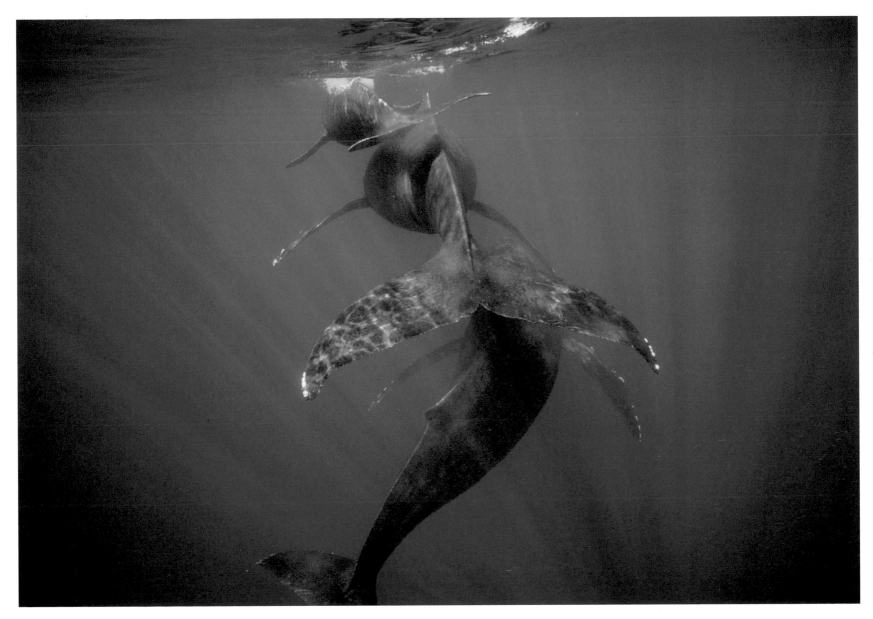

HUMPBACK WHALE (*Megaptera novaeangliae*) MAUI 1981
A mother and her young, accompanied by an escort male, travel in close formation.

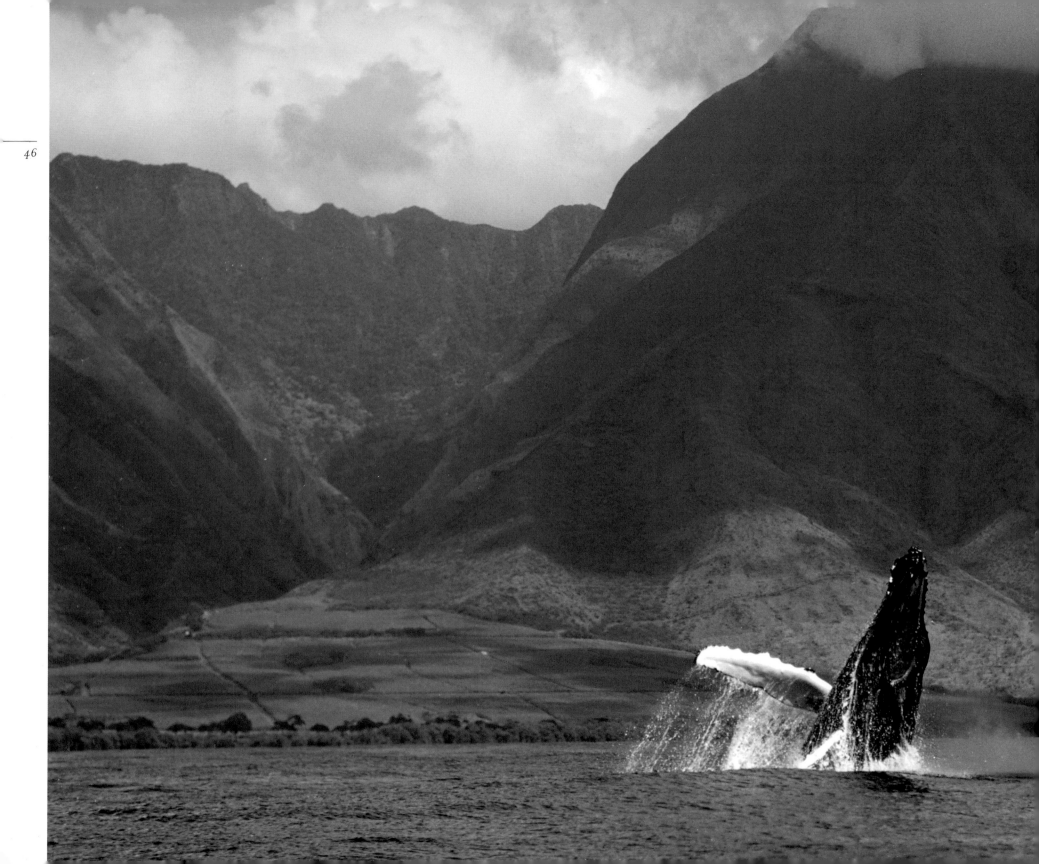

HUMPBACK WHALE *(Megaptera novaeangliae)* MAUI 1998
*Humpback breaching off Olowalu. This is where we usually start
each day—a place with few boats and more whales all the time.*

HUMPBACK WHALE *(Megaptera novaeangliae)* MAUI 2005
A yearling in the last stages of dependence on its mother. The two will soon separate.

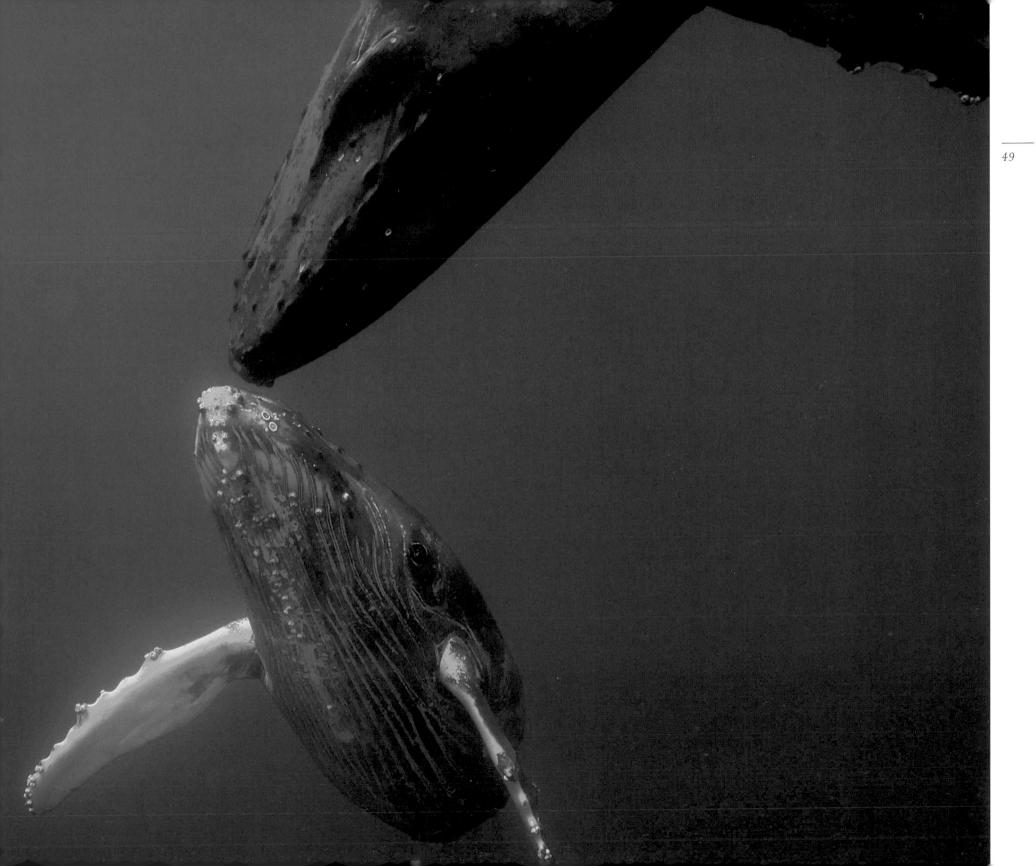

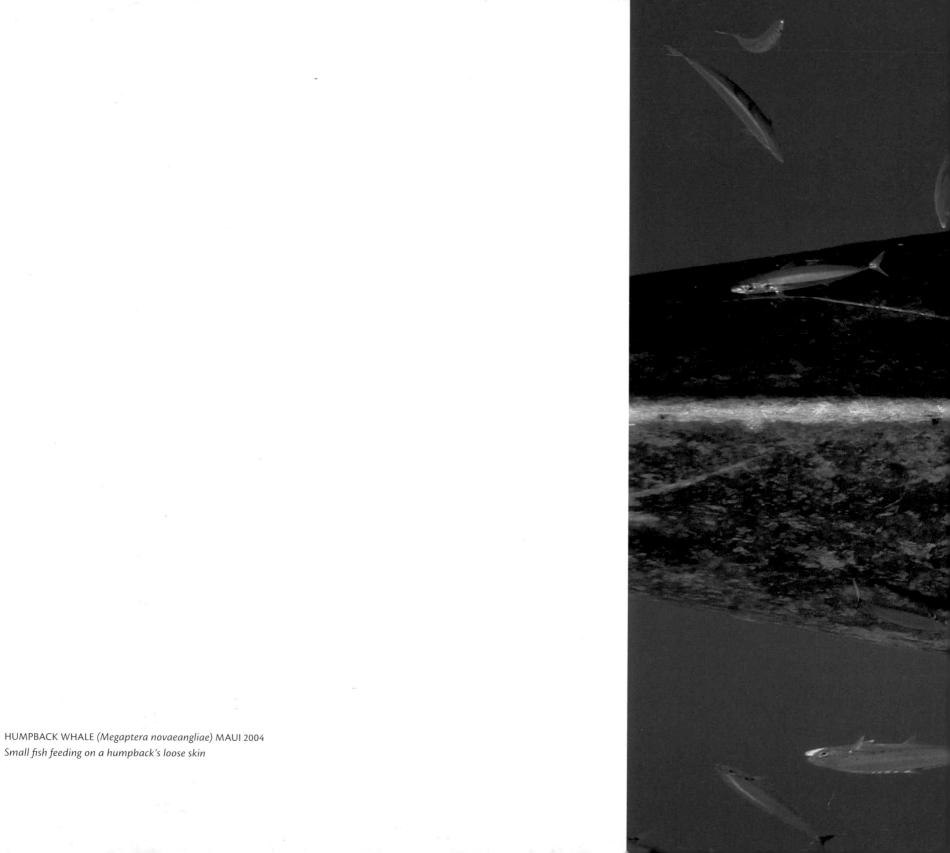

HUMPBACK WHALE (*Megaptera novaeangliae*) MAUI 2004
Small fish feeding on a humpback's loose skin

HUMPBACK WHALE (*Megaptera novaeangliae*) MAUI 2010
*A female humpback with cooperating males around her. She had just
slapped her pectoral on the surface and that caused the bubbles.*

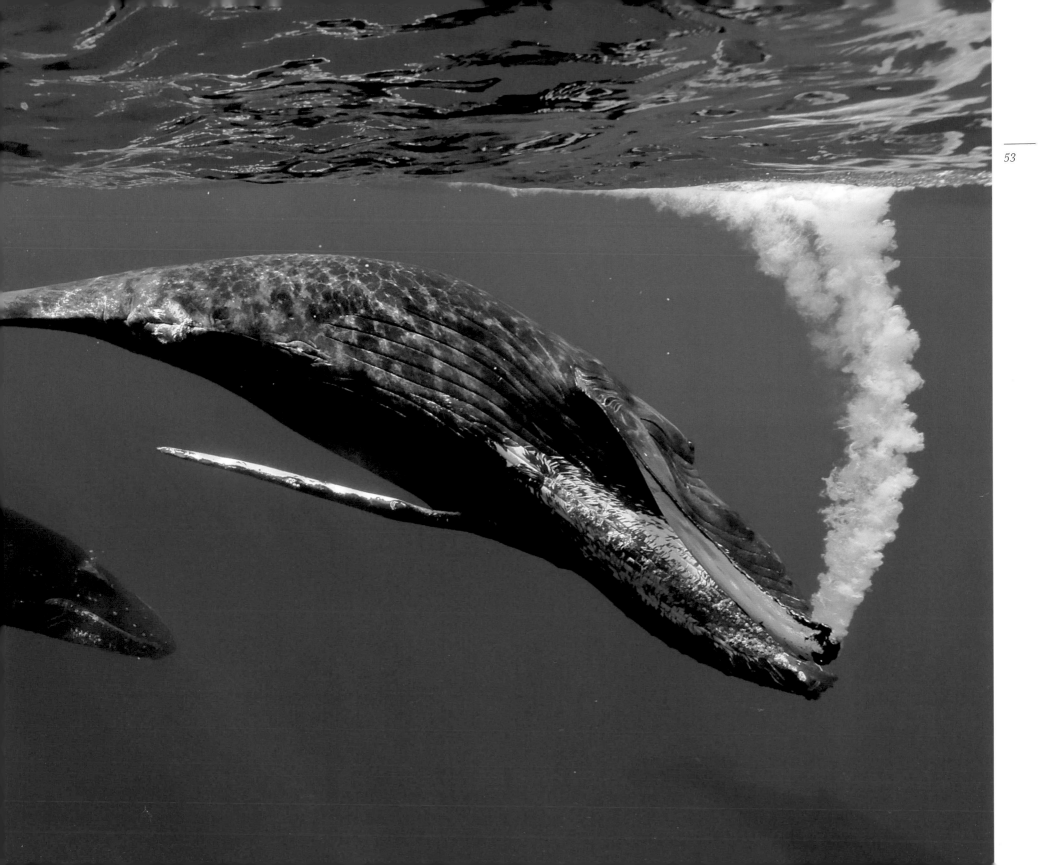

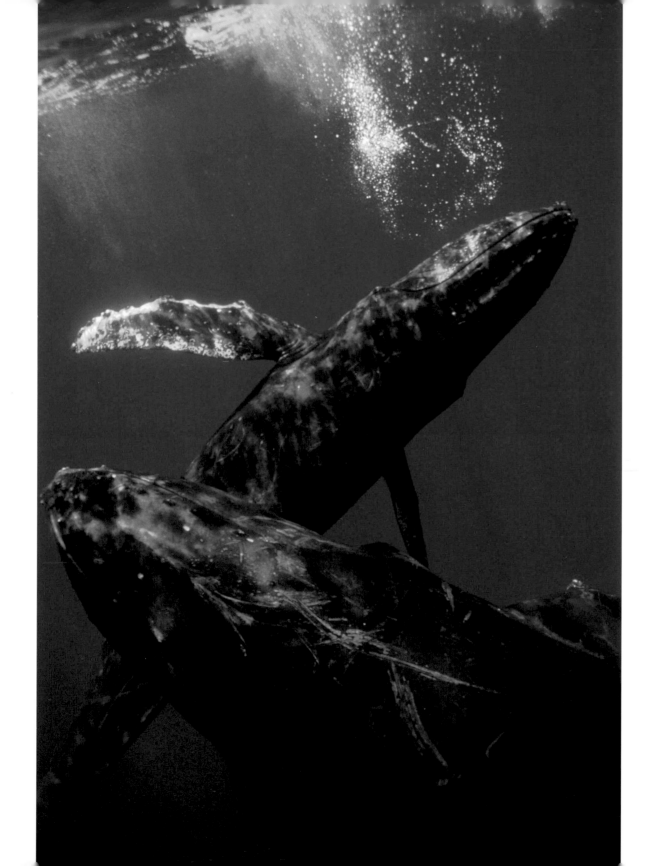

LEFT:
HUMPBACK WHALE
(*Megaptera novaeangliae*) MAUI 1998
*The first pictures of a joiner and a singer
(background), terms cetacean researchers
apply to humpbacks involved in particular
behaviors*

RIGHT:
*Jim getting ready to start humpback photo-
identifications in southeast Alaska, 1998*

JIM DARLING ON HUMPBACKS

WHALE TRUST

WHEN I STARTED in Hawaii in the mid-1970s, hardly anything was known about humpbacks. They appeared in winter, some with newborn calves, so it seemed that Hawaii was a breeding ground. But that was about the extent of our knowledge. We had no idea how many were present, how long individuals stayed, where they went when they left Hawaii, or anything at all about social groups or mating behavior. Much has changed.

By the end of the '70s, with the use of the then-new technique of photo-identification to study individual whales, we began to get some first glimpses into the behavior of living whales at sea. Now with decades of research and a bunch of new research tools, these glimpses are turning into clear windows into the lives of these animals.

Some of the first really exciting discoveries were the photo-identification matches of whales that had been in both Hawaii and in southeast Alaska in 1979. These were the first migratory connections found in the northeast Pacific. We also identified whales that had visited Mexican breeding grounds one winter and Hawaii another, and with that, many of our preconceptions of these whales began to fall away.

Since then there have been migratory connections found among virtually all corners of the North Pacific and, recently, satellite tagging has given us actual routes and speeds, not just destinations. Now the map of known migratory connections in the North Pacific looks like a road map crisscrossing the entire ocean basin.

Photo-identification has also provided us with the basis to calculate population size much more accurately than in the past. Repeat sightings of individuals from year to year allowed 'mark-recapture' analyses to estimate the total population size. These estimates show a steady and significant rise in humpback populations in Hawaii, from 1,000 to 2,000 animals in the early 1980s to 4,000 to 6,000 in the 1990s to about 10,000 in the mid-2000s—a near five-fold increase.

Perhaps most exciting is the progress made on understanding mating behavior and reproductive cycles. Early on, the repeat sightings of individual whales in specific groups led us to realize there are patterns of interaction. We found that social groups on the breeding grounds were short-lived: Males coalesce around a female and often fight with each other, then the groups split up. Through photo-identification we found females that were the focus of males one year with a new calf the following year. Long-term studies have now given us birth rates, the age of sexual maturity, and even estimates of mortality rates of newborn calves.

We are slowly beginning to understand the lives of these animals, but there are still a million questions. It's just starting to get interesting.

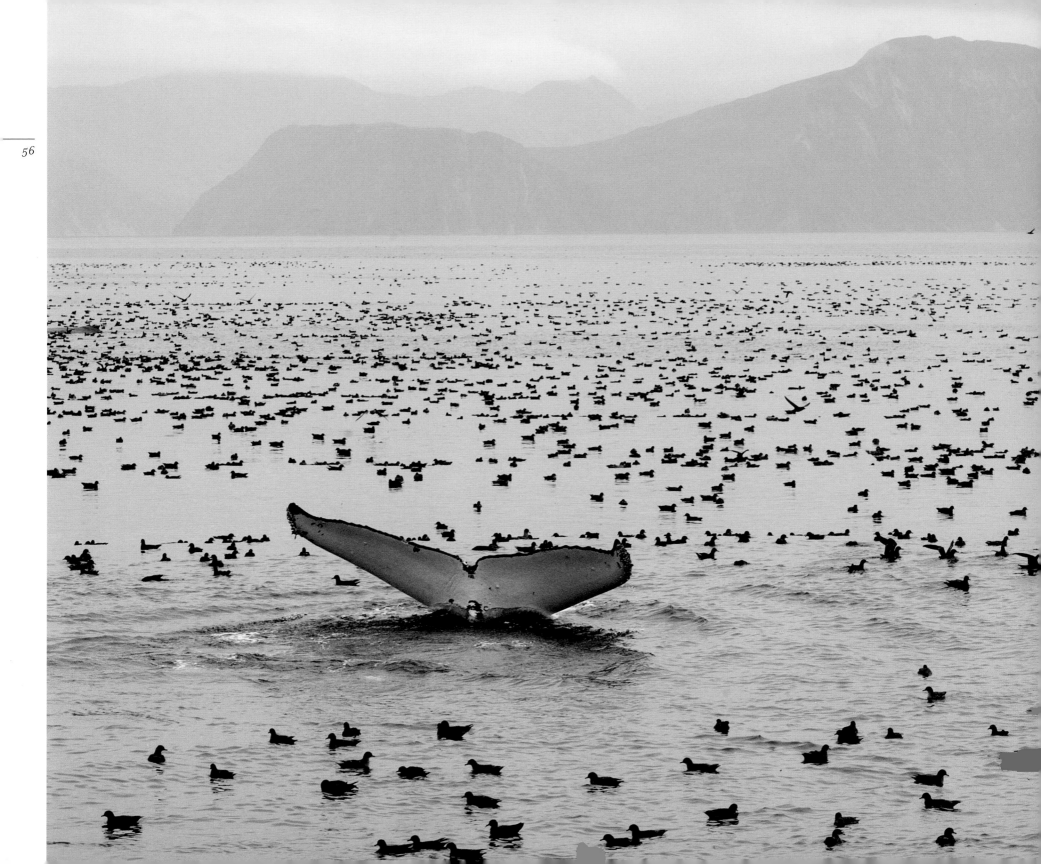

HUMPBACK WHALE (*Megaptera novaeangliae*) UNALASKA, ALASKA 2004
Surrounded by thousands of shearwaters, a humpback dives to feed.

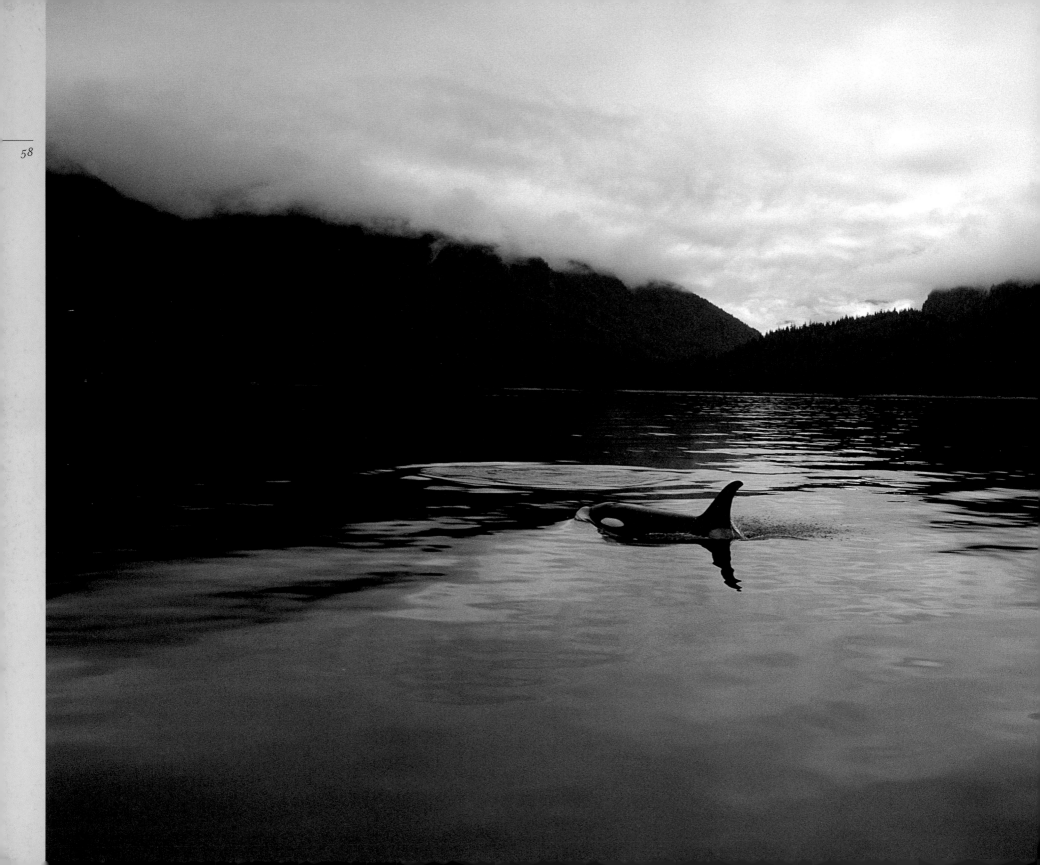

New Era of Discovery

KILLER WHALE *(Orcinus orca)* ROBSON BIGHT, VANCOUVER ISLAND 1981

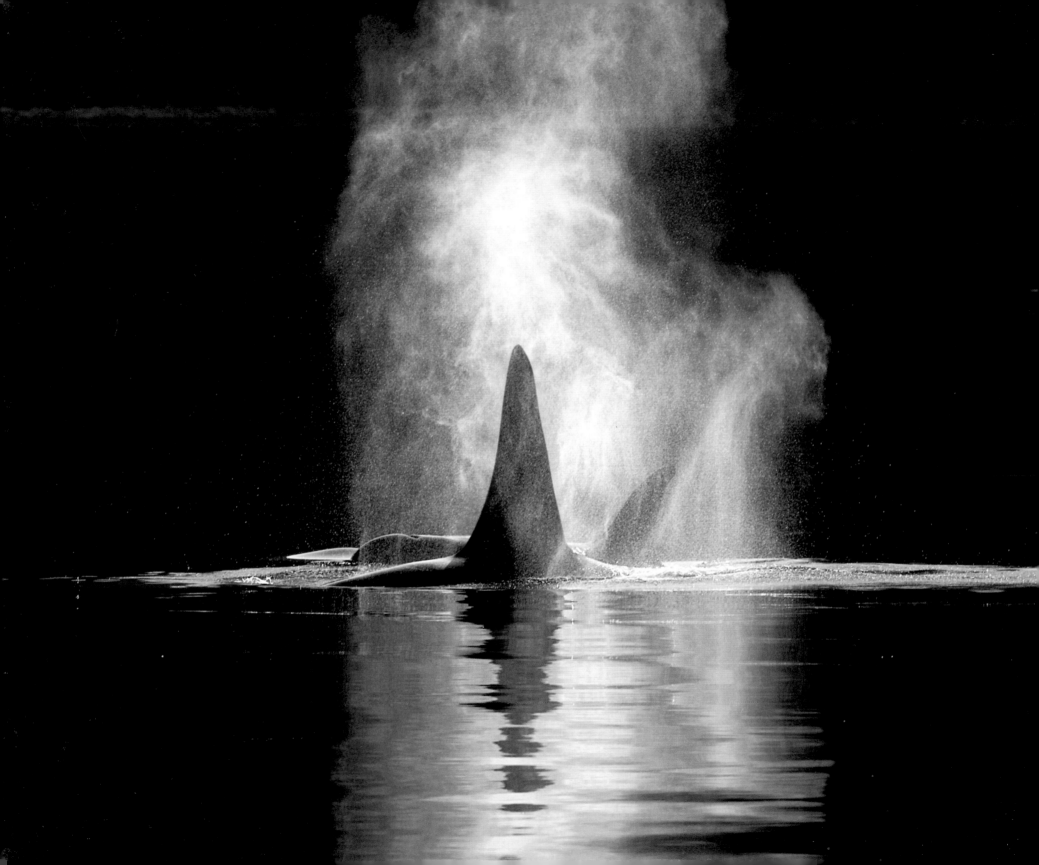

"If you get dead, you can't take any more good pictures."—Chuck Nicklin

MY WORK WITH JIM DARLING on Maui had brought me in contact with the scientific community of whale researchers—a small group at that time. I'd gotten to know two Canadians, Graeme Ellis and John Ford, who were doing work with the killer whale—another cetacean that people knew very little about. Legends abounded of this "extremely ferocious" animal. One popular writer had even called it "the biggest confirmed man-eater on earth." The true expert on these whales was Mike Bigg, a marine mammalogist with the Canadian Department of Fishes and Oceans. He'd discovered that these predators are highly social, cooperating with one another and forming tight family groups around older females, who, Mike suspected, "may live as long as a century."

He'd also made a revolutionary discovery about their numbers. People believed thousands of them lived around Vancouver Island, off the west coast of Canada. But by IDing individual whales, he and Graeme found there were only about 300. As they came to be known as individuals, the public perception of them changed from a menace eating up all the salmon to a precious natural resource. So Mike and Graeme, working in small boats, doing "voodoo" research few people believed in, had already pushed the knowledge of killer whales forward.

KILLER WHALE (*Orcinus orca*)
PERIL STRAIGHTS, ALASKA 2004
While killer whales are magnificent hunters, they're hardly the ferocious man-eaters they were thought to be just a few decades ago.

 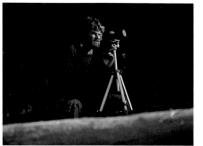 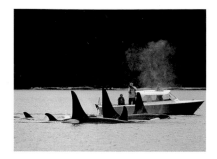

With support from Mike, Graeme and John were going to Telegraph Cove on Vancouver Island for the 1981 summer season to study the killer whale pods near shore. They believed they could ID family groups of killer whales by their sounds and individuals by their dorsal fins, and they invited me to come along. I'd never been farther north than San Francisco before, and at first I was really out of place in that coastal Canadian wilderness, but I soon came to love it.

Graeme and John had positioned themselves on a rocky outcrop east of the island near Johnstone Strait. It was at the junction of two waterways, where orcas came to rest, play, and feed in summer. Graeme and John had their families with them and had set up camp—a blue tarp overhanging chairs and tables they'd made of driftwood. It was beautiful. We were living on rice and beans and the fish we (usually Graeme) caught.

All day Graeme and John stared out across the Inside Passage and Johnstone Strait through their spotting scope, scanning for killer whales. John had dropped a hydrophone in the water, because he'd learned to ID groups by their vocalizations from miles away. Graeme was IDing them by their dorsal fins. I was there to tell the story to *Geographic* readers.

I spent a lot of that summer sitting around, waiting for something to happen. I didn't realize it then, but that was what I'd be doing in the years ahead. Like so many adventures, the waiting part outweighed the adventure part—in my case, waiting for the animals, the weather, and the action to be good all at the same time. But it was always worth the wait.

With the killer whales, I hoped for one big, new picture that first season. Graeme and John had showed me pictures of the rubbing beaches in the area, where pods would go in and scratch themselves on small rocks the size of M&Ms. We could only guess at why they did this. John and Graeme had some shots from above water, but I wanted an image of the whales underwater.

One overcast, chilly summer morning we spotted a pod coming in on a path we knew would take them to the rubbing beaches. We headed for a beach not many people knew about, trying to get there before the whales. Killer whales are very aware of what's going on around them, particularly in shallow water. If you stick your foot in the water, they won't come close. So the plan was that I'd be in the water when they got there, wearing a dry suit. I had found a crevice in some rocks along a beach bluff that extended into the sea. I figured I could hide in that crevice and wait for, well, killer whales. John and Graeme had told me that the whales wouldn't hurt me—at least not by mistake. Not very reassuring. I remembered Chuck's fatherly advice to me:

OPPOSITE, LEFT TO RIGHT: LITTLE HANSEN ISLAND 1982 *John Ford and Debbie Cavanaugh in the "hydrophone tent" listening for passing killer whales; Graeme Ellis at the spotting scope; Graeme and Debbie working on a killer whale ID catalogue; Graeme, right, Mike Bigg, center, and Michelle Bigg take ID pictures of killer whales in Johnstone Strait.*

BELOW: KILLER WHALE (*Orcinus orca*) JOHNSTONE STRAIT CANADA 1982 *A family group comes within touching distance of each other as they rest. The whales here rested about 20 percent of each day.*

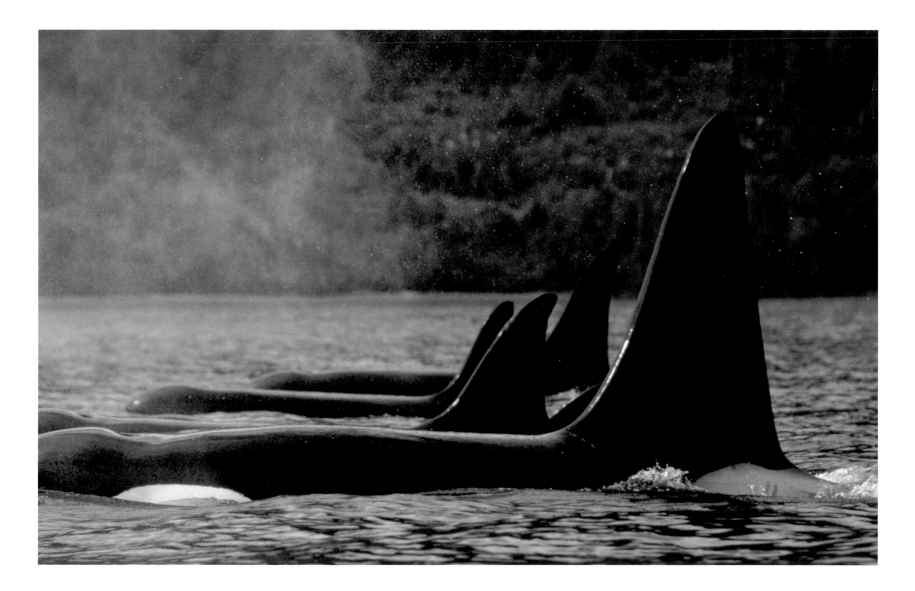

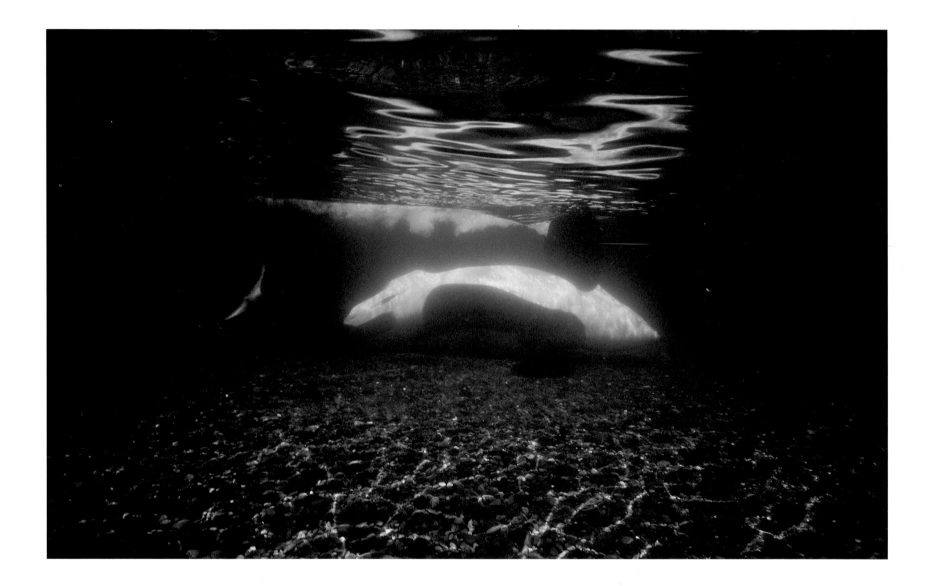

KILLER WHALE (*Orcinus orca*) VANCOUVER ISLAND 1981
This is one of the first images made underwater at the "rubbing beaches,"
a place killer whales often went to give themselves a good massage.

"If you get dead, you can't take any more good pictures."

I was in ten feet of water, with just my face and snorkel above the surface, when I heard the whales blowing. John hissed at me from shore, "They're coming." I looked down and saw black and white shapes gliding by below. I took a big breath, submerged, and crawled along the underwater rocks till I was within a few feet of the whales. Killer whales. They ignored me.

I got off some underwater shots. Then I crawled away, came up near shore, and handed John the camera. He pulled that roll of film out for safekeeping and reloaded. I crawled back to the whales. All and all, I was with the orcas somewhere between 20 minutes and a lifetime, and in that time only a curious calf came up to me. I could theorize till I'm blue in the face about why they tolerated me around them. Had a key elder female, the dominant figure in an orca pod, given the okay? I don't know. All I could do was stay focused on what was going on and not worry about why.

Those initial rubbing beach pictures were what I needed to convince the Geographic to give me a full-blown assignment on killer whales. The next summer I was back on Vancouver Island with Graeme and John. Graeme was a great woodsman, and again this summer he'd taken a chain saw to giant driftwood and bucked out a table and chairs. We sat underneath Douglas firs and hemlocks, watching eagles soar and pluck fish out of the sea. We fished, too, catching plenty of salmon and lingcod for dinner. I dove for abalone, and we cooked it all on an open fire, washing it down with a bottle of wine we'd chilled in the cold waters of the Inside Passage.

All the while we listened for whales on the hydrophone and watched for them offshore. One clear night we heard whales blowing. We all crawled out of our tents to see moonlight rippling across the sea and whales leaving a trail of bioluminescence in their wake. Nobody said a word.

I got more than half the coverage for the killer whale story that second season. I was learning that on assignment you wait and wait, and somehow all the best stuff shows up at the end. My life was starting to follow a pattern that wove together two strands: the National Geographic and the new way of doing marine mammal research—in the field with the animals.

In those years we were making big changes in our understanding of whales, how to study them, and where to find them. Hal Whitehead, a very bright grad student in the field, had done a groundbreaking survey of the Indian Ocean and found lots of sperm and blue whales off Sri Lanka. In the early '80s Chuck got an assignment to shoot underwater film of these whales. I sent a proposal to Geographic to cover sperm whales off Sri Lanka myself and got the assignment.

At National Geographic headquarters in Washington I met Hal Whitehead, who was going to write the story. What gratified me most about the meeting was something the picture editor, Mary Smith, said to Hal. "I'm not sure anybody can do this—shoot sperm whales underwater—but if anybody can, it's Flip. He's our whale guy."

In truth, no one had ever taken a good picture of a sperm whale underwater. Marine mammalogists thought there were plenty of the whales around, but in very deep water, and no one knew if they were approachable. These were the Moby Dicks of the whale world, literally. Big whales with teeth.

Herman Melville, whose own experiences as a whaler show up in his master-piece, called them "the most formidable of all whales to encounter; the most majestic in aspect."

In 1983 I took off for Sri Lanka to find these most formidable of all whales. I was on an exploratory trip for the *Geographic* assignment; my brother, Terry, a seasoned diver himself, came along as my assistant. To us, Sri Lanka was as exotic as anything we'd experienced—a mix of Sinhalese and Tamil cultures and filled with the smells and flavors of the East. The opening salvos of the separatist conflict that would terrorize the country for decades to come had recently sounded, but that wasn't going to stop us—though it sure was going to slow us down.

Despite military checkpoints, we made the trip from Colombo to Trincomalee on the northeast coast with no problems. It was when we got to Trincomalee, a ramshackle port/resort, that the problems started. We went to the boatyard where we were supposed to meet Hal and were told that

he had already sailed away. He'd left no message for us, and nobody there knew his plans. I had no idea what to do. We hung around the "resort" we'd checked into—the only tourists there— drinking orange juice that was really Tang mixed with brackish water.

Then we got a call from the head of Sri Lanka's national aquatic research institute asking us to come back to Colombo for a big meeting. He obvi-ously wanted the *Geographic* photographers to mix with the international group. We agreed, and when we arrived at the meeting, there was Hal. He was calm—and I tried to be calm. No worries, he was going to go back to Trincomalee, and we could get a boat there and follow the *Tulip*, his 33-foot sailboat and research vessel, to look for sperm whales. He'd spotted some, he said, in clear water.

Finding a boat we could hire in Trincomalee wasn't that easy, but we finally made a deal with Benny, the captain of a one-lung, beat-up diesel ferry appropriately named the *Sea Witch* (think *African Queen*). The first day we were 40 miles offshore, quite a ways out, when Benny asked where we were going to put in to anchor for the night. I told him we weren't going to anchor, we were going to stay out on the open ocean. He wasn't happy.

I saw my first sperm whale on that trip. It was staying on the surface a lot, and we realized that it was tangled in a gill net, a big problem for whales. Terry and a member of Hal's crew got in the water and began a pretty daring attempt to help the whale. If they got caught in the net themselves, they'd go down with the whale. We'd never seen a sperm whale before, and now we were trying to rescue one. I got in the water with them, shooting as they

BELOW: SPERM WHALE *(Physeter macrocephalus)* SRI LANKA 1983
My first real portrait of a sperm whale
OPPOSITE: *Hal Whitehead aboard his research vessel* Tulip, *Sri Lanka, 1983*

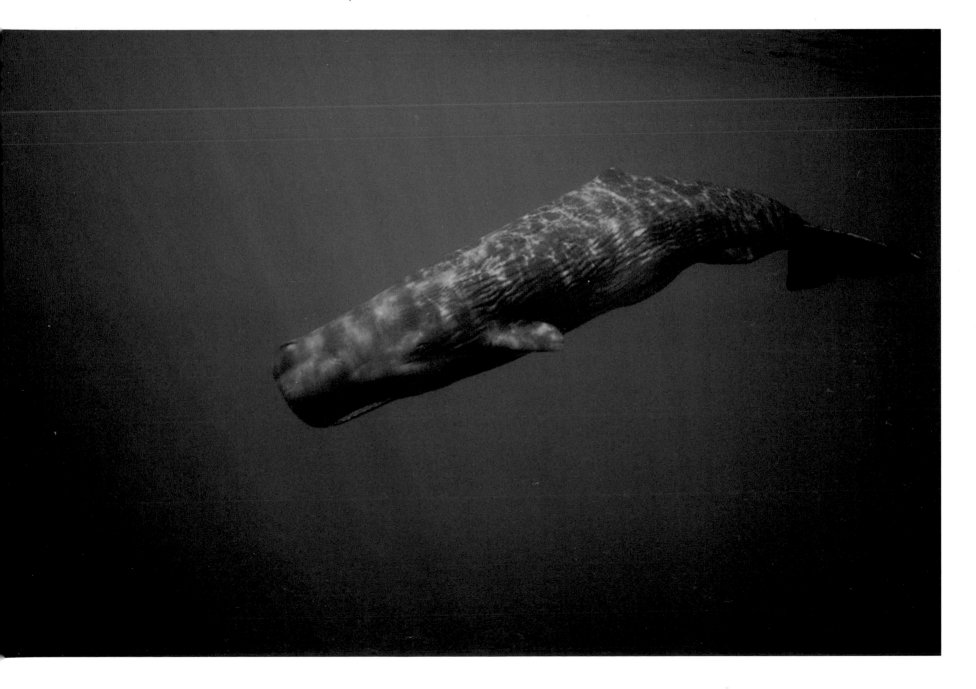

SPERM WHALE (*Physeter macrocephalus*) SRI LANKA 1983
My brother, Terry, and Phil Gilliam work to free a sperm
whale tangled in a fishing net—very dangerous work.

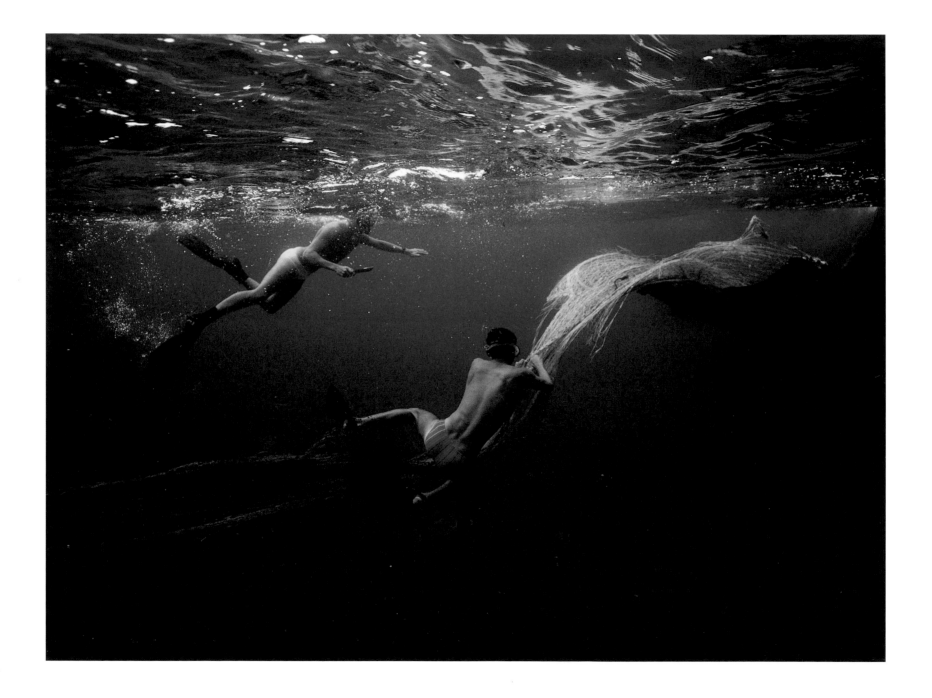

cut away sections of net. The whale was just hanging there, moving its tail slowly up and down. When they got part of the net off, the whale dove. We never saw it again.

When Benny and the *Sea Witch* had to return to Trinco after a couple of days, Hal let me come aboard the *Tulip*. It was small and crowded with researchers, crew, and equipment. As a sailboat, it offered the advantage of being able to stay out at sea for long stretches with no need to refuel. Hal went through some very rough water on that trip, but he was a great seaman. I spent ten days in the hot sun with no shower, no shaving, and rough water, but we did spot two more sperm whales—one lying on the surface, so I could get a picture of its face, and the other diving. I got a shot of that one, too.

I planned to go out again with Hal. But back in Colombo he showed up one night, overwrought, which wasn't like him. He was being chased around by a film crew that wanted to follow him back to sea and document what he was doing. All these photographers were going to slow him down and get in the way of his research. He didn't even want me along on the second trip. Very bad news for me, but clearly his call. I wanted something from these researchers, their scientific story. A lot, really.

I had gotten three publishable shots from the three whales we saw on that first trip. The next January, Terry and I were back in Trinco, a little more hardened and savvy than we'd been the year before. We were joined periodically by Jim Darling and Mike Bennett, a boat captain I'd worked with on Maui. Both knew how to maneuver around whales, and both were good mechanics who could fix engine problems. This time the problem was weather.

The monsoons that particular year raged six weeks longer than usual. Hundreds of thousands of local people were washed out and displaced. The weather, and particularly the ongoing war, made food scarce. We ate a lot of canned mackerel and rice with rocks in it. It took us three days to buy a tough chicken, but we plucked that bird, cooked it, and relished it. We kept hoping the next day would clear. When it finally did, we made small day trips while we waited for the *Tulip* research team to show up. We knew we'd never locate sperm whales on our own, without the *Tulip*'s team and equipment. What amazed us on those day trips, though, was the blue whales we spotted. This was a big deal. I hadn't expected to see a blue whale in my life. And it was then the austral summer, when they should have been in the Southern Ocean. Clearly these whales were year-round residents of the Indian Ocean.

Thanks to Hal's research and efforts with the governments of the Seychelles and Sri Lanka, the Indian Ocean had been designated an international sanctuary for marine mammals, and Trincomalee had become the hotspot for whale spotting. Even Sir Peter Scott, the legendary founder of the World Wildlife Fund, which was helping to support Hal's research, flew in. The son of Antarctic explorer Robert Falcon Scott, Sir Peter was in his 70s at the time, but he was still a force. While he was there, he spent time searching the dirty shallows around Trincomalee for wildlife and doing watercolors of what he found in his logbook.

It was pretty thrilling for me to spend time with this giant of the environmental movement, and I was anxious to oblige him and his wife, Lady Philippa, in any way I could. They wanted to leave a letter with us

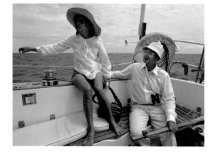 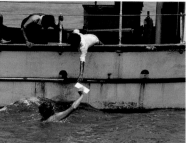

to give to a friend of theirs, Dottie Larsen, who would be coming through whale watching after they had gone. On the day Dottie showed up, the ocean was rolling, too rough to bring our boat and the boat she was on close together. So I swam the letter over to her, holding it over my head.

Meanwhile, we waited—and waited—for the *Tulip* to show up. Finally, after a month and half, it did, but as we got ready to follow it back out to sea, Terry and Jim began to feel sick. The first night out, we anchored off an island in the middle of the shipping channel. By then Terry and Jim were desperately ill, probably from food poisoning. There was no choice, we had to turn around, knowing that the *Tulip* would keep going without us. I couldn't believe we were missing the opportunity we'd waited for so long. But we made the right decision. When we got back to Trincomalee, Terry and Jim had to be physically carried off the boat.

Once again we waited. I remember eating a lot more rice with rocks in it and wondering about the career I'd chosen.

When the *Tulip* finally showed up next, we didn't miss our opportunity. We followed it back to sea in our own hired sailboat. The *Tulip* was being captained by Jonathan Gordon, another young name in cetacean research who has since made his own large mark on the field. When his crew located a

likely group of sperm whales, I slipped in. Underwater, I could see a shadowy human shape taking form on the other side of the whales. As it grew closer, I recognized it. Chuck, my dad—here in the middle of the Indian Ocean.

We stayed out with the *Tulip* for weeks, roaming 40 to 60 miles offshore. At night we kept our lights off to save the batteries, and the world dissolved into darkness, except for the heavens overhead. We needed to stay close together without hitting each other, a tricky thing to do on moonless nights. Sometimes when I was on watch, a shape would suddenly loom out of the darkness right beside us—the *Tulip*, way too close. I'd quickly maneuver to put distance between us.

Of the six long, hard months I'd spent in Sri Lanka, I'd managed only a few weeks offshore looking for whales. When we got back to port, I had very few pictures. But I did have images of sperm whales underwater, and I'd gotten some good shots of blue whales. The combined images amounted to enough for a story, and it ran in the *Geographic* in December 1984.

For a guy who'd never been north of San Francisco a couple of years earlier, I'd now seen a lot more of the world. And that was just the beginning. For the next quarter-century, I averaged eight months in the field a year. Some of those years, I only spent 30 days at home, and "home" itself became a strange

SPERM WHALE *(Physeter macrocephalus)*
SRI LANKA 1983
Bubbles leak from her blowhole as a
sperm whale rests at the surface.

OPPOSITE, LEFT TO RIGHT:
SRI LANKA 1983 TO 1984
Sir Peter Scott, founder of the World
Wildlife Fund, and his wife, Lady Philippa;
me hand-delivering a letter from Lady
Philippa to Dottie Larsen, who came to
look for blue whales; researchers on the
Tulip use the traditional way to spot
whales in the Indian Ocean; me waiting
out the endless monsoons

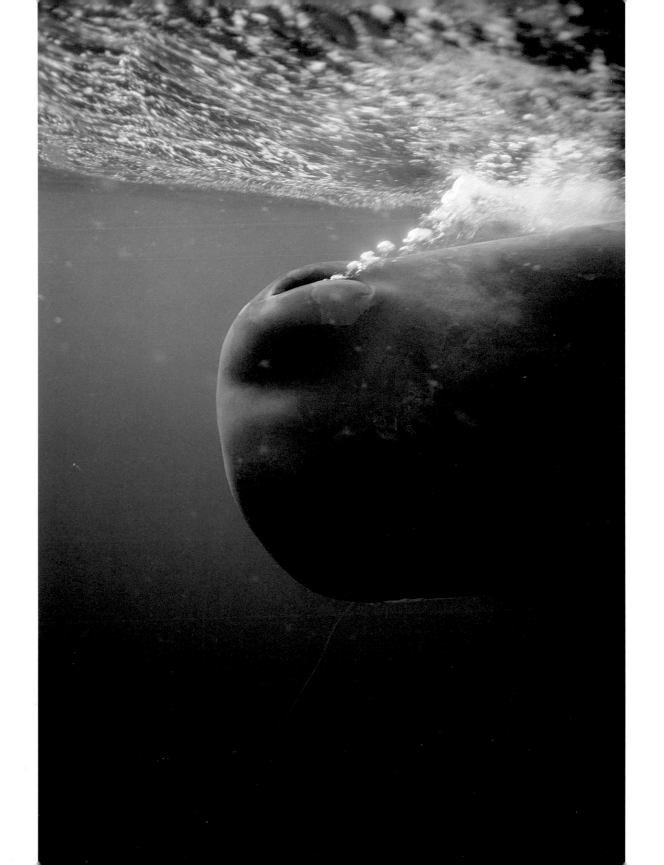

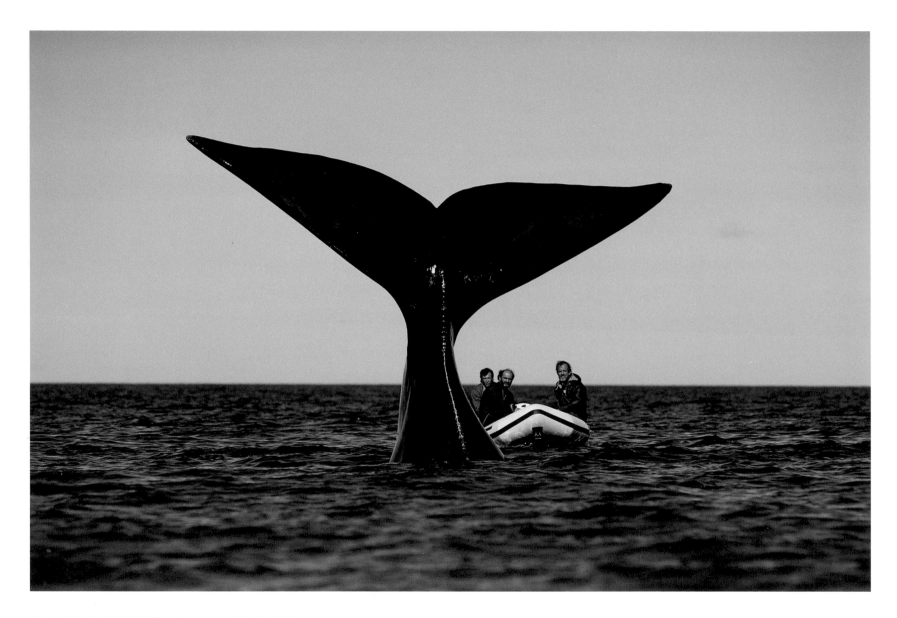

SOUTHERN RIGHT WHALE *(Eubalaena australis)* PATAGONIA 1986
Three generations of whale researchers—Jim Darling, left, Gustavo Alvarez Colombo,
center, and Roger Payne—watch a southern right whale hold its tail into the wind.

concept. I loved life in the field, but it cost me a personal life. It was as if I lived under a strobe light, where the scenes blinked on and off without much continuity. I'd be out on assignment working hard for months, then I'd come back to La Jolla, where I was living at the time, and all my relationships would fall apart. I'd indulge in two weeks of wild and crazy excess to make up for the hardships on assignment, but then what? My friends, with their settled family lives, couldn't relate to my life in the field, and I couldn't relate to theirs. More and more, the field became my real home, and the researchers I knew my closest circle of friends.

In the field was both a harsh and exciting place to live. Most of the time, the living was rough and often tedious, with more waiting around than anything else, and the situations uncompromising. But the camaraderie made up for it. And when we finally found the animals we were after and conditions were good for photographing them, there was no more thrilling way to live.

For a decade I'd been putting everything I had into building my career as the *Geographic*'s whale photographer. I knew I'd finally gotten there in the mid-'80s, when the magazine staff started planning the special December 1988 centennial edition. I was to shoot "Era of Discovery"—a great opportunity to tie together what had been learned about marine mammals in just a decade or two and where the perils to their survival lay. My friend Jim Darling, now quite a name in whale research, would write the text.

I was really pleased to be included in the centennial issue, but word got around pretty quickly among *Geographic* photographers that more stories had been assigned than could be used. We were all jockeying for a position in that issue, and we knew that only the best coverage would make it in.

For the next two years I traveled the oceans, following whales and whale researchers. The place I remember most in that blur of travel was Patagonia—right whale territory and Roger Payne country. That year he was trying a new camp, along a stretch of the Península Valdés overlooking Golfo Nuevo. Years before Chuck had been with Roger to shoot the first *Geographic* wild whale story along this coast. Chuck warned me the ocean off Patagonia was usually rough and green and that the wind never stopped blowing. He told me to start putting dirt in my food so I'd be used to it once I got there. He also told me that on the good days, the whales were great.

I flew to Buenos Aires, then drove down the coast to Roger's camp, a collection of tents clustered around a camper in the middle of nowhere. Still, it was a lively place, with the novelist Cormac McCarthy there for a visit, three Argentinian grad students in residence, and a camp tender named Carlos Garcia who made me speak Spanish, which I hadn't spoken much since I was a child. A true Argentinian, Carlos loved his *parilla* (barbequed meat), and we feasted every day on grilled rabbit, lamb, and sausage. But I also spent a lot of time reading in my tent, trying not to get anxious about the weather and hoping the wind would ease.

We could see right whales offshore, often trying to sleep on the surface as kelp gulls harassed them with pecking. Getting out to the whales was the problem. We had to walk our boats out through the shallows, and that required rare calm days. I got a few days of shooting over the course of my month there. It was hard, slow, and great.

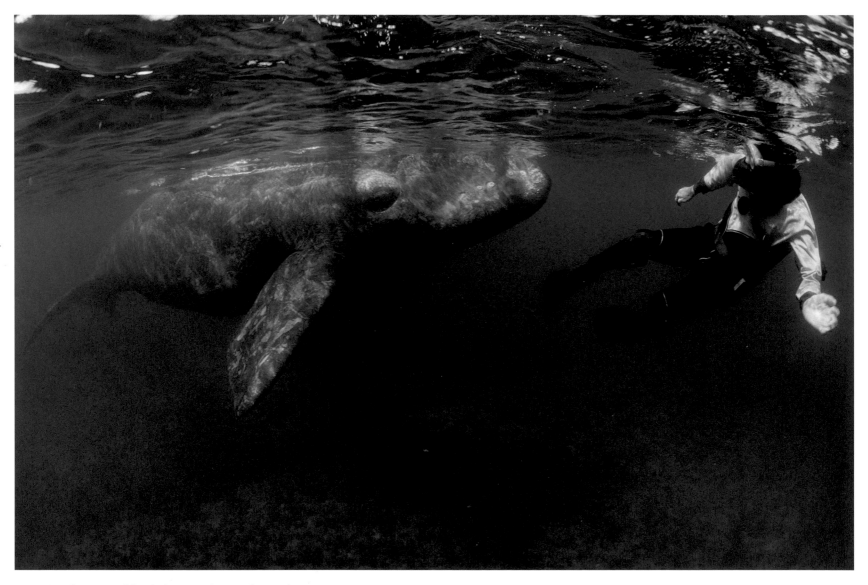

ABOVE: *A curious young right whale approaches my photo assistant,*
Michael Bennett—a little too much of a good thing, Patagonia, 1986.
OPPOSITE: *A right whale actually lets Roger Payne pet it, Patagonia, 1986.*
In 1972 National Geographic's first wild whale story featured these animals.

One day we spotted right whales in 15 feet of water. Two males were actually cooperating to mate a female, something Payne called "reciprocal altruism." What they had to do was get the female's tail down so that one of the males could get his tail stalk over hers and mate with her. Then that male would help the other male do the same with another female right whale. It was a delicate business—the mating of these two enormous animals—and so was what I needed to do—get in close to these behemoths as they "altruistically" converged on the female. I had to get the shot I needed without getting caught in the middle of the business at hand. Occasionally, right whale calves make that mistake, and they get pounded in the sand. I managed to swim amid their huge waving tales and not get squashed.

I also photographed right whale calves so curious they'd run over me. Roger helped us find friendly subadults, so I spent a lot of time just sitting on the bottom with them. They'd lie right next to me, so close I could reach out and touch the hairs on their skin. One day I slowly reached over and petted one of them on the fold of skin under its eye, then I scratched its side. All fine until it dragged its tail over me. My mask came off, and I was knocked around, but the whale came back to be scratched again and again, dragging its tail over me each time. I was pretty beat-up by the time Carlos and Jim finally hauled me out of the water. That's when I gave up petting whales.

I was anxious to hear what the picture people at the *Geographic* thought of my take, but making a phone call required a trip to Puerto Madryn, a couple of hours away over rough roads. Still, town meant a shower and a pizza, well worth the drive at that point. When I got through to the young picture

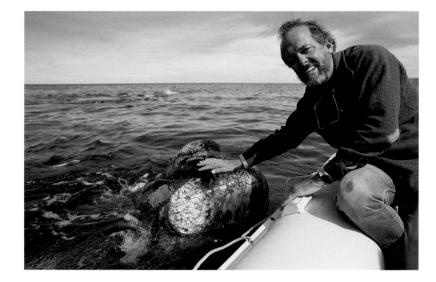

editor who was reviewing my film, Kathy Moran, she said the images had come through just fine but that the whales looked "a lot like pickles." Since then, Kathy and I have done a dozen magazine stories together, and she's become one of the most respected natural history editors working today. Her "pickles" reaction is one I've gotten a lot from sources over the years.

People have no idea how varied whales are in their looks and behavior. It has been my job to show them, but I was just beginning to realize this myself as I got farther into the "Era of Discovery" article for the centennial issue. That assignment took me all over the world—from Japan to Newfoundland to the Canadian High Arctic. I didn't realize it at the time, but in the next decade, the High Arctic would be more truly my home than any other place on Earth. I had a house in La Jolla during those years, but I was rarely there. I spent a lot of nights in a tent perched at the perilous floe edge of the ice, in a place where the polar bears outnumbered the humans—and the whales outnumbered both. But that's the next story.

KILLER WHALE (*Orcinus orca*) GULF OF ALASKA 2003
A killer whale about to surface

KILLER WHALE (*Orcinus orca*) JOHNSTONE STRAIT 1982
*A killer whale breaching. The southern resident populations have declined
in recent years, largely due to the lack of king salmon, their major prey.*

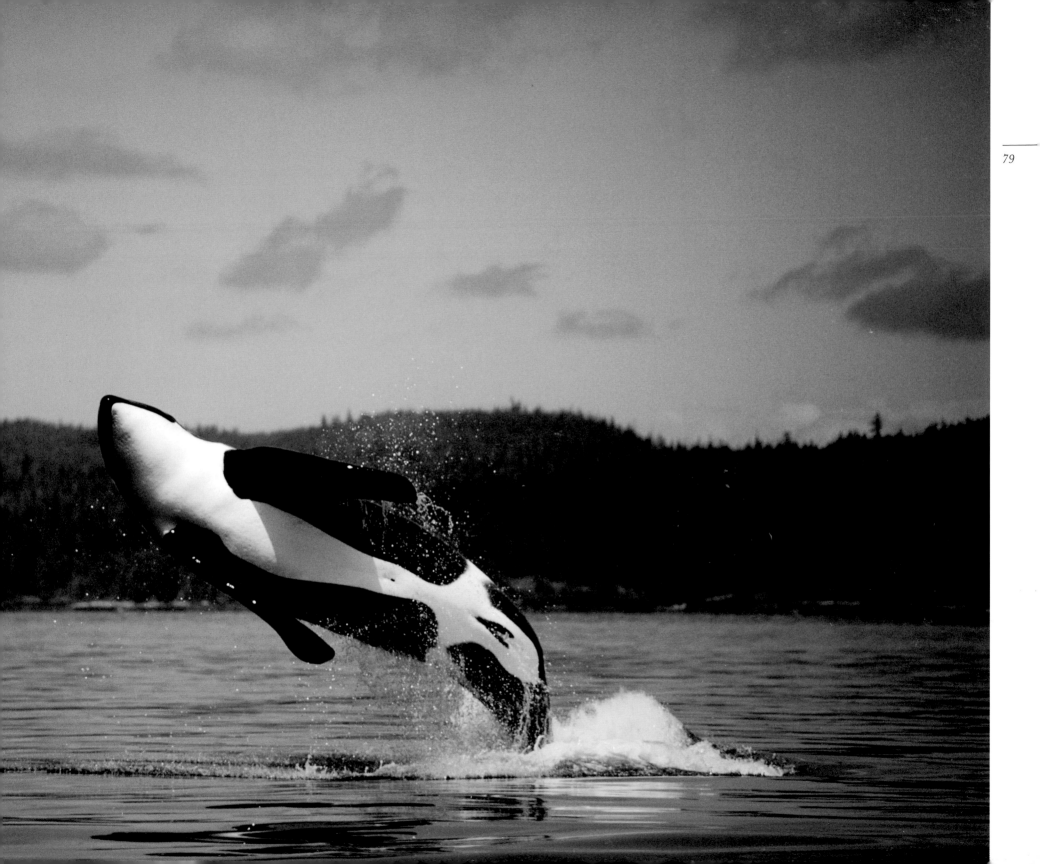

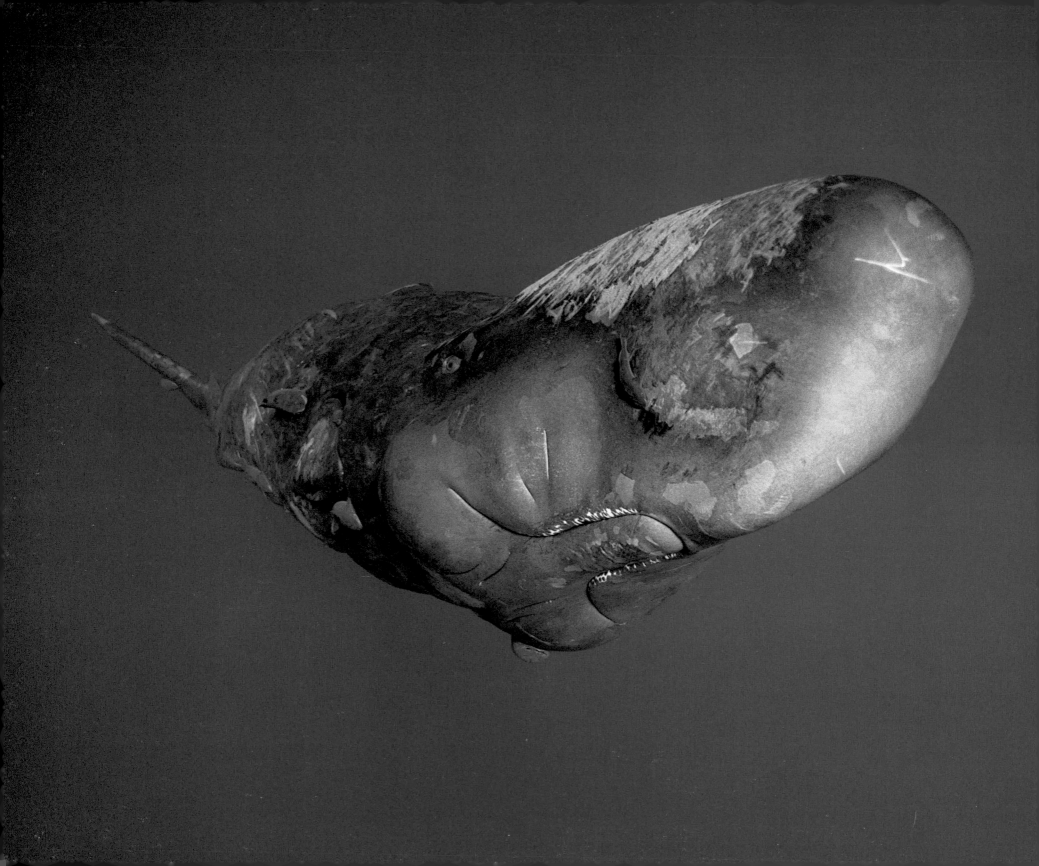

SPERM WHALE *(Physeter macrocephalus)* DOMINICA 1993
A very young sperm whale waiting near the surface for
its mother to return from the depths

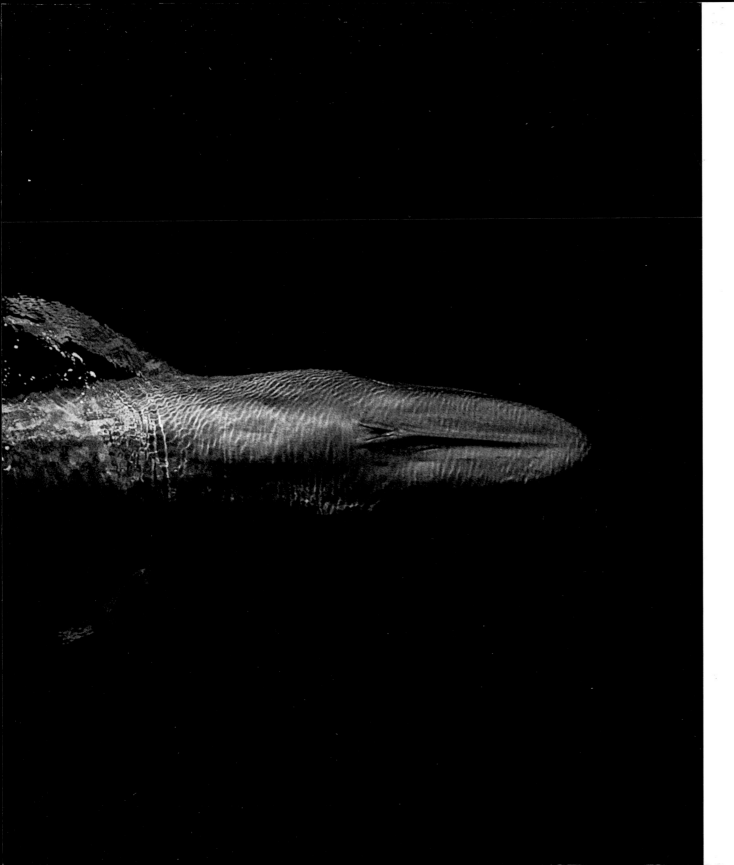

BLUE WHALE (*Balaenoptera musculus*)
BAJA CALIFORNIA 1988
*The largest animals on Earth, blue
whales have been known to reach
110 feet and almost 200 tons.*

GRAY WHALE *(Eschrichtius robustus)* TOFINO, CANADA 1986
A gray whale feeding in very shallow water by biting mouthfuls
of sediment then filtering the sediment for small animals

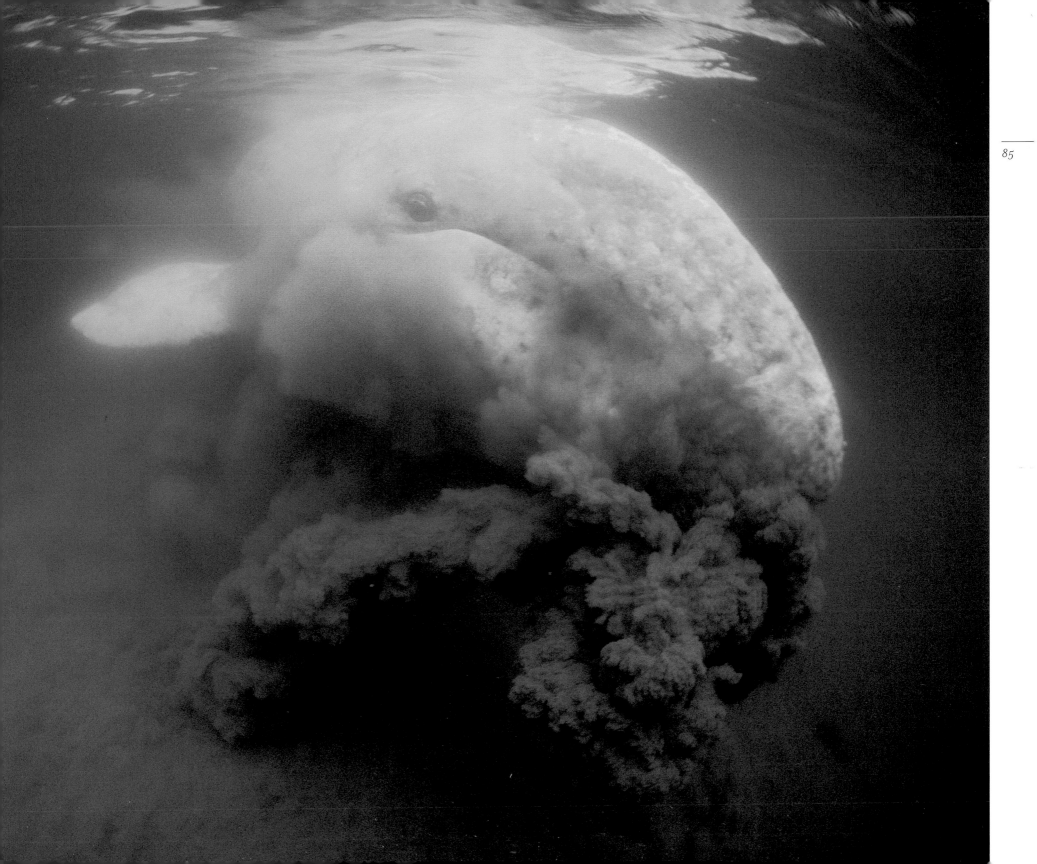

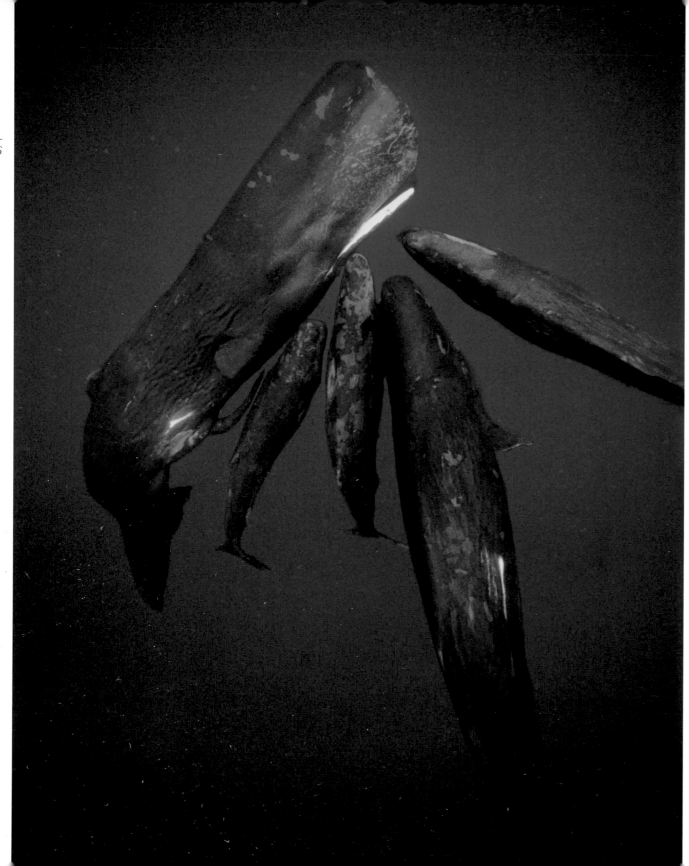

SPERM WHALE (*Physeter macrocephalus*) DOMINICA 1993
A male sperm whale coming into a group of females and young is greeted by rubbing. At the time the picture was taken no one knew if the male's intrusion would be peaceful. Now we know these animals are very social.

OPPOSITE: *Hal Whitehead and his family on a research trip to the Galapagos Islands, 1994*

HAL WHITEHEAD ON SPERM WHALES

UNIVERSITY RESEARCH PROFESSOR, DEPARTMENT OF BIOLOGY, DALHOUSIE UNIVERSITY

WHEN FLIP CAME to cover our work in Sri Lanka in the early 1980s, we were making the first major attempt to study living sperm whales. Some of the techniques we tried then worked, some didn't. One that did work, and that we're still using, is identifying individual animals photographically, and Flip helped a great deal with that. The thing is, though, these are deepwater animals, and understanding them is slow going.

In the years since then, we've found that female sperm whales have a complex social structure. They live their entire lives with their mothers, other female relatives, and sometimes other unrelated females in what we call a social unit. That unit is a vital part of every female sperm whale's world. This social group is probably more important to them than our human groups are to us. Even though they're nomadic animals, moving throughout the warm-water oceans, the females always stay with their unit—it's their "home." Members of the unit feed and protect and nurse each other's young and even develop their own distinctive cultures. We've found that some sperm whales in the Pacific form clans of more than a thousand animals with unique dialects—patterns of clicks—and learned behaviors they pass on to their young.

As to male sperm whales, when they're somewhere between six and fifteen years old, they leave their mother's unit and start to head for the colder waters near the poles, periodically forming bachelor groups with other adolescent males. The bigger the individual males get, the smaller these groups become, until finally the biggest, oldest males often travel alone.

The old males become huge—three times the size of females. The only social interactions involving the males that we regularly see are when they return to the warm-water oceans to mate. The females, and their young, may surround a male as he enters their group, clicking at him and touching him.

I suspect we're missing much about the socialization of male sperm whales, some complexity we just haven't discovered yet. They may have quite complex societies a lot like male elephants', but you can't sit with a pair of binoculars and watch the lives of these deepwater animals. Still, new technologies are helping us learn more about them all the time. Small, unobtrusive suction tags we attach to sperm whales record their vocalizations and every movement, and now some of the tags even have tiny video devices in them. We are beginning to actually see what the whales are doing underwater, what they're eating, their moment-to-moment lives.

As recently as the 1970s we saw sperm whales as a major resource to exploit. Now we see them as extraordinary individuals embedded in extraordinary societies. And I'm sure the more we learn about them, the more amazed we'll be.

SOUTHERN RIGHT WHALE *(Eubalaena australis)* PATAGONIA 1986
A scraped-up right whale calf swims near his mother in a mating group.

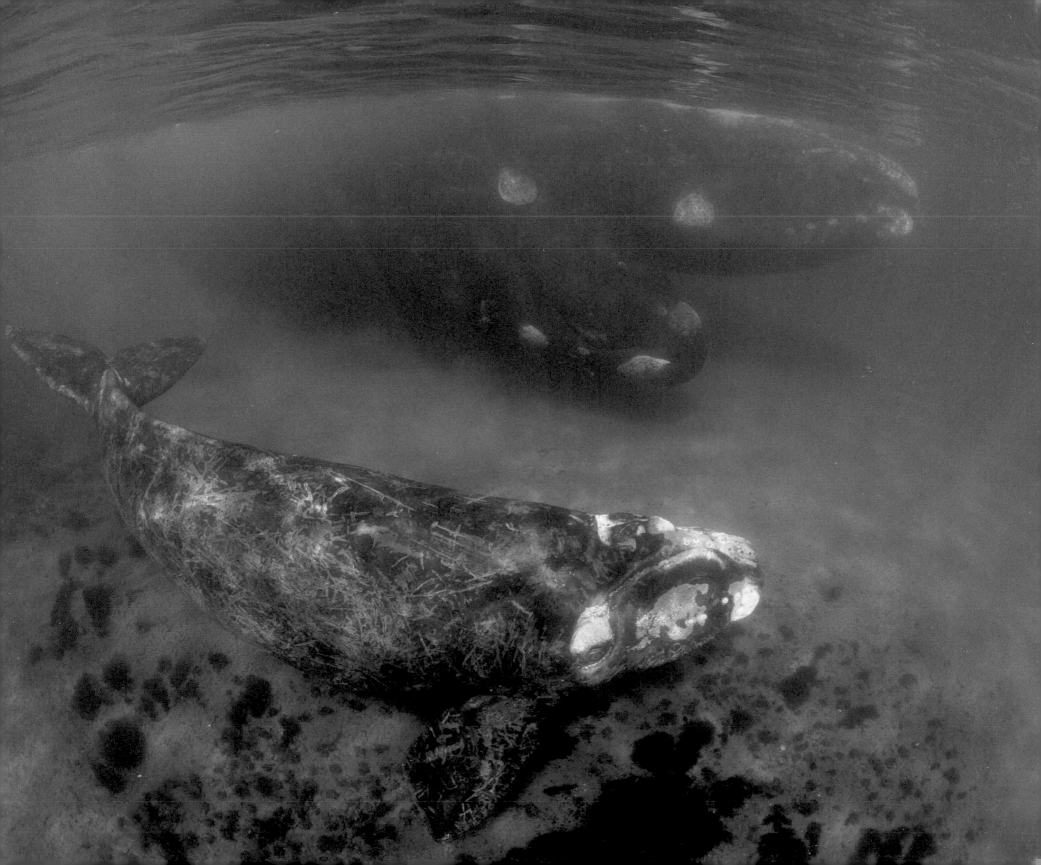

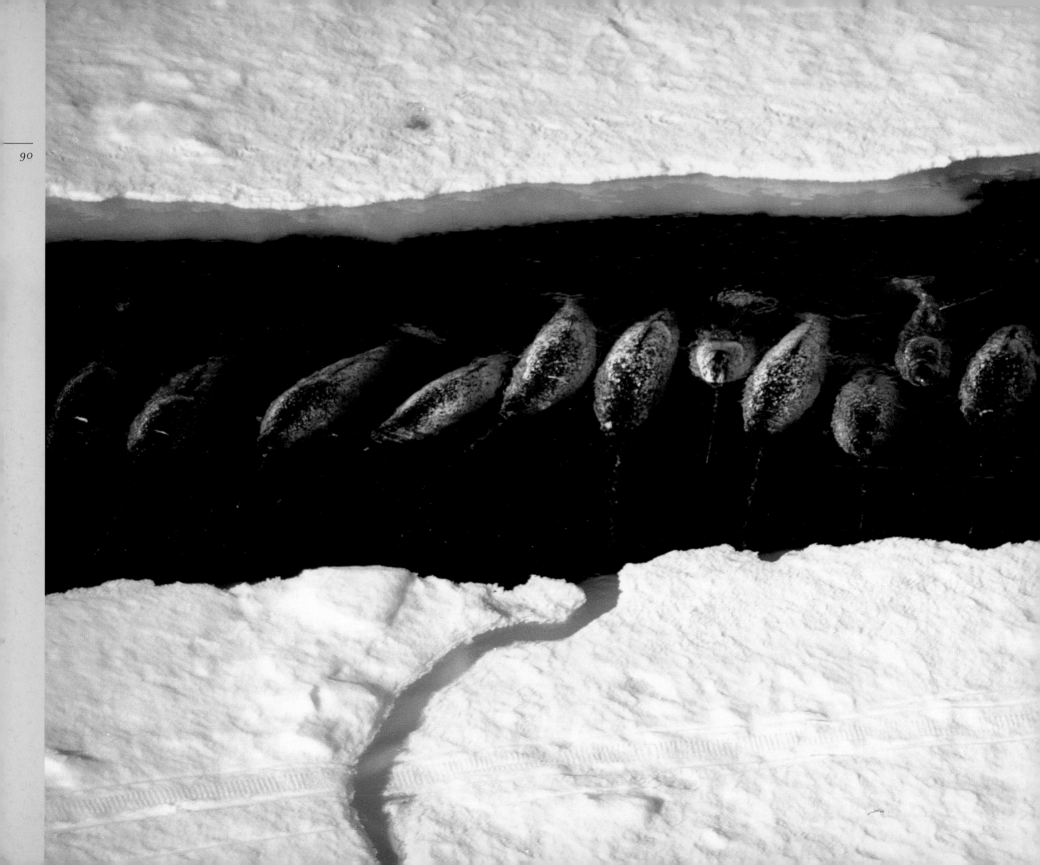

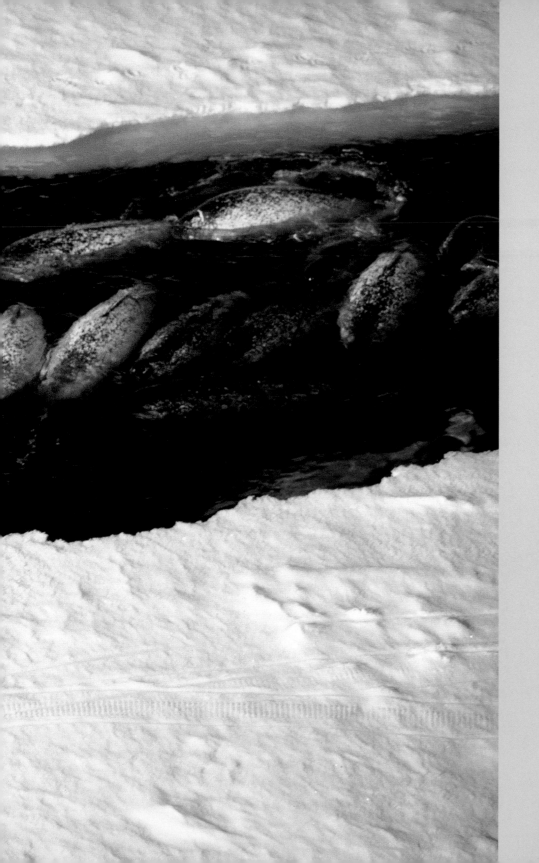

Life in the High Arctic

NARWHAL *(Monodon monoceros)* LANCASTER SOUND 1987
Male narwhals in a lead

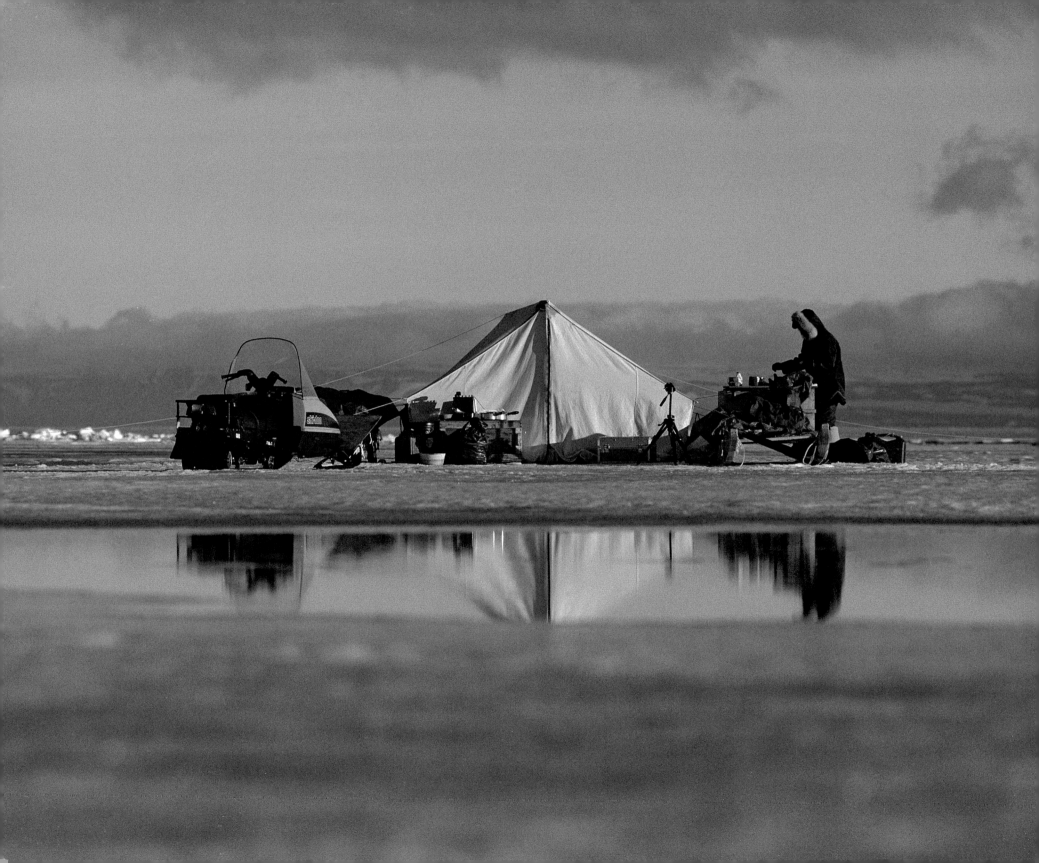

"We camped at the entrance to the Northwest Passage, a wild place inhabited by ghost-white belugas, narwhals, singing bowheads..."

IN THE 1980s the focus of my life shifted north for the first time and in every way. I'd left the world I'd always known, the temperate beaches and family atmosphere of San Diego, and moved up the coast to Santa Cruz. UC Santa Cruz was doing some pioneering whale research, and there was a community of serious photographers in the area as well.

But Santa Cruz played a minor part, really, in my new north-facing life. In 1985 I flew into a world that was unlike anything I had ever experienced—for one thing, a lot colder than any place I'd ever been—the High Arctic. For the next decade or so, my springs and summers were spent around the top of Baffin Island. Being in a culture as foreign as anything I could imagine made me learn how to be a successful visitor. To shoot here, I had to learn a whole new language of survival. I was lucky—I had some good teachers.

The Inuit were nomadic until the late 1960s, when they settled into small communities. But many were still at home "on the land," and most important, on the frozen sea. When they learned to hunt, they learned from their grandfathers or their uncles, by watching them or going out with them. Good routes and trails got passed down in family stories. They went to the same places their ancestors had. And they didn't just survive in that world, they thrived in it. What I found out fast was that up there, literally at the top of the world, you had to know who to follow, the guy who'd get you where

ADMIRALTY INLET 1989
*My guide Andrew Taqtu at one of our typical camps on the ice—
a walled tent, a couple of snowmobiles, and photo and camping
gear positioned so we can move quickly if the ice starts to break up*

you're going and not get you killed.

On my first trip I was focused on narwhals, the unicorns of the whale world. No one had managed to do a story on narwhals in the wild, for good reason. Getting into and under water as cold as 29.5°F is a daunting experience.

I was with a couple of people from the Vancouver aquarium when I first flew into Pond Inlet, an Inuit community that overlooks Eclipse Sound, an arm of Baffin Bay. In winter the sound freezes solid, but by June or July the *upinngaaq*, the seasonal breakup of the ice, is beginning, and the narwhals are moving back into inlets as ice starts to melt and leads form in the sea ice.

We knew we needed to be where the ice meets the open water—the floe edge—to see narwhals, so we hired a young Inuit guy to get us out there. In the years to come I learned that the Inuit don't mince a lot of words in instruction, they teach by example, but this was my first experience with Inuit ways.

We all mounted our snowmobiles and took off across the rough ice, pulling 20-foot sleds loaded with camping gear. Negotiating that kind of terrain in a snowmobile takes some getting used to, particularly when you come to a big open lead in the ice. Then you have to unhook the sleds, get going really fast, and skip the snowmobile across water that opens like a dark, frigid tomb beneath you. Better yet, you can have someone really good at it do the snowmobile skipping for you. Our guide could do that. Once the snowmobile made it across, we would get on the sled and float it out into the lead, and one of us on the snowmobile would pull it across with a rope. At one point,

our guide cracked his head on the snowmobile handlebars and we worried that he might have a concussion, but we kept going.

When we got to the floe edge, I saw that the trip out to Lancaster Sound had been worth it. I had heard nothing but scary stories about the sound, but it was beautiful, with the sun sparkling off the ice like mica, whales blowing in the distance, king eiders swimming in the open waters, and ivory gulls circling overhead. This was my first taste of the Arctic and the 24-hour summer sun. I sipped a cup of coffee and sat by the floe edge, waiting for the whales to come up. Everything was new to me, beautiful and benign.

We camped at the entrance to the Northwest Passage, a wild place inhabited by ghost-white belugas, narwhals, singing bowheads—and polar bears, which had my constant attention. After a few days, the rest of my party had to leave, and our guide went with them. He said he'd be back in half a day or so. The hours passed as I watched the High Arctic sun move across the sky but never set. I could see narwhals, no more than bumps in the distance, too far away to make a picture. I could also see the occasional lone bear patrolling the floe edge, on the lookout for seals.

One day bled into the next and still no guide. I could see hunters out on the ice. Otherwise I was alone with the animals. When I slept, I kept a wary ear cocked for any suspicious sounds. What I didn't expect to hear was a human voice calling me out of my sleep. A renewable resource officer who was camping nearby was saying into my tent, "You can't be here." "It's okay," I said, "I have permits. I'm fine." "No, you're not fine," he said. "Where you are isn't going to be here soon."

POLAR BEAR (*Ursus maritimus*) WAGER BAY, CANADA 1998
*In summer bears around the northern Hudson Bay are on the
land or on multiyear ice left behind after the annual breakup.*

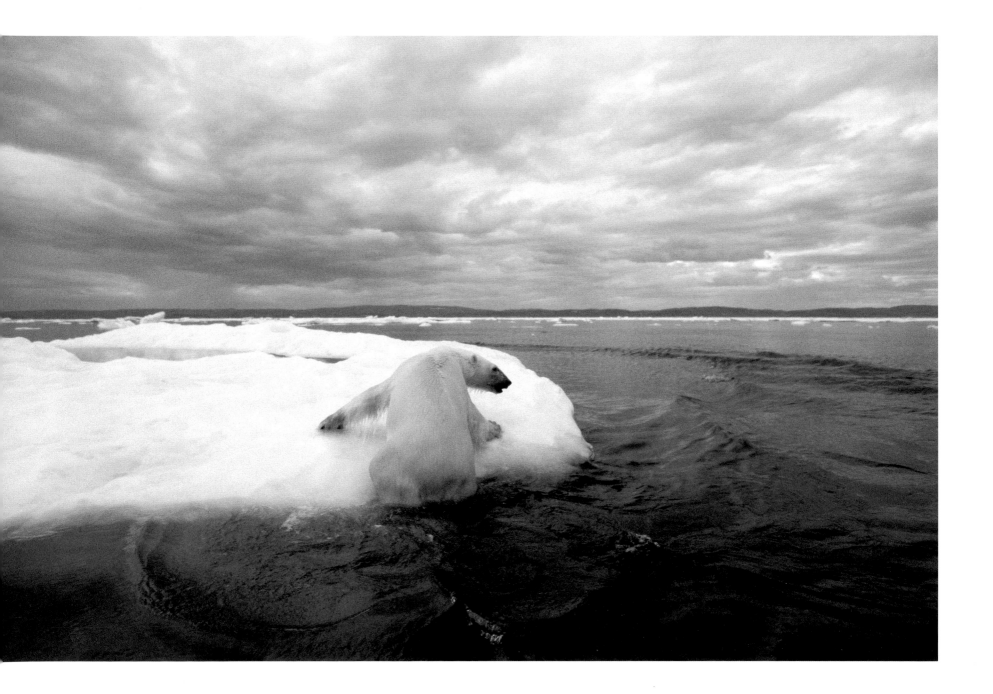

BELOW: *Me alone near Pond Inlet in 1985 on my first trip to the floe edge, when I was doing just about everything wrong*

OPPOSITE, LEFT TO RIGHT: *Judah Taqtu with a double-tusk narwhal he took on Lancaster Sound, 1987; John Ford examines a tent "redecorated" by a polar* bear at Navy Board Inlet, 1987; Glenn Williams (in white), Andrew Taqtu (in red), and Koji Nakamura (in blue) and his film crew use whatever tools they can find to travel over the broken ice on Admiralty Inlet, 1989; Canadian government researchers work at the floe edge on Lancaster Sound, 1986.

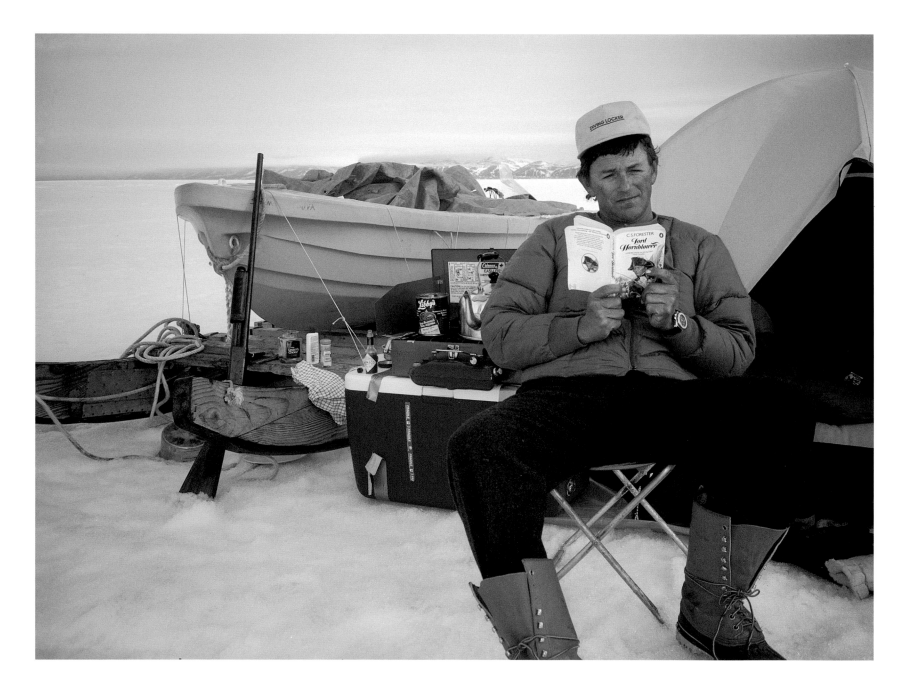

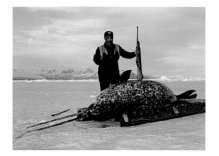 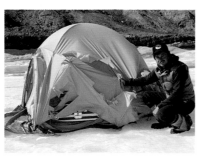 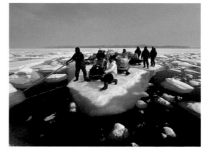 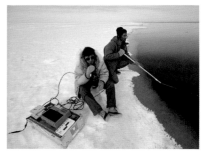

The wind had changed directions, and he realized it was going to blow the ice I was camped on out to sea. The world of ice, I suddenly realized, may look solid, but it's not. It's truly ground that can shift beneath your feet. I struggled out of the tent, bundled my gear onto my *qamutiit* (Inuktitut for 'sled'), got in my snowmobile, and followed the guide off the unstable ice.

The renewable resource officer, Seeglook, was a great rough-ice driver, and I was a bad one. My sled kept tipping over, and I realized I had on way too many cumbersome clothes. It took us a couple of hours of driving before we reached a gravel shore. I was safe, but embarrassed and discouraged. I thought that I'd never fit into this place, these conditions, this culture.

But I wasn't ready to give up. I'd made contact with Glenn Williams, a no-nonsense renewable resource officer for the Northwest Territories, and, I would learn, a real veteran of polar survival. Glenn was married to Rebekah, a member of the large, extended Tungraluk family. He worked out of Arctic Bay, an Inuit village northwest of Pond Inlet. I flew over and went out on the ice with him when he made his rounds. At one point he shot a seal, slit it open, and feasted on the still warm liver, slicing a piece off for me. I sprinkled it with a little Tabasco—I always carry a bottle with me—shoved the slippery-soft meat into my mouth and chewed. It tasted like any liver. I knew it was a test, to see whether I was adaptable to Inuit ways. It only made sense for them to live off the land as they traveled in this world. They couldn't possibly pack in enough to keep them going for weeks. Also, one of the Inuit's unbreakable rules is that you can't own food. By tradition, you share anything you catch, kill, or gather. It's even impolite to thank people for food you take because that implies someone can own it. But all of this was new to me at the time.

One fog-draped day when Glenn and I and a few other guys were camped at the edge of the fast ice, I began to hear the blows and squeaks of whales in the waters all around us. No one was up yet but me. I walked toward to the edge of the ice, and I could see narwhals, narwhals everywhere. What I didn't realize was that the ice edge I was on was undercut by the current. Suddenly, it gave way, and I was in the water with the narwhals. Moving quickly, I managed to throw my camera case up on the hard ice behind me and, with the adrenalin of fear fueling me, I was out of the water as fast as I'd fallen in. Soaking, I changed into dry clothes, came back to the ice edge—and did it all again. Back in the water, drenched, crawling out of it into 20° F temperatures. Not good.

I went into the tent and stood beside our stove, hoping to dry out and save my dignity. Outside I could hear the whales, but I was freezing and had no dry clothes left. I had a lot to learn from the Inuit, like the way they test the ice by thumping it with a staff or the heel of their foot to see if it's solid. After that day I never fell in again.

Another day we spotted three black dots moving in the distance. As they neared our camp, the dots became Inuit hunters, three generations of them, their snowmobiles pulling a canoe piled full of game and narwhal tusks. They pulled up beside us, set up a tent, and slept for a long time.

"Those are the guys you want to be with when you come back," Glenn said to me. That was encouraging. Glenn was a gruff guy, protective of the traditional culture he lived in, and I knew he had just invited me back. "The good thing about Flip," he'd say to people, "is that when he comes up here, he knows he's a guest." Getting to know Glenn on that trip had been like finding a brother I hadn't known I had.

After three months in the High Arctic, I sent some film back to the *Geographic*. The response from them was "nothing usable yet." I was pretty sure at that point that I'd be going back to selling fins, masks, and snorkels in the family dive shop. But I kept at it, hoping that something would turn up before I left Baffin.

I had always planned to end this assignment at Milne Inlet, on the northeastern side of Baffin Island. John Ford, whom I'd worked with on humpbacks in Hawaii and then later killer whales off Vancouver Island, was now studying narwhals and was assigned as the writer for the piece I was shooting. He had located narwhals before at Milne Inlet, so he and I and my assistant, Rick Geissler, planned to go there next. We hired an Inuit guide couple, and a small boat took us from Pond Inlet to Milne Inlet, dropping us off with tents, canoes, kayaks, and all of our other gear. We had two two-man kayaks with us, hoping that in kayaks we could maneuver around the narwhals without making much noise.

By this time in the late summer the ice was gone and Milne Inlet was a brown, scarred landscape. We set up camp and waited. John was using acoustic equipment again, but he was feeling his way, trying to figure out how to study these elusive animals. The narwhals were there, again lumps on the surface. But any time I'd get in the water with them, they'd move too far away to photograph. Also plankton in the water made for poor visibility. Summer was ending, and it was getting colder and darker at night, and nothing was happening between us and the narwhals.

Since this was the time of good hunting and of plenty, Inuit families had left their villages behind and were out on the land. There were people living in family camps with the barest essentials and people living in walled tents full of amenities. We'd be in our own camp in what we thought was the middle of nowhere and suddenly visitors would stop by—boatloads of adults and kids and dogs. Babies, grandmothers, pets—everybody was out on the land.

On a nice calm day, John came in from kayaking to get Rick and me. He said something was going on with the narwhals. We grabbed our gear and got in a two-person kayak. When we got out to the whales, we saw the strangest thing. A dead or dying female was floating at the surface, and two male subadults kept coming around her, crossing tusks, and at times pushing her underwater. Other males too were circling around, and we were in among them in a canvas boat, with ten-foot ivory swords thrusting out of the water all around us.

I got in the water a couple of times, but suiting up in a kayak is not an easy thing. I had to get zipped into a dry suit, tight around my neck, and put

ADMIRALTY INLET 1986
Two Inuit men test an iced-over ship's wake to see if it's safe to cross.

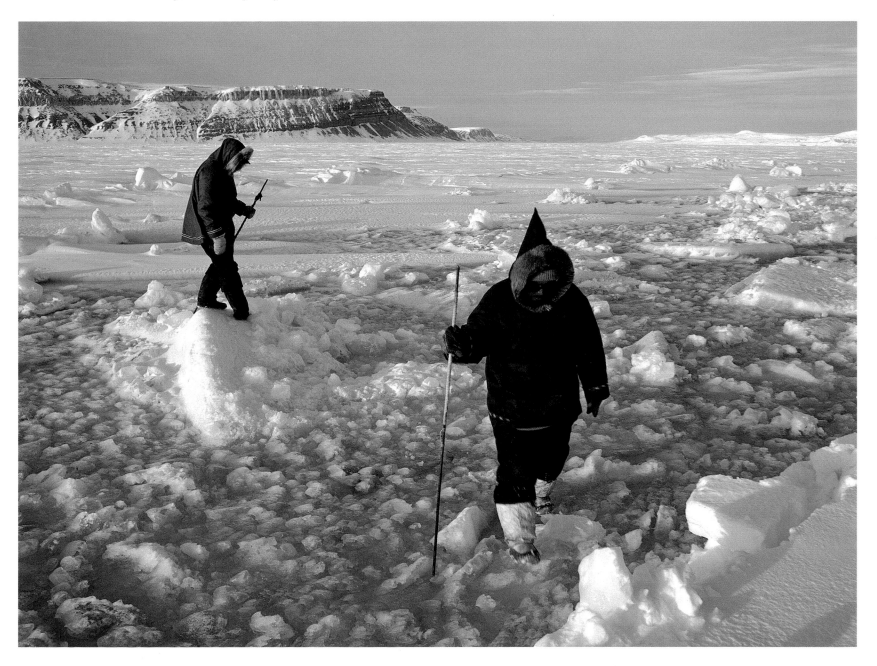

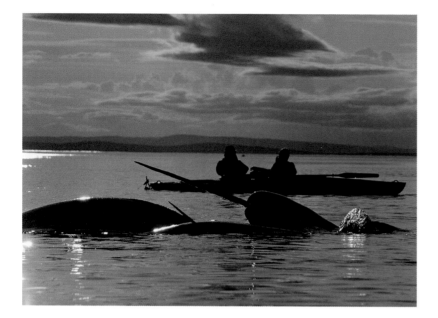

I got seven hours of shooting in during that strange episode with the narwhals, and it made up for the four previous months. We finally towed the dead whale back to shore so John could do a necropsy on her. He found that she had been a lactating female and had been harpooned through and raked all over by tusks. We had no idea what the narwhal ritual surrounding her had been all about. We still don't know.

That turned out to be the last calm day before we left, but it redeemed the whole assignment. I never did go back to selling fins, masks, and snorkels.

Despite my occasional misadventures, the Arctic had captivated me. The polar ice built a blue, translucent landscape of floating bergs and pressure ridges—a crystalline world inhabited by harp seals, narwhals, belugas, and humans who lived lightly on the land.

The next year, 1986, I was back in Arctic Bay, and Glenn put me in touch with two of the Inuit I'd met briefly the previous year when they came and napped in our camp—Judah and Andrew Taqtu, a father and son team.

This time I was in the Arctic to work with renowned underwater photographer Koji Nakamura, who was shooting footage for Japanese television. I had known and worked with Koji since 1983 in the Channel Islands. I had been his native guide then, and he had changed my view of how to photograph wildlife. He taught me to stay with an individual animal and keep shooting. There's such a temptation to move on, shoot snapshots, but Koji understood what it meant to do studies of one animal.

On the trip to the High Arctic we started going through cracks to get under the ice. Our younger guide, Andrew, really got interested in getting

on fins, mask, snorkel, and weights—all of it while straddling the boat. Rick had to work hard to stabilize the kayak while I got this done and again when I maneuvered out of my gear after a dive.

The third time I got in the water, the animals were really involved in the fight over the female—so involved they didn't seem to mind me. As I submerged, the scene in front of me in the murky gloom looked like a brawl in a pool hall. Males were slashing at each other with their tusks, and the younger males were raking the bigger males, who were trying to approach the dead female, their penises out. I took a chance that they wouldn't notice me and slipped in closer. Suddenly, one of the subadult males was in front of me, his tusk angled toward me and within 18 inches of my chest. For a few seconds I could feel his sonic clicks. Then, just as suddenly, he turned and went back to the fight.

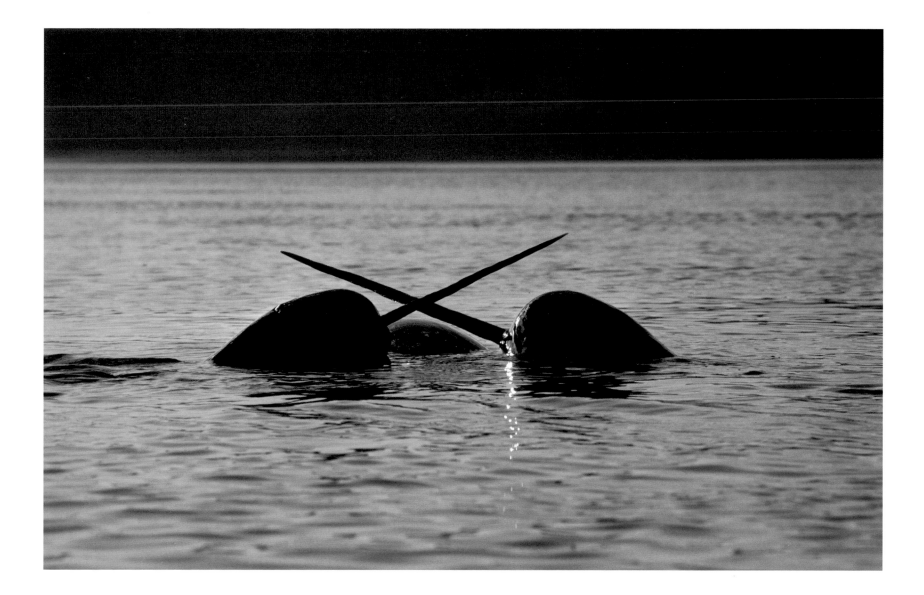

NARWHAL (*Monodon monoceros*) MILNE INLET, CANADA 1985
Two male narwhals slowly cross tusks over a dead female.
The two fought off other males for seven hours.

OPPOSITE: *Researchers John Ford and Debbie Cavanaugh observe*
the fighting narwhals from their canvas kayak.

under the ice, too. He wanted to try diving himself, so one day he cut a hole in the ice, then came back and announced, "Okay, I'm ready." We helped him into a dry suit, put a rope around him, and lowered him down for a quick look. That was the first of many dives under the ice for Andrew. I've come to think of him as the Jacques Cousteau of Arctic Bay.

The next year, 1987, I was back in the Arctic for *National Geographic.* This was a wild ice year. Admiralty Inlet and Lancaster Sound were frozen, and it took us three days over amazingly rough ice to cover the 120 miles out to the floe edge. At one point we came to a pressure ridge, where the floe edge had been in previous years. The ridge was an impenetrable wall built of ice, 15 feet high and so long that it wasn't practical to go around. I thought we had literally hit the wall for this trip, and it suddenly occurred to me that just because I wanted to do something didn't mean I could.

I felt stupid and discouraged, but the Inuit and Glenn, who was with us, weren't ready to give up. They picked up harpoon shafts, handed me one, and we started chipping hunks out of the ice to make a small path over the ridge. Then we got on our snowmobiles. They told me just to climb up the ice wall with the snowmobile and a sled behind me and keep going. "Don't slow down and don't stop," Glenn warned. I was pretty anxious, but I made it over. We all did.

We camped that night in really dense fog, in a place that seemed a lot better suited to polar bears than to me.

After three days, we finally got to Navy Board—60 miles of ice beach— but offshore was the place every bowhead, beluga, and narwhal that wanted to get into Lancaster Sound had to wait until the ice broke up.

We left one tent with extra equipment near the Baffin shore and drove farther out into the sound in our snowmobiles to set up camp. Glenn had gone back to Arctic Bay, but Jim Darling, my old friend and colleague, was due to join us as the writer for the *Geographic* story.

He had never been to the High Arctic before, and the trip out to the floe edge was a new experience for him. He was pulled through the fog and frigid cold and across rough ice while sitting in a boat that in turn was on a 20-foot sled. Glenn's nine-year-old son, Ben, was in the boat with Jim. Whenever the qamutiit he was in would go on its side because of ice, Jim would grab the sled with one hand and wrap the other around Ben. When they finally got to Navy Board, what emerged from the fog to greet them was our gear tent, ripped to shreds by a polar bear. Welcome to the High Arctic, Jim.

Still, we saw a lot of belugas and narwhals on that trip. We even saw a few bowheads, which at the time were considered to be very rare and endangered animals.

One day one of our Inuit guides came to me while we were fixing dinner and kind of muttered under his breath, "Those big whales, the ones you like, maybe Glenn saw one." "Well, that's great," I said.

"Glenn thought you might want to see it," he muttered.

"Good, maybe after dinner?" I said.

When he brought it up a third time, I said, "Okay, let's go take a look." I drove down to the shore on a snowmobile. Glenn was there, watching a baby bowhead that was hanging around close to shore, belugas nipping around it.

ADMIRALTY INLET 1989
Glenn Williams swims under an open lead as a tour group watches from above.

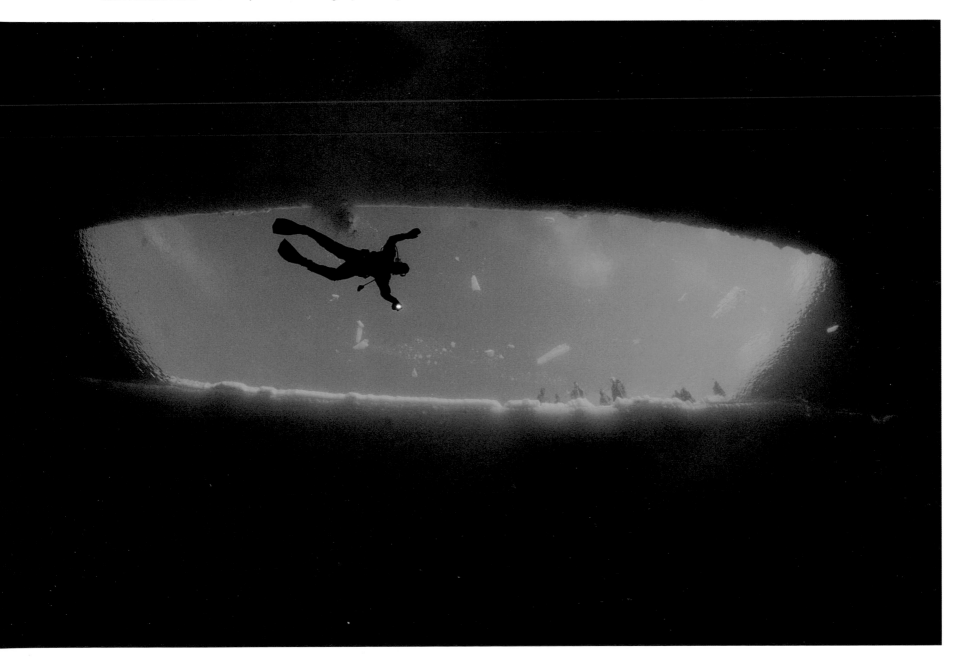

I couldn't believe my own stupidity. It was a great situation. I raced back to camp, put on a dry suit, picked up my Nikonos, and drove back to Glenn.

When I slipped into the water, it was just wonderful. A bunch of belugas had backed this little bowhead up against ice, and they were kind of nipping at his fins. They were just below the ice edge, so light was coming through the ice just right, and there were all these white whales clustered around this one small, very important dark shape. It was spectacular.

I shot half a dozen pictures, then they moved off a little. I got out and ran down the ice edge after them and slipped in again. This happened a few times. I shot a whole roll of film—very, very cool stuff. Then I pulled the camera apart to put in a second roll of film and saw that the whole housing was iced up inside. Nothing was going to come out. I had messed this up every way I could.

It was like a punch in the stomach; it literally made me feel sick. Those images would have been a big deal. There had never been a picture of a bowhead underwater. It was too crushing to think about. I decided that I could either be mad at myself and mad at everybody else or let it go. I let it go, went back to the camp, and made cherries jubilee for everyone.

I was trying not to put my pressures on other people, trying not to be the hard-pushing, self-centered photographer they expected me to be. And I wasn't out there doing natural history stories with discoveries by Flip Nicklin. I wanted to document what the scientists were doing—they were the ones making discoveries.

As the season progressed, more people showed up on the floe edge—researchers and Inuit who had come to hunt. But our time on the ice was up. We either had to fall back or leave. We chose to leave, this time helicoptering out with our gear. As we flew out of camp, staying low, just above the leads near shore, I looked down and could see a pile of male narwhals in a crack in the ice. They were only a few hundred yards from where we'd camped. The pilot started circling while I shot. Once again, as so often happened, I got some of the best stuff at the very end of an assignment.

A few seasons later, in August, I went out to Isabella Bay with Kerry Finley, a leading researcher on bowheads. A big bowhead is 50 tons of powerfully built but slow-moving animal. That, and the fact that they don't sink after dying, made them a great favorite with whalers, even into this century. The bowhead hunt didn't end until the early 1970s, and most marine mammalogists believed there were only a few hundred animals left in the eastern population, which inhabited the waters between eastern Canada and Greenland. Kerry was convinced bowheads congregated in the canyons offshore in Isabella Bay, feeding on copepods, animals smaller than the tip of your finger. When we got there, we soon realized he was right—Isabella Bay was the place to see bowheads—and bears.

You always have to stay alert for polar bears in the High Arctic, but they were more concentrated here than in any place I'd been. They were everywhere. As soon as we got a dusting of snow, they disappeared into the background, making it that much more interesting to make a nocturnal visit to the loo.

It was on that Isabella Bay trip that I learned just how important a good

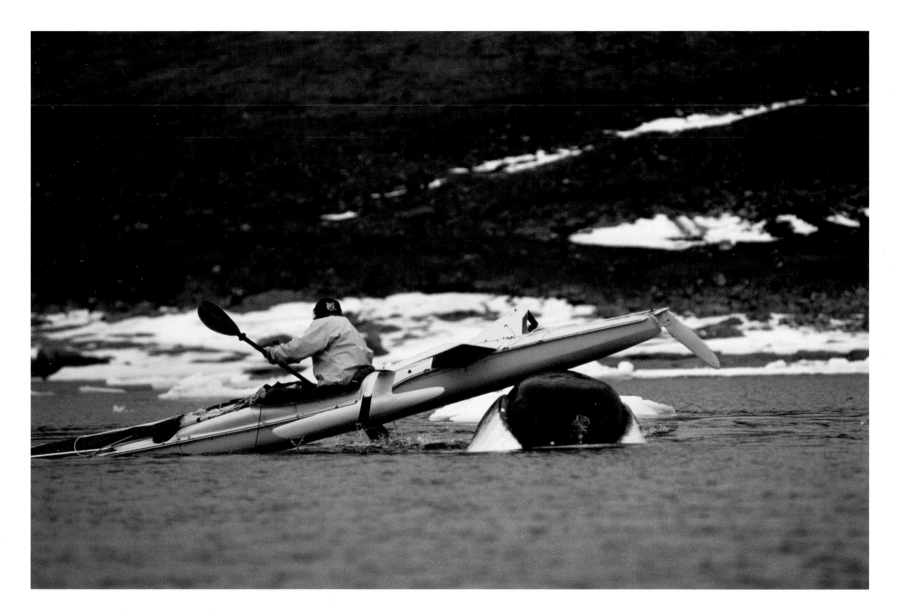

BOWHEAD WHALE (*Balaena mysticetus*) ISABELLA BAY, CANADA 1994
A bowhead pokes its head up under Kerry Finley's kayak; the same thing happened
to me soon after. With the water below freezing, this was not that much fun.

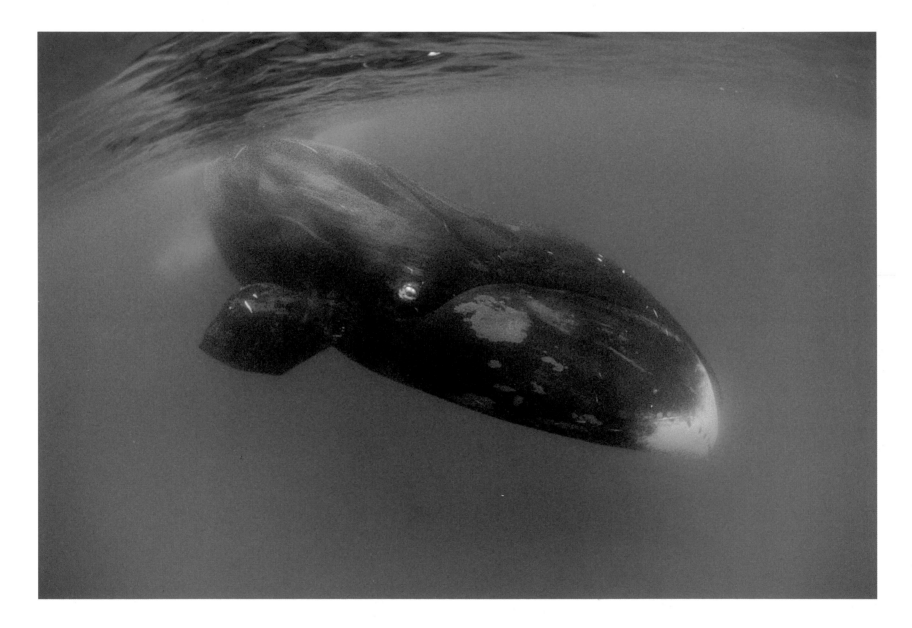

BOWHEAD WHALE *(Balaena mysticetus)* ISABELLA BAY, CANADA 1990
First published underwater picture of a bowhead whale

bear dog could be. We had a great little 40-pound Inuit mutt with us, and he was a genius at dancing with the bears. He'd chase a bear away from camp, then the bear would chase him—but neither of them would do the other any harm.

Camp was usually no more than a tent and a little warming shed that somebody had built on the shores of the bay. The persistent wind howled through, just adding to the cold. And I was cold, always cold. But we were seeing bowheads.

Bowheads are skittish whales that take off if you make any noise at all, let alone try to approach them in a motorized boat. So Kerry and I would glide out to them in kayaks, dipping our paddles in as quietly as we could. That part was easy. I got decent above-water shots of the whales from the kayak, but again it's no mean feat to suit up on a kayak, and I never did get an underwater bowhead image that way.

One day, though, we spotted a whale a couple of hundred yards off-shore, a place we often saw whales and sometimes bears. I decided to try to swim out to it with my camera. I was free diving, so I could be quick and light, but I did have on a dry suit.

Dry suits aren't much more than underwater windbreakers to keep you dry. What you put under them is what keeps you warm, but I typically didn't put much under mine—maybe just a sweat suit. At the end of an hour of shooting that way, I'd be really cold, and even before that, my hands would be too stiff to work a camera.

Now, with the bowhead offshore, I waded into the green, frigid water and swam out to where the whale was. The green surroundings helped set off the black body of the whale, and a couple of times the whale came up pretty close, so I could get pictures of its face and the white patches around its eyes. I knew it was really rare to get pictures of bowheads on the surface, and I knew this was something special—something people hadn't seen.

I was told early on in my career that there are two kinds of pictures. The first kind shows viewers something they haven't seen before; the second shows them something they have seen, but in such a different way that it makes the subject new and compelling again. This bowhead shot was the first kind. It had taken me three weeks of waiting in this windy, cold wilderness to get that image. But it made up for the bowhead shots I lost when my Nikonos had leaked three years before.

Very often, I found, the images I worked really hard to get didn't go anywhere, and the best images just happened on the spur of the moment. But you always had to be ready for that moment.

I'd been shooting pictures since the late '70s. When I did that first real *Geographic* assignment on schooling hammerheads, all I could think about was the sharks. I couldn't even focus on the other phenomenal underwater life around that seamount off Baja California. Now ten years later, I had a broader vision: I saw stories everywhere, and I realized all the issues with whales were issues for the larger environment as well. I also realized that whales were iconic animals that could get and hold the public's attention. To tell the story about whales without telling the story about the world they lived in wasn't enough anymore. The next time I went back to the High Arctic, issues, not just animals, drove me.

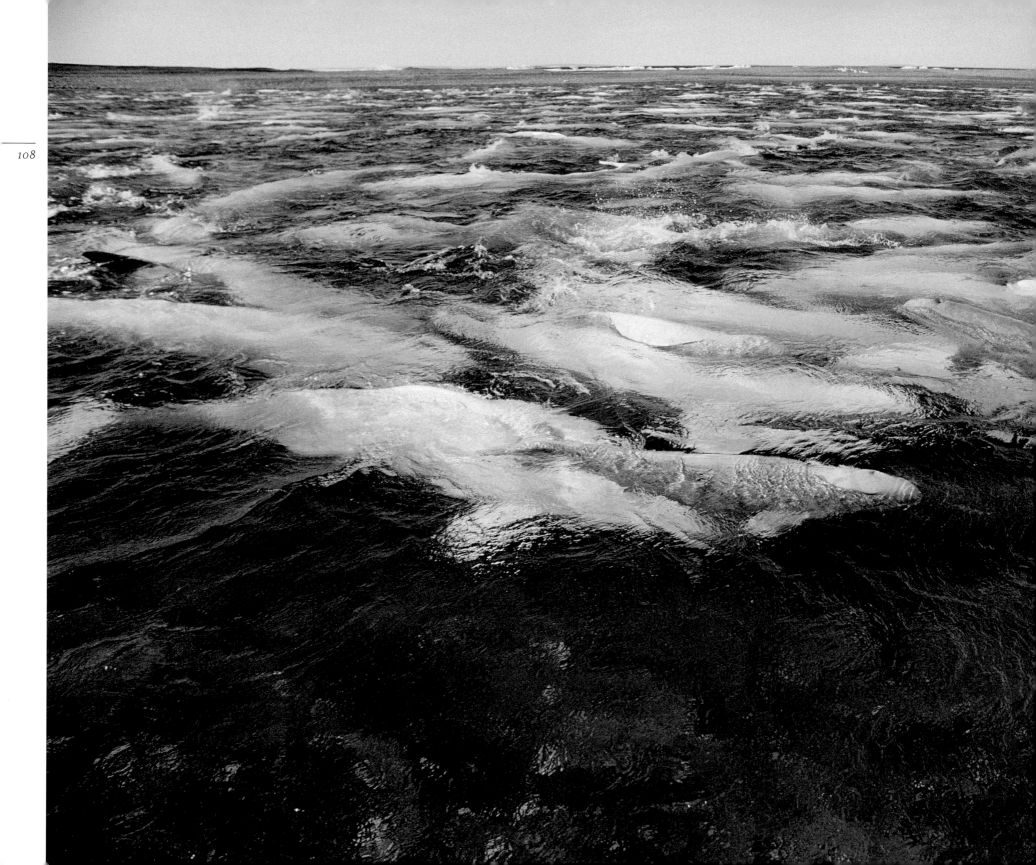

BELUGA WHALE *(Delphinapterus leucas)* PEEL SOUND, CANADA 1993
*Belugas cram a small river off Peel Sound. That year ice kept them
from going farther up the sound.*

POLAR BEAR (*Ursus maritimus*) WAGER BAY, CANADA 1998
Using a camera mounted on a stick, I took this underwater
picture of a swimming polar bear.

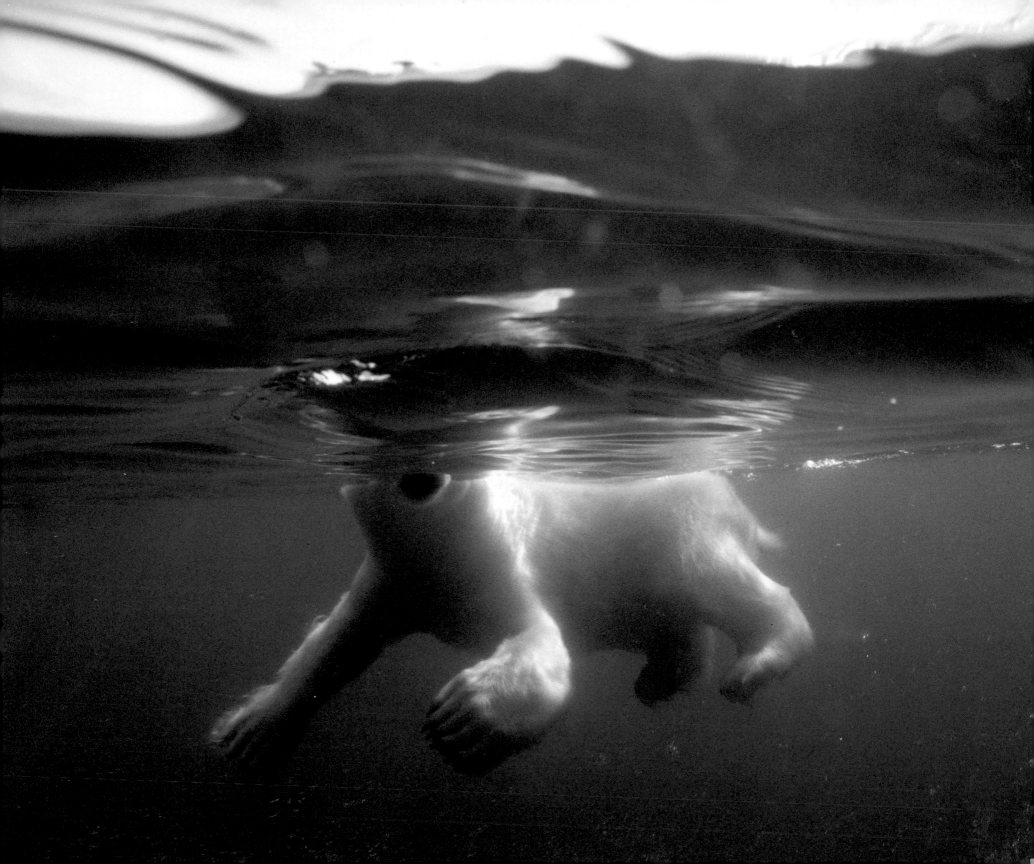

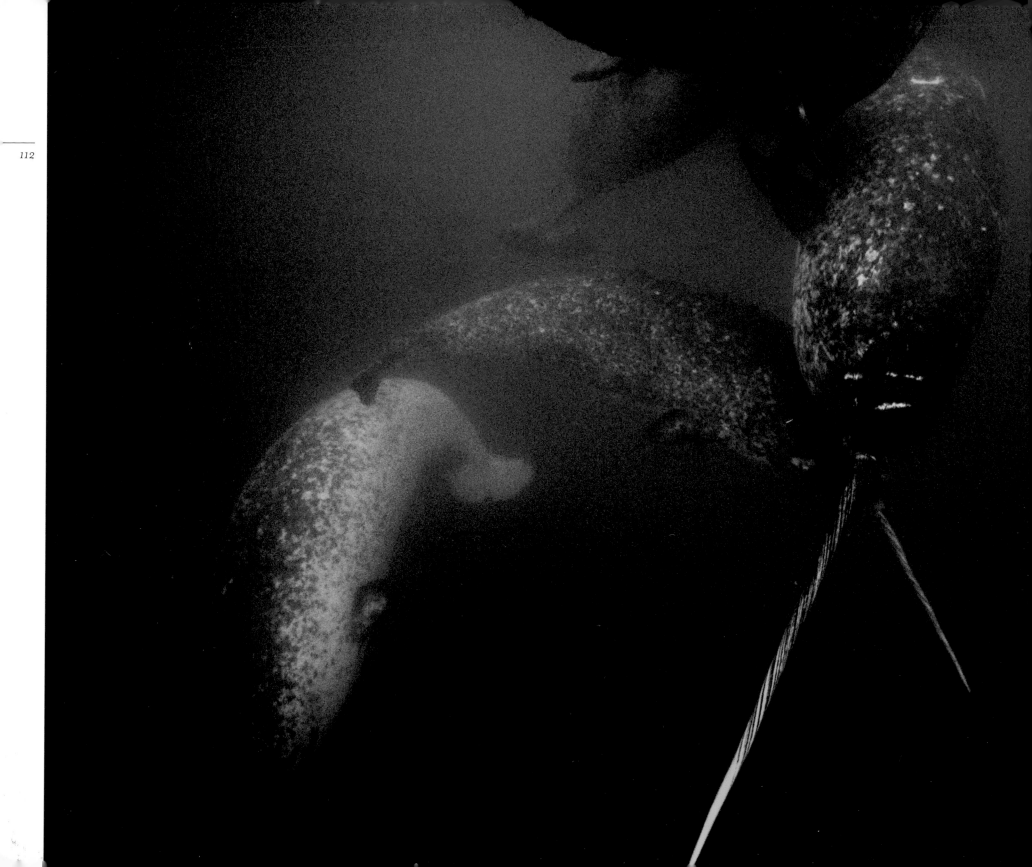

NARWHAL (*Monodon monoceros*) MILNE INLET, CANADA 1985
Two male narwhals fight off numbers of larger males as they
approach a dead female. The episode raised lots of questions.

BOWHEAD WHALE *(Balaena mysticetus)* ISABELLA BAY, CANADA 1994
Three mating bowhead whales. In recent years the Baffin Island bowhead
status has moved from endangered to species of least concern in the
International Union for Conservation of Nature Red Book.

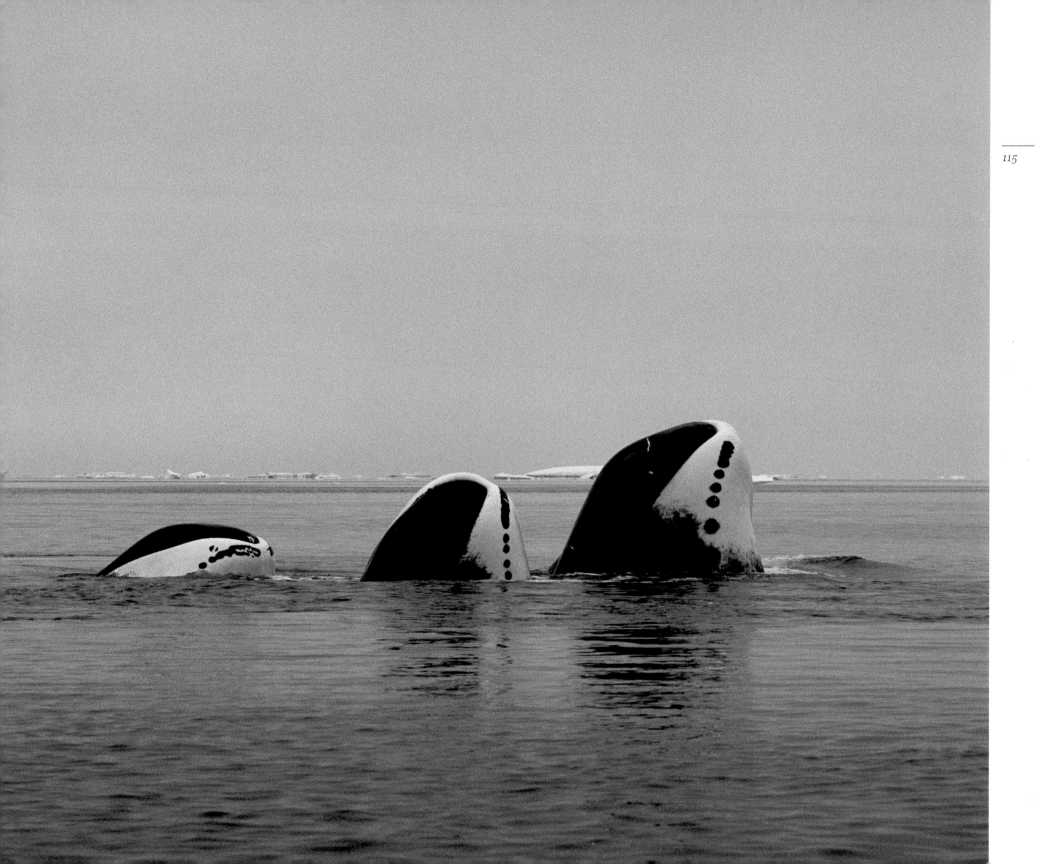

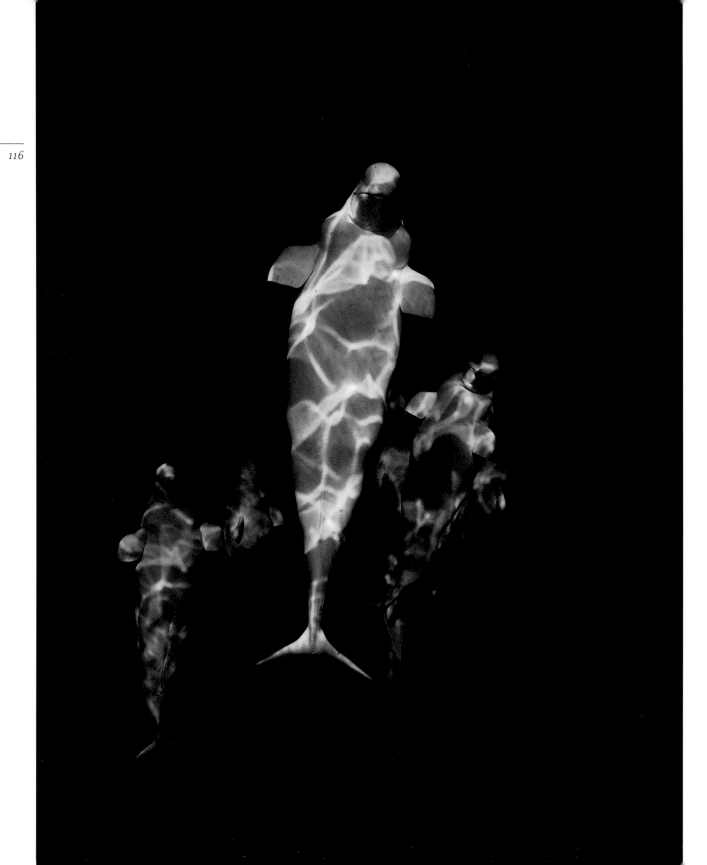

BELUGA WHALE (*Delphinapterus leucas*)
LANCASTER SOUND, CANADA 1987
*Beluga whales look up at me with curiosity
as I snorkel off the ice edge.*

OPPOSITE: *Glenn Williams working as
a renewable resource officer for the
government, Admiralty Inlet, 1989*

GLENN WILLIAMS ON THE CANADIAN ARCTIC

WILDLIFE CONSULTANT

THE BIG QUESTION that keeps getting asked about the Arctic these days is how climate change is affecting things. Right now, that's not clear to me. The multiyear pack ice is receding in August and September, but there will always be sea ice in the Arctic during winter, and that first-year ice is the most productive marine-ice habitat. Also, the Canadian Arctic is spanned by an archipelago, so even if there's less ice, the polar bears, as an example, can go from island to island.

In the south Hudson Bay, the bears are getting really fat in summer when there's no ice. And the bear population is up, despite a study done several years back to the contrary. Since the early '70s when conservation programs to increase bears were started, we've gone from 8,000 to 15,000 and 20,000 bears. Conservation-wise, we have too many bears. There's more competition among them for food, and that's having an effect on the eider ducks and ring seal pups they hunt.

As for whales, we're not seeing declines, but we are seeing shifts in their movements. We're spotting narwhals in areas where we didn't see them before. And the weather doesn't fall into the patterns it used to either. Storms used to come in three-day increments. We don't get a good three-day

blow anymore, but all of this doesn't mean everything is getting worse.

I don't think the science about the impact of climate change is being approached open-mindedly enough. One problem is in the way funding is done. We need more research on what's really happening, but if scientists don't produce papers that identify a dire need, they won't get money for research. At this point, we just don't know what the future effects will be on the humans and animals that live up here.

In the meantime, we're committed to passing on our Inuit traditions. In the winter and fall we men hunt. I take the "country food" we get from the hunts—caribou, seal, muktuk—to the kids in daycare so they'll acquire a taste for it. Spring and summer are a time of plenty here, and we go out on the land with our families to harvest what the land offers—caribou skins for clothes, fat fish, goose eggs, ripe berries. We take our kids and grandkids with us to expose them to all this. But more people are getting jobs in the trades, so they don't have the days off to spend summers away, and the equipment, especially to hunt, can be expensive. And the dog teams we used in the past take a lot of work, revenue, and time—things people don't have anymore. Still, I am hoping our traditions will go on forever.

BELUGA WHALE (*Delphinapterus leucas*) ADMIRALTY INLET, CANADA 1987
*Belugas are sometimes called the canaries of the sea. Even when we
couldn't see them, we could hear them.*

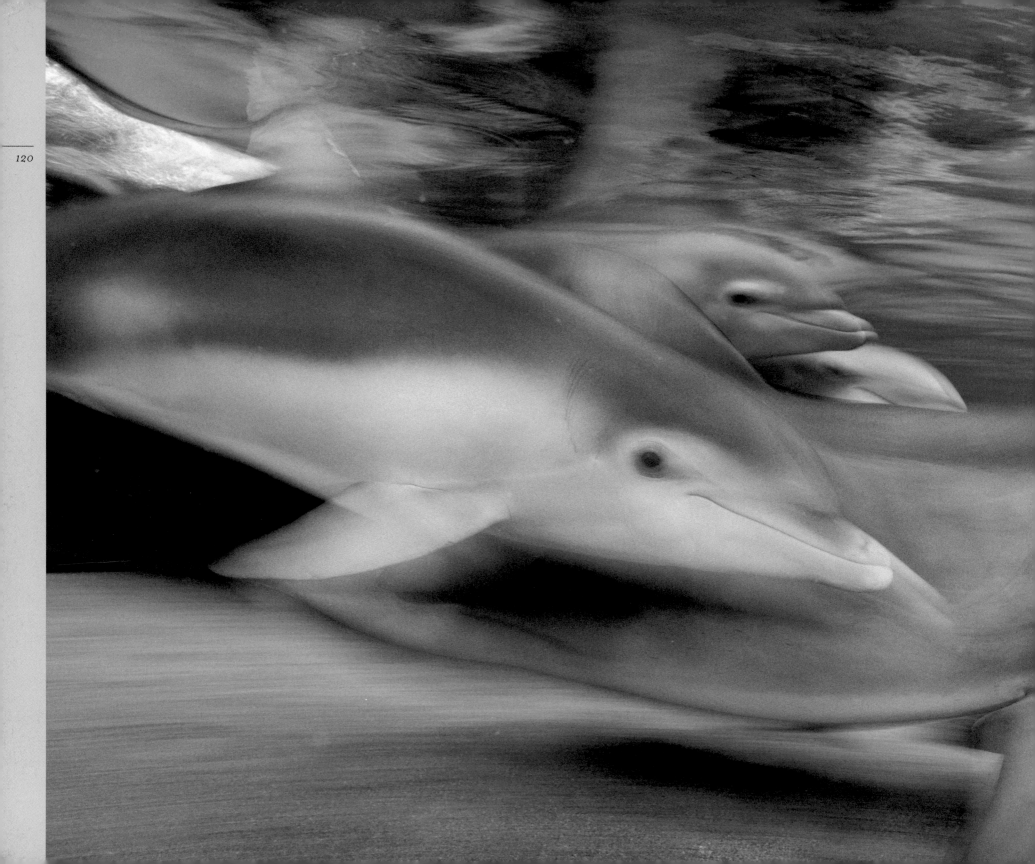

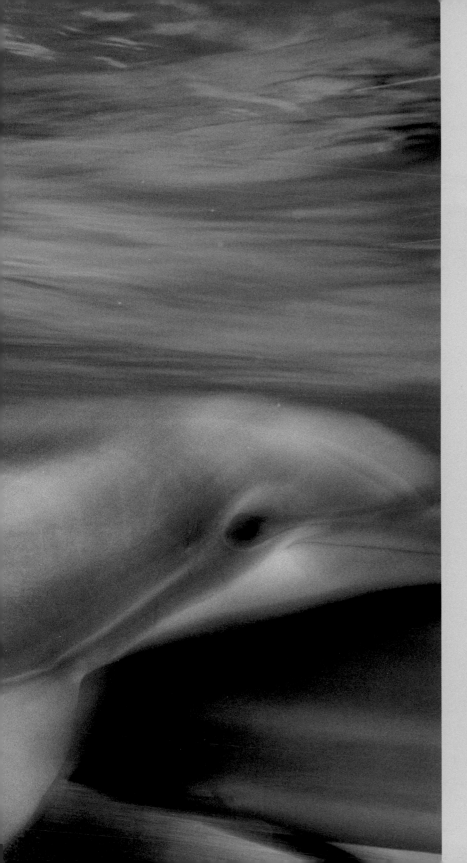

Trouble in the Ocean

BOTTLENOSE DOLPHIN (*Tursiops truncatus*)
DOLPHIN QUEST, BIG ISLAND OF HAWAII 1997

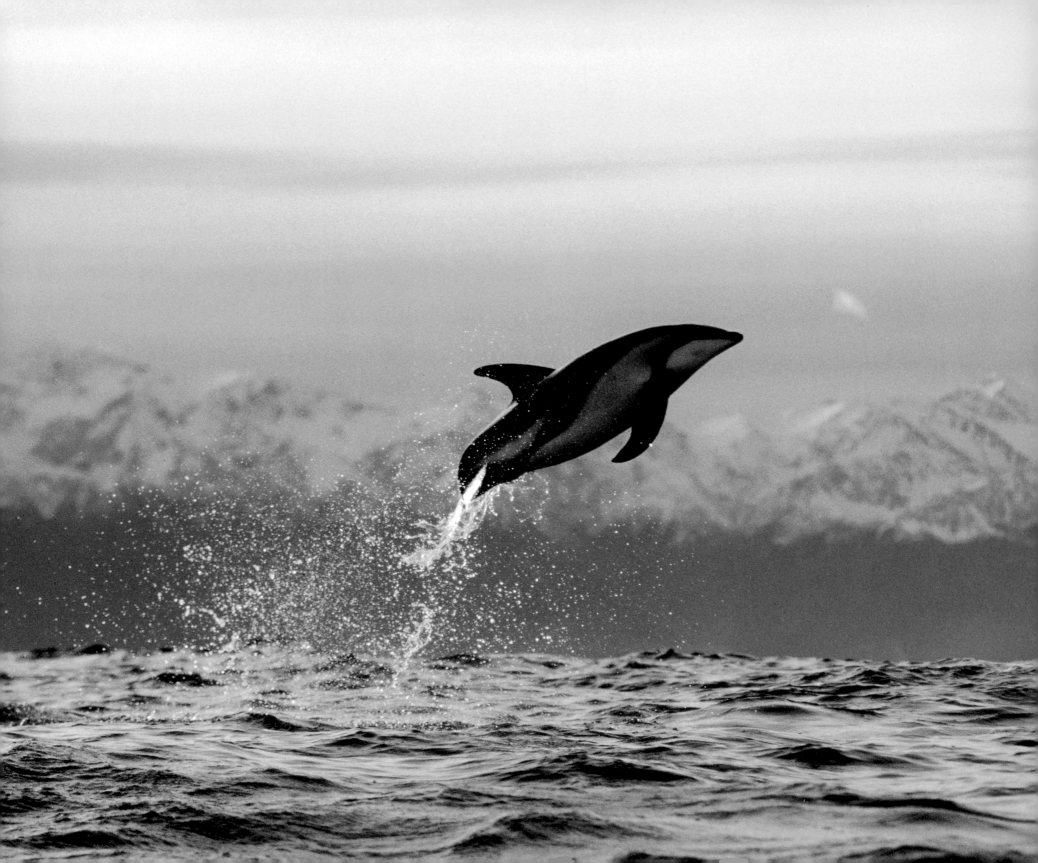

"I was a guest at the researchers' table—it was their project, not mine."

DUSKY DOLPHIN (*Lagenorhynchus obscurus*)
KAIKOURA, NEW ZEALAND
Duskies are among the great leapers in the dolphin family.

BY THE EARLY 1990s conservation had caught fire as a major issue of the day, and when we did stories on whales, it wasn't enough anymore to present them as amazing creatures. We needed to address the issues that were threatening them. With that in mind, I proposed a story on dolphins to the *Geographic*, because dolphin bycatch in tuna nets was becoming a serious issue, and pollution and habitat loss were also affecting dolphin populations. All of this was creating a big emotional response from the public. I suggested that Ken Norris, who had been a pioneer of cetacean research and especially dolphin societies, be assigned to write the story, and the magazine agreed.

One sunny, beautiful Florida day, I positioned myself in a small skiff on crowded Sarasota Bay to cover the release of two subadult bottlenose dolphins that had been captured there by Ken's colleague, conservation biologist Randy Wells, two years before. There were all kinds of people on hand to watch the release of Echo and Misha into the wild, including other reporters packed into a press boat. My routine in situations like that was to get close—but not too close—then wait until the scientists asked me to come over and start shooting. I had learned long ago not to pressure researchers if I hoped to work well with them. I always remembered the parable of a wedding my grandmother used to tell me as a child: One guy goes in and boldly sits with the wedding family and is taken outside and beaten up for his brazenness.

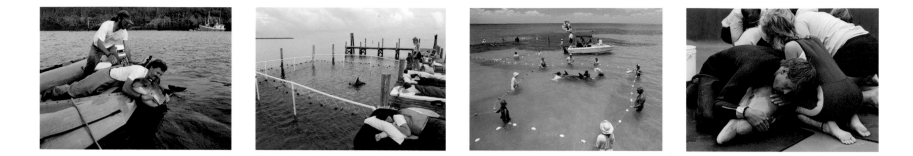

Another guy comes in and sits discreetly at the back and waits to be called forward. That was the guy I wanted to be. After all, I was a guest at the researchers' table—it was their project, not mine.

That day, Randy was in about four feet of water getting ready to release the dolphins. He was radioing back and forth to another boat monitoring the wild dolphins in Echo and Misha's original family group—one of the most intensely studied cetacean groups in the world. The idea was to release Echo and Misha near their family so they could rejoin it.

When the conditions were just right, Randy looked around and realized I wasn't there. He radioed me and said, "Well, why aren't you over here?" I said, "I will be," and I swam that hundred yards holding my new Nikon f4 and strobe up out of the water. It all happened extremely fast, but I got two great shots of the release.

The funny thing was, instead of going out into the deep, the dolphins headed for the shallows and stayed there. After about an hour the crowd started getting anxious. Careers and animals were riding on this thing. Everybody was thinking, "Are they okay? Do they not want to go?" Apparently, what Echo and Misha were doing was audio mapping with sonar—seeing their world with sound instead of sight before swimming

into it. Finally, they swam off together and rejoined their family. Misha passed away just a couple of years ago, so for almost 15 years she was a part of the larger population. As of now, Echo is still alive.

The ironic thing about captive animals in the last decades of the 20th century was that they focused public attention on wild animals. In 1963, the same year my dad rode the Bryde's whale, the Vancouver Aquarium wanted an accurate model of a killer whale. They sent a crew out to kill a whale so they could get measurements, and nobody thought twice about it. They harpooned a whale called Moby Doll, but it didn't die. They brought it back to the docks, and thousands and thousands of people went to look at it. And they could see that this killer whale wasn't a vicious animal, that it was actually a beautiful and charismatic dolphin.

The dolphin story took me all over—to an ex-penal colony off Brazil to shoot spinner dolphins; to Shark Bay, Australia, to cover human/bottlenose dolphin interactions; to New Zealand for Hector's dolphins; to Grand Manan in eastern Canada, where harbor porpoises were being caught accidentally in fishing weirs; and to the Bahamas, where I worked with behavioral scientist Denise Herzing. In the Bahamas, I'd get in the clear, warm Caribbean, dive to the bottom, lie there, sunlight playing across the sand in these shallow waters,

OPPOSITE, LEFT TO RIGHT: *Andy Read, Duke University, releases a small harbor porpoise that had been trapped in a fishing weir on Grand Manan Island, Canada, 1991; research assistants tend Echo and Misha when they were first captured, Florida, 1989; short-term capture-and-release work off Sarasota, 1991; a dolphin undergoing a physical exam at Long Marine Lab, UC Santa Cruz, 1991.*

BELOW: BOTTLENOSE DOLPHIN (*Tursiops truncatus*) SARASOTA, FLORIDA 1991
The release of Misha into his Tampa Bay home after a two-year study. The dolphins best-known to humans, bottlenose, can speed along at 18 miles an hour and more.

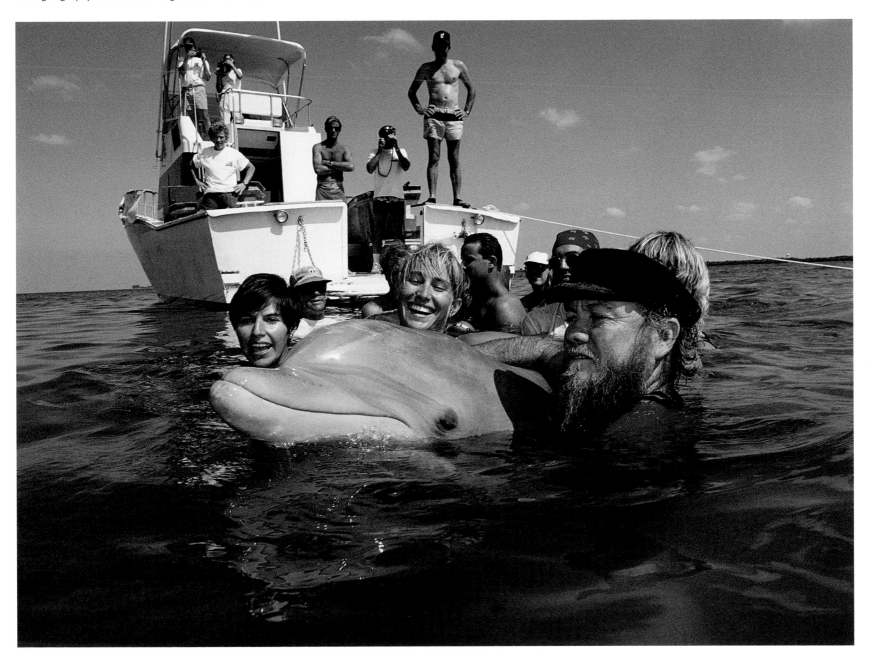

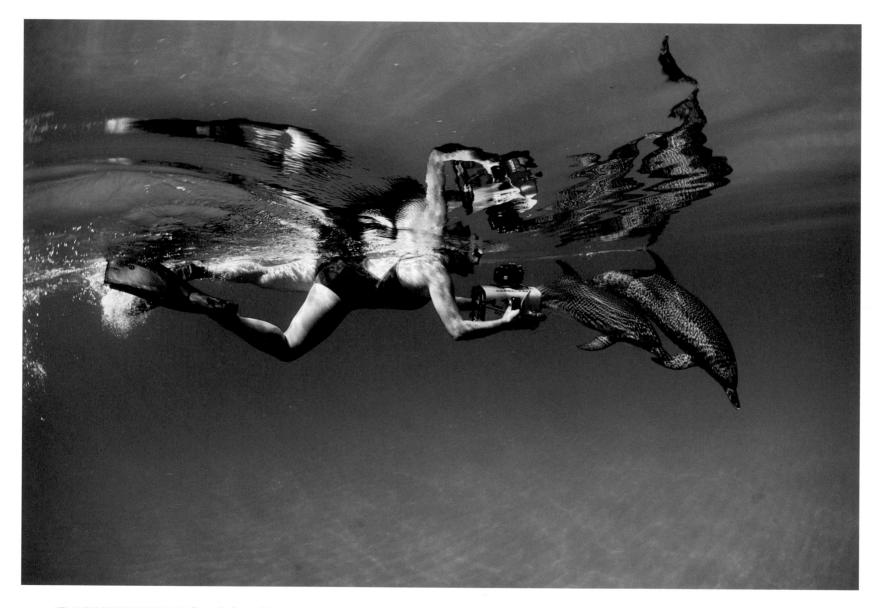

ABOVE: ATLANTIC SPOTTED DOLPHIN (*Stenella frontalis*) BAHAMAS 1991
Dr. Denise Herzing of the Wild Dolphin Project videotapes Atlantic
spotted dolphins in the Bahamas.

OPPOSITE: VAQUITA (*Phocoena sinus*) GULF OF CALIFORNIA 1991
The only vaquitas we found here had been killed as bycatch in a local gillnet fishery.
Just a few hundred of these small, critically endangered cetaceans remain.

until the dolphins came to me. The visibility was great—about a hundred feet. You could see mating and all kinds of remarkable behaviors. Denise's rule was never to chase or touch the animals, so I didn't. But when I swam, dolphins would form a pod beside me and slow down to let me keep up with them. At one point one of them had his belly on my elbow while I held my camera. They were just letting me be a dolphin for an hour, and it was about as much fun as you could have.

The science and behavioral work is the meat and potatoes of what I do, but the chocolate cake is the rare situation where everything just comes together and you find yourself in a world full of whales. It is the *best* when they know you are there and continue to interact. It still amazes me how these animals, particularly the giants among them, can be so graceful around each other and still manage to lift a pectoral or drop a fluke as they pass a tiny human observer.

Off the northwest coast of Mexico, I covered vaquitas, the smallest porpoises and probably the most endangered cetaceans on the planet, on the verge of extinction. Bycatch from fisheries has been killing them off, and in the area I was covering, the loss of water from the Colorado River—it's now no more than a stream when it empties into the northern Gulf of California—was changing the ocean ecosystem.

I lived pretty rough in a lot of those places, the way the researchers did. It would have been awkward not to. With my travel budget, I tried not only to get the best deal for the *Geographic* but to use some of the money to help cover the logistical costs of the researchers who were letting me go out with

them. I didn't want to burden the scientists who were making it all happen.

After the dolphin story, belugas were my next big assignment, and again I teamed up with Ken Norris. One of the key issues we wanted to look at was how pollutants were affecting whales in the Gulf of St. Lawrence. An ice age remnant population of about 500 animals lives there, and some had been turning up dead and with tumors. Pierre Béland, from the St. Lawrence National Institute of Ecotoxicology, had some theories. He said that a hundred years ago there were ten times as many belugas in the area. Overhunting had started the decline, but even after the ban on hunting in the 1950s the species didn't recover.

We wanted to find out what was killing the whales. A big aluminum plant in the area had dumped carcinogens into a local tributary in the past, and traces of the chemical might have remained bonded to the whales' DNA. Another possibility involved a pesticide called mirex. It had been banned

Tony Martin, Tom Smith, and Jack Orr attach telemetry gear to a beluga, while Ken Norris takes notes on shore, Somerset Island, Canada, 1993

in the 1970s, but it stayed in the sediment in the Great Lakes where it was picked up by eels that migrated downstream. And belugas were eating those eels. One expert had declared that the dead belugas were so poisoned that they should be treated as toxic waste. It made a great headline, and it turned up everywhere. I wanted to get a shot of scientists in protective masks taking a beluga apart.

Once we were in the area, we got a report that a dead whale had turned up. When we went out to take a look, there it was, floating in the St. Lawrence. I was wondering how to get a picture that would address the real issue, when Pierre took a rope and flipped the whale over—the side that had been water-down was clean and perfect. I thought it actually made a more compelling statement: Here was this beautiful animal that had issues beneath the surface—the tumors were all on the inside.

I got a picture of Pierre standing on the boat, leaning over the dead beluga. When he performed a necropsy, it turned out that the toxic waste headline wasn't quite true. If the toxins throughout the whole animal had been at the level of some of the toxins in some of the organs, it would have been considered toxic waste. But that wasn't really the case. In fact, as I remember, the beluga was headed to a pet food factory.

There were two important things I took from that job. First, I thought I was going for a certain kind of picture—of a diseased whale—but a completely different picture told the story better. I've always liked shooting beautiful, illustrative material, but that hard-fought stuff is what I love most. A picture of a breaching whale is fun and easy, but pictures showing behavior or research are the most rewarding—and take most of my effort. Also, though the headline made a good point, the real science is more complex. If you don't have hard research, then you don't know what the real issues are and you can be swayed by the superficial, emotional tugs of the day. If you don't get the science right, you can go in the wrong direction with the solutions to complicated environmental problems. And the science takes a lot of hard work. Whale watchers at any level can make up guesses and stories about the behaviors they observe, but to take those observations to the point where they're ready for peer review in scientific journals means years of often tedious data collection.

In 1994 I moved to D.C. and spent the next three years working on a book for the Geographic called *Whales, Dolphins, and Porpoises* as the author and creative consultant.

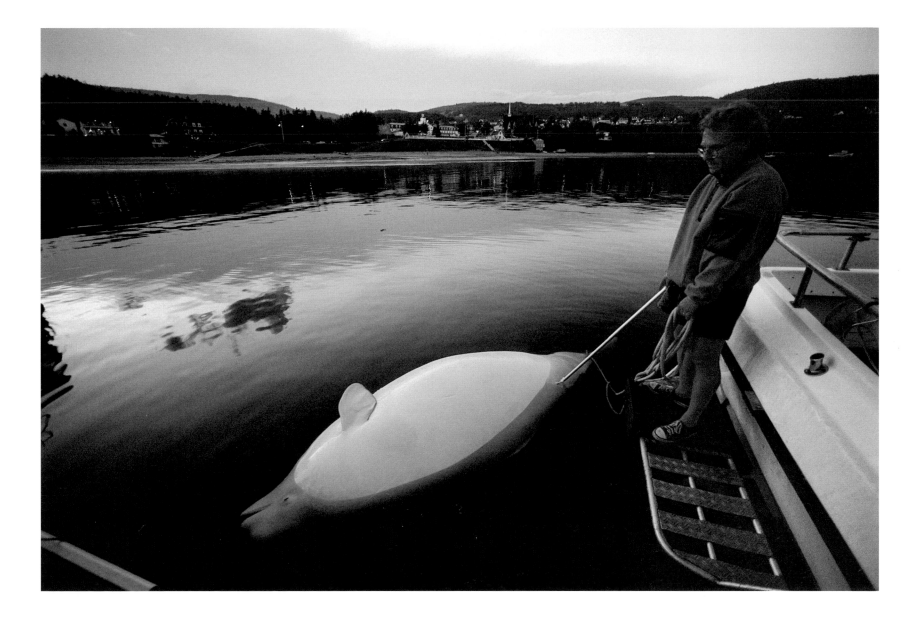

ABOVE: BELUGA WHALE (*Delphinapterus leucas*) TADOUSSAC, CANADA 1993
Late afternoon light falls on a dead beluga recovered in the St. Lawrence River by Dr. Pierre Béland.

DWARF MINKE WHALE (*Balaenoptera acutorostrata*) GREAT BARRIER REEF, AUSTRALIA 1999
A curious dwarf minke swims along as I'm being rope-towed beside it. The most
abundant baleen whales, minkes are hunted by Norway, Iceland, and Japan.

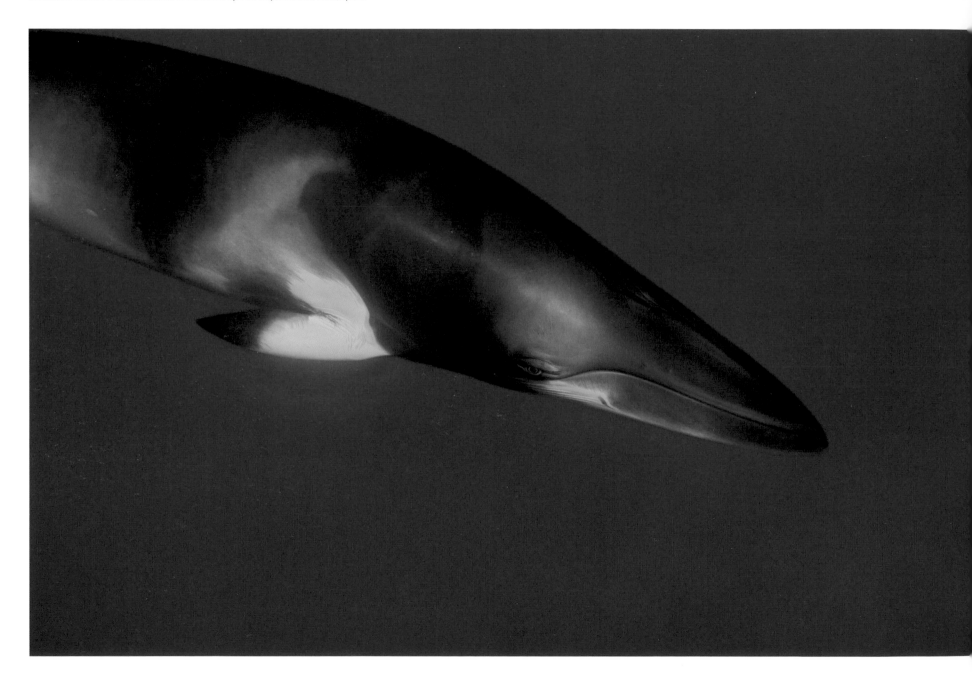

Living in D.C. was a big change, and I started out with an inferiority complex: I was this beach guy with no college degree who was suddenly wearing a suit every day and working with idea people. But I found that we were much more alike than I had thought. Still, after I finished the book, I moved back to the West Coast, where I was offered a chance to sell my collection of photographs, my life's work, to the Minden Pictures photo agency. That sale gave me some economic freedom to think about what I really wanted to do.

One of the first things I did was to call Jim Darling. "Want to go back to Hawaii?" I asked. I told him I had ten thousand dollars to blow, and I thought we should go look at Maui again and see if it was worth picking up where we left off in the '80s. We decided to poke around and see if Jim could design a worthwhile humpback research study with the resources we had and the funds we thought we could raise. It turned out to be the best thing I ever did. I was becoming part of the research effort instead of just going out and tracking the researchers.

So there we were, back in Hawaii, and that first year was a wild ride. We had a realtor friend who found condos for us that were vacant for a day or two between vacation rentals. It meant that we moved every couple of days. We had a tiny little rental car and a Radon fishing boat called the *Nuki*, loaned to us by a friend at the harbor. It had been blown up and sunk a couple of times—it measured 21 feet on one side and 20 feet 6 inches on the other. After a month, the money was gone, but the prospects looked good. We'd be back.

After a few years Jim and I had become such fixtures in Hawaiian whale research that we became fictional characters. A writer named Chris Moore was looking for researchers to help with a novel he was writing. To give us an idea of his style, he sent us a copy of an earlier novel, *Island of the Sequined Love Nun*. We had our doubts, but Jim was willing to take this guy out one time. Chris ended up being practically one of the crew, and his novel, *Fluke*, was a wonderful, funny depiction of the life of whale researchers. It also made me locally famous.

By the late 1990s Jim and I were working every winter on Maui, and I was still doing *Geographic* stories—sometimes too many at a time. I did a story on bowheads and on minkes, both species that are hunted. Inuit and Inupiat were taking bowheads, and the Japanese and Norwegians were hunting minkes. The Japanese harvested about 500 a year under a controversial International Whaling Commission (IWC) provision for "scientific" study. Instead of doing "science," the Norwegians filed an objection with the IWC and went on taking another 500 annually. The minkes had never been on the endangered species list, so the question arose: What were the issues beyond resource management for commercial or subsistence hunting? How do we weigh the pros and cons of captive display? How do we respect the different cultural, economic, and ethical considerations involved in our relationship with whales and dolphins?

The expert who guided me through the minke story was Jon Stern, and the writer was Doug Chadwick. We'd done a number of stories together, and on this assignment we spent time in Norway, where there weren't any big industrial whaling operations, just family businesses. The whalers in one

 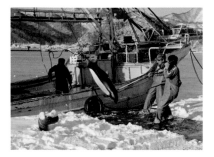

small port town told us that when they were at sea, they'd sit and wait for the minkes to come to them, then they'd harpoon the whales. They invited us to have a meal with them on their hundred-foot-long sidetrawler. In the cramped galley they served us stewed minke, and we knew they were testing us. I'd seen this before with the Inuit. I wouldn't have chosen to eat whale, but I always tried to approach other cultures with an attitude of respect. My goal was to be a journalist first, to try to give fair coverage to everyone.

After the Norwegian whalers gave us the whale stew, one of them turned to Chadwick and asked, "Greenpeace?" And Chadwick answered, "No, *National Geographic*." And the whaler laughed and passed us a bowl of peas, repeating, "Green peas?" It was a joke, but they were sizing us up.

In Tokyo we went to the huge Tsukiji Market, the city's central market and one of the biggest fish markets in the world—block after block of seafood. In the early morning, there were so many frozen tunas they created a fog bank. You could get all kinds of minke there—raw, salted blubber as bacon, smoked as wafers, and packaged as crunchy cartilage.

The minke industry turned out to be more complicated than it first appeared. American geneticists and Japanese toxicologists discovered that a portion of labeled minke was really meat from protected whales, dolphins, and porpoises. And yet, a shopkeeper told us that the sale of whale meat had declined over the years, so the supplies had gotten lower and the prices higher. One older customer explained why he wasn't especially fond of whale meat: After World War II, when food in Japan was scarce, the U.S. had encouraged the Japanese to hunt whales, even supplying boats for the purpose, to supplement the meager diet. For a lot of people whale meat was practically all they ate during those hard years.

But some interest groups in Japan and Norway were, and are, dug in on whaling, and they are fighting pressure by the anti-whaling movement. The problem is that protection for nonmanagement reasons—for reasons other than protecting an endangered animal—can be a hard sell. The United States, in fact, remains a nation that hunts large whales. So when we tell another nation to change its whale-harvesting practices, the arguments become political and complex.

I covered one of our sanctioned whale hunts in 1993—the bowhead hunt in Barrow, Alaska. It was dangerous work and very cold, but the hunters were undeterred. The ice shelf in Barrow was three miles wide—that is, three miles of ice between the land and the open ocean. That may seem like a lot, but it's actually narrow compared with the 60-mile frozen fjord off Baffin Island.

OPPOSITE, LEFT TO RIGHT: *Whale bacon, Tsukiji Fish Market, Tokyo, 1999; fishermen
load minke meat into a processing facility on Lofoten Island, Norway, 1999; detailed
drawings by Australian marine researcher Alistair Birtles of James Cook University,
1999; harpoon fishermen unload True's porpoises in northern Honshu, Japan, 1991.*

ABOVE: *Octogenarian Hosano San, then the oldest whaler in Taiga, southern Japan,
prepares for a parade celebrating the beginning of the 1987 whaling season.*

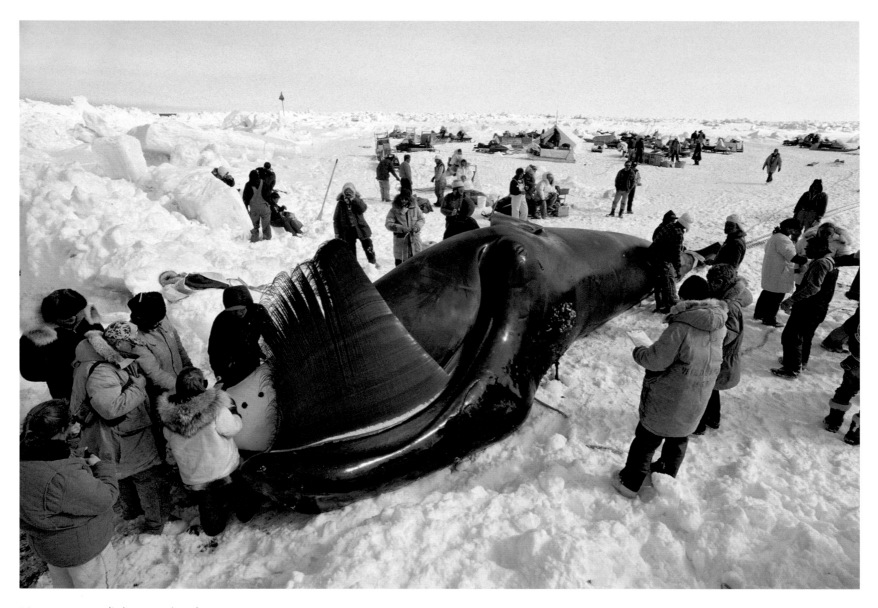

BOWHEAD WHALE (*Balaena mysticetus*) BARROW, ALASKA 1994
Inupiat turn out to help harvest a freshly killed bowhead,
as scientists take its measurements.

I found the whole culture of the hunt fascinating. Hunters would spend weeks out on the floe edge, waiting for whales. They disguised the camp with big broken pieces of ice so that there were no silhouettes of man-made objects to break up the white world. Some of the boys in the community would come out on weekends to learn the hunt, bringing their homework with them. The community was fairly prosperous, thanks to oil, so they had the time and money to invest in this kind of hunting.

I never did see an actual whale kill, but I did see a post-hunt celebration. Since a whale can weigh up to 50 tons, it took 50 to 80 people to pull it up onto the ice with a block and tackle. The whole community turned out to help. The animal was cut up, and everyone ate the meat, either raw or boiled. They particularly relished the muktuk—the skin and fat that used to be the major source of vitamins for the Inupiat in the days before vegetables were shipped in. Later, the whale captains distributed the meat in the prescribed manner, with the old people getting the best parts. The whale meat would be prepared in all kinds of ways—marinated, spiced, fried.

After the hunt, the scientists who were on hand in Barrow discovered some interesting things from the dead whales. By finding old hunting artifacts embedded in them and later studying amino acids in the whales' eyes and wax plugs in their ears, they found that bowheads can live up to 200 years.

What impressed me with the whole situation surrounding the bowhead hunt was that the discussion between the community and the scientists about how many whales to take was very reason-driven. The community effort that got the whale hunt reinstituted in Barrow was greatly influenced by Harry Brower, Sr., an Inupiat elder and hunter. After the Endangered Species Act was passed, federal biologists did a visual census of bowheads off Barrow in 1978, and that count was very low. But the elders believed there were more bowheads than could be seen, and Brower decided to try to enlist the help of Chris Clark at Cornell's bioacoustics lab. While the community scientists at Barrow continued the visual census of bowheads, Chris's team positioned an array of hydrophones near the ice floe edge to take an acoustic census of bowheads. By extrapolating data from the two censuses taken in 1985, a new estimate put the bowhead population at about 6,500 animals— a figure that astonished just about everybody and made it clear that there were enough bowheads to support a regulated hunt.

The "whale wars" touch off all kinds of issues and force us to consider what our relationship to these animals should be. A new generation has grown up loving whales, and the attitudes, policies, and emotional responses to whales have changed radically from what they were 50 years ago, and they continue to change. The next decade should be telling.

We covered a number of other issues during the 1990s and into the early 2000s, and those assignments and the time I spent with scientists made me realize that while whale hunting has become a big ethical and emotional issue, it's not the only threat. Bycatch, pollution, habitat loss are all threats for cetacean populations.

A story on bottlenose whales highlighted that. One of the least-known cetaceans, the northern bottlenose is a beaked whale that can dive to 5,000 feet and stay down for almost two hours—longer than any other whale.

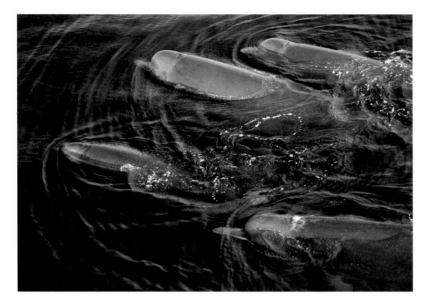

It also happens to live in a big oil and natural gas drilling region of the North Atlantic. Our story helped establish guidelines to protect bottlenoses in the Gully, an underwater canyon off Nova Scotia. And our story on blue refuges brought some attention to the need for more marine sanctuaries.

A recent *National Geographic* story I did on orcas (killer whales) pointed to the fact that while orcas in Alaska and the Aleutians are doing okay, the population that spends time between Washington and Vancouver Island is having all kinds of issues. There is concern about toxins and ambient noise from boats in the area, but the biggest problem is food. These waters used to have a tremendous amount of king salmon—critical to the killer whales here—but with overfishing and dams on the rivers, the salmon are just about gone. That's going to have a serious impact on the resident whales there.

Over the decades whale journalism has moved from commodity stories

to describe-the-whale stories to save-the-whale stories. My friends and I joke about the generic magazine whale story: "Whales are large, they're endangered, foreigners kill them, and this one liked me personally." The next generation of stories we cover may be make-room-for-whale stories. If whales come back strong, the questions will change: Will we be willing to share the ocean's resources with them, or will we compete with them for food? And what happens when they themselves threaten endangered species? You can see that happening already at Lynn Canal in southeastern Alaska. There's serious talk of putting the Lynn Canal herring on the endangered species list, and humpbacks feed on them there. One local humpback has even figured out when and how to get to king salmon fry as they're released from a hatchery. He makes bubble nets at the release area and eats all the fry in one bite.

Throughout my career, I've thought of my job as presenting readers with things to think about, not telling them what to think. I often don't know what to think myself, but I just keep digging and following the research. I do know that beyond just considering how we manage whales as threatened or endangered animals, we need to consider our moral and ethical obligations to them and their environment. We're making big decisions about the health of the ocean without knowing enough about the ocean ecosystem.

Whales are iconic animals that help us focus on larger issues. You can't have whales without having a working ecosystem, and you can't have a working ecosystem unless you share the resources with these largest of all creatures. I think we can keep the magic and sensitivity in our relationship with them and still listen to good science—at least I hope we can.

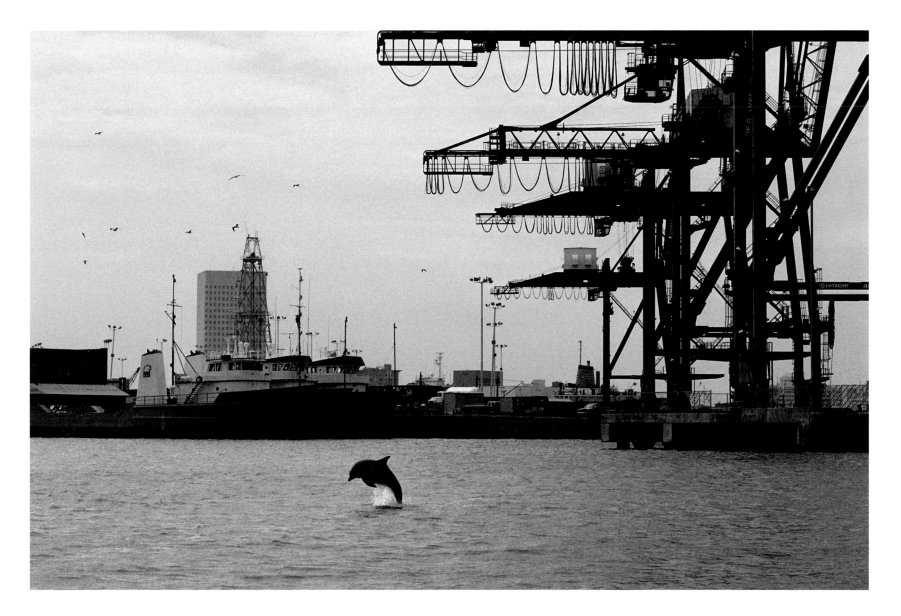

ABOVE: BOTTLENOSE DOLPHIN (*Tursiops truncatus*) GALVESTON, TEXAS 1991
A dolphin frolics in Galveston Harbor, Texas, where heavy industry and
wildlife exist in close proximity.

OPPOSITE: BOTTLENOSE WHALE (*Hyperoodon ampullatus*)
THE GULLY, NORTH ATLANTIC 1997
Bottlenose whales can dive to 5,000 feet and remain submerged for almost two hours.

BOTTLENOSE DOLPHIN (*Tursiops truncatus*) SHARK BAY, AUSTRALIA 1991

COMMON DOLPHIN (*Delphinus delphis*) BAJA CALIFORNIA 2009
A group of dolphins riding in the wake of a tour ship in the Gulf of California

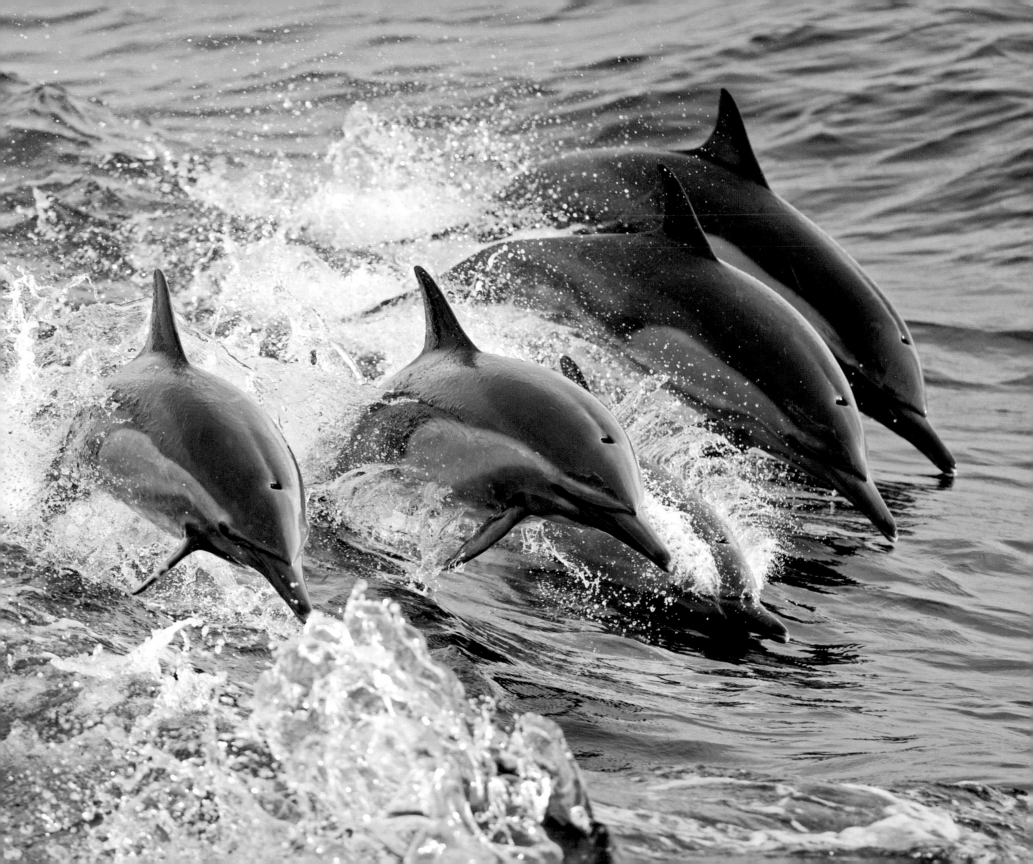

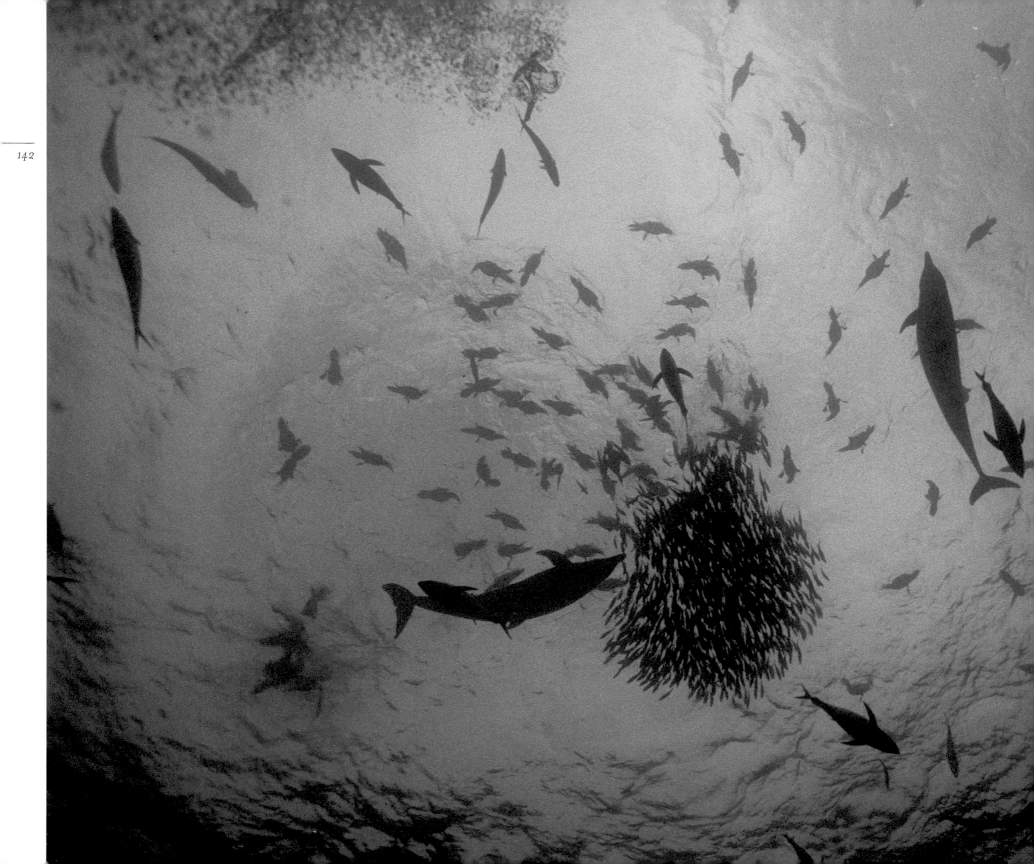

BOTTLENOSE DOLPHIN (*Tursiops truncatus*) COCOS ISLAND, COSTA RICA 1989
*Bottlenose dolphins feed on a bait ball—a tight school of fish—300 miles southwest
of Costa Rica. This large group of fish pounded open a seam in our inflatable boat.*

AMAZON RIVER DOLPHIN (*Inia geoffrensis*) SILVER LAKE, BRAZIL 1991
This introduced boto—as these dolphins are sometimes called—tried to bite my assistant on the leg, a hazard akin to being nibbled by a large puppy.

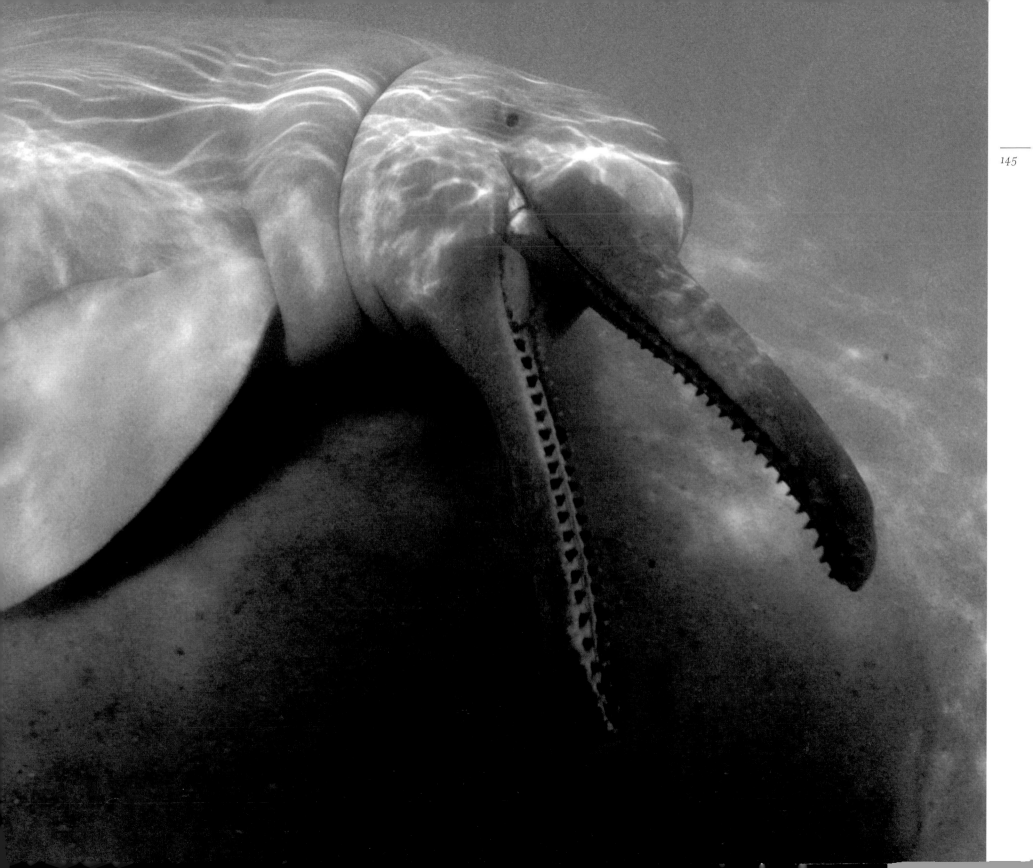

ATLANTIC SPOTTED DOLPHIN *(Stenella frontalis)* BAHAMAS 1991
A large group resting and socializing in shallow water far from shore

JON STERN ON MINKE WHALES

PROFESSOR OF BIOLOGY, SAN FRANCISCO STATE UNIVERSITY

OPPOSITE: DWARF MINKE WHALE
(*Balaenoptera acutorostrata*)
GREAT BARRIER REEF, AUSTRALIA 1999
*A minke whale nosing up to our research
vessel near Lizard Island*

MINKE WHALES are currently the most heavily hunted of all whale species. They're harvested off Norway, Japan, and Antarctica, and in other areas, they're accidentally caught in fishing nets. In the Southern Hemisphere there are maybe a few hundred thousand minkes, and Japan wants to take about a thousand a year—less than one percent of the population. That seems like a reasonable take. So we have to ask ourselves if it's reasonable to allow a hunt of that magnitude on a population that is relatively large. *Can* you safely remove individuals from a population without affecting its viability? That's a scientific question. *Should* you take them is a moral and ethical question.

The scientific question is more complex than just population numbers. I've been studying a relatively small population of minkes off Washington and California, and what we're finding is that there are relatively small, localized populations that don't seem to move around a lot. If this is the situation in places where they're hunted or being taken as bycatch, such as off Japan, there's a high probability of doing some serious and unseen damage to a population.

We also have to look at these organisms in the context of the world they inhabit. Whales eat a lot of food, so they take a lot of energy, store it, and move it around. And they have predators that depend on them. Removing minke whales from this community of organisms might have an impact that isn't seen and is difficult to track. We're modeling energy flow and nutrient cycling in these ecosystems to understand better what that impact might be.

In the past we've assumed that if we reduce the harvest of a troubled population, the animals will rebound. But other animals fill their niche, making a comeback harder, and with climate change and ocean acidification, we might not be able to rely on the oceans as we have before. The systems that sustain available food for whale stocks might be breaking down.

The current attitude among hunters is, "We're gonna harvest what we want and if you don't want us to do that, then you have to prove we're having an impact." The reverse should be the case: Those who propose a harvest must show it will not have an impact on the population.

The time is ripe for a discussion of whaling and what it is that both sides—the harvesters and the anti-whaling faction—really want. One of the big fears is that Japan will join Norway and Iceland in commercially hunting whales outside of the International Whaling Commission's purview; then they can do whatever they want. The anti-whaling people don't seem to realize that Japan has a different culture—an island culture with a different notion of using available resources. They've whaled for hundreds of years. If we want to make significant progress on the important issues, we have to be more respectful of each other, and be honest about our short and long-term goals in the face of a changing environment.

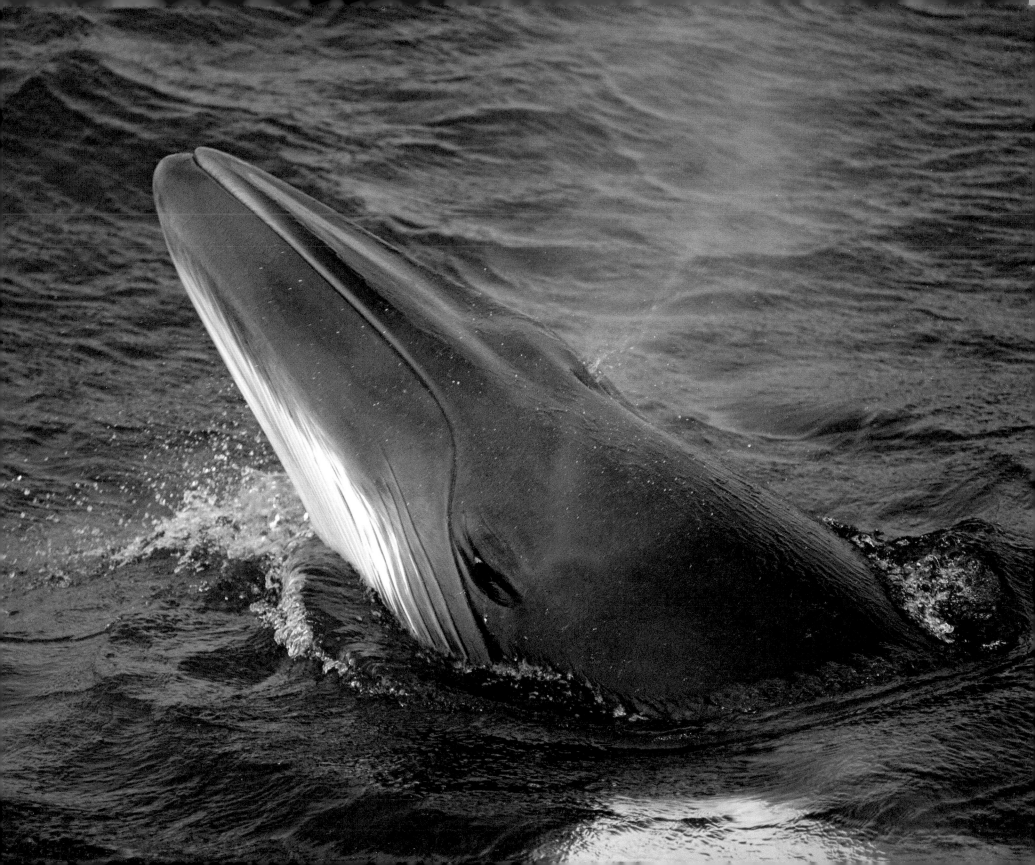

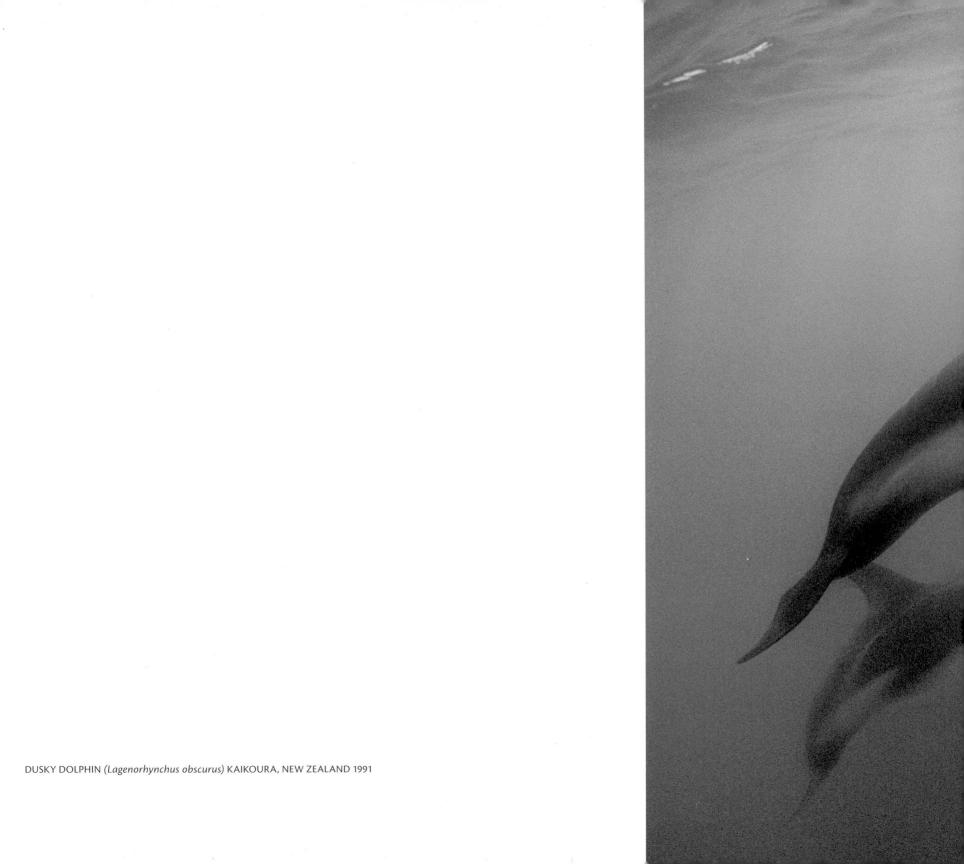

DUSKY DOLPHIN (*Lagenorhynchus obscurus*) KAIKOURA, NEW ZEALAND 1991

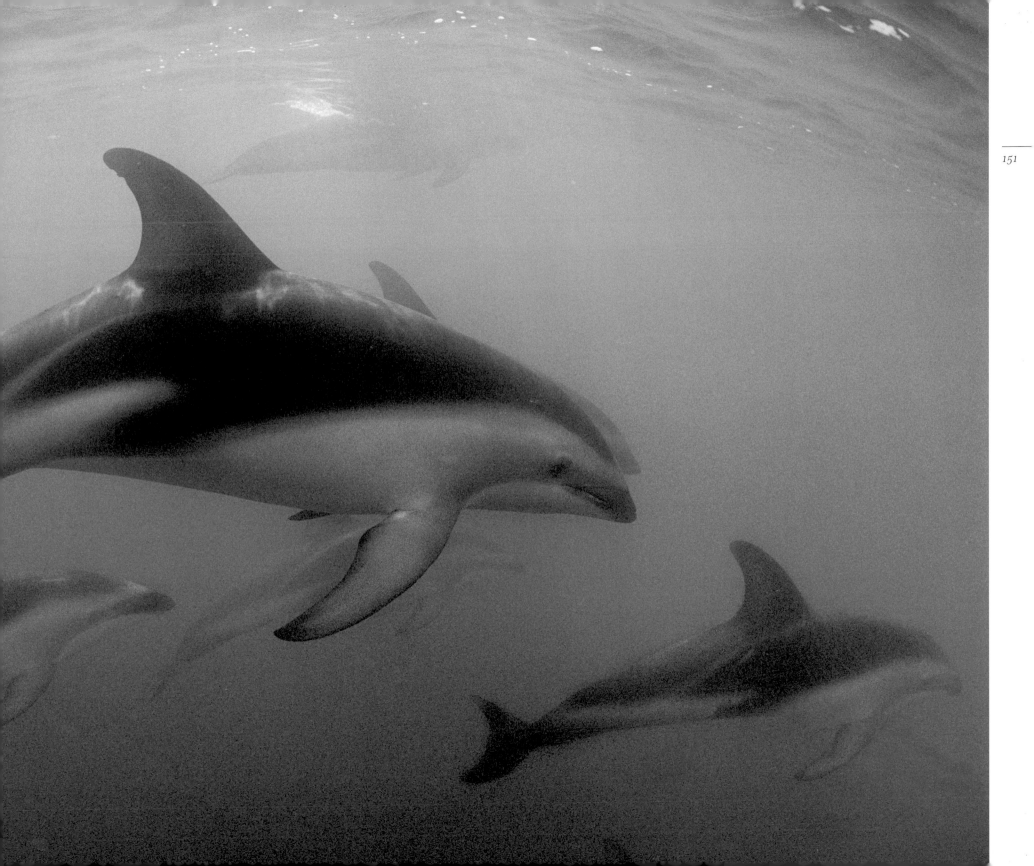

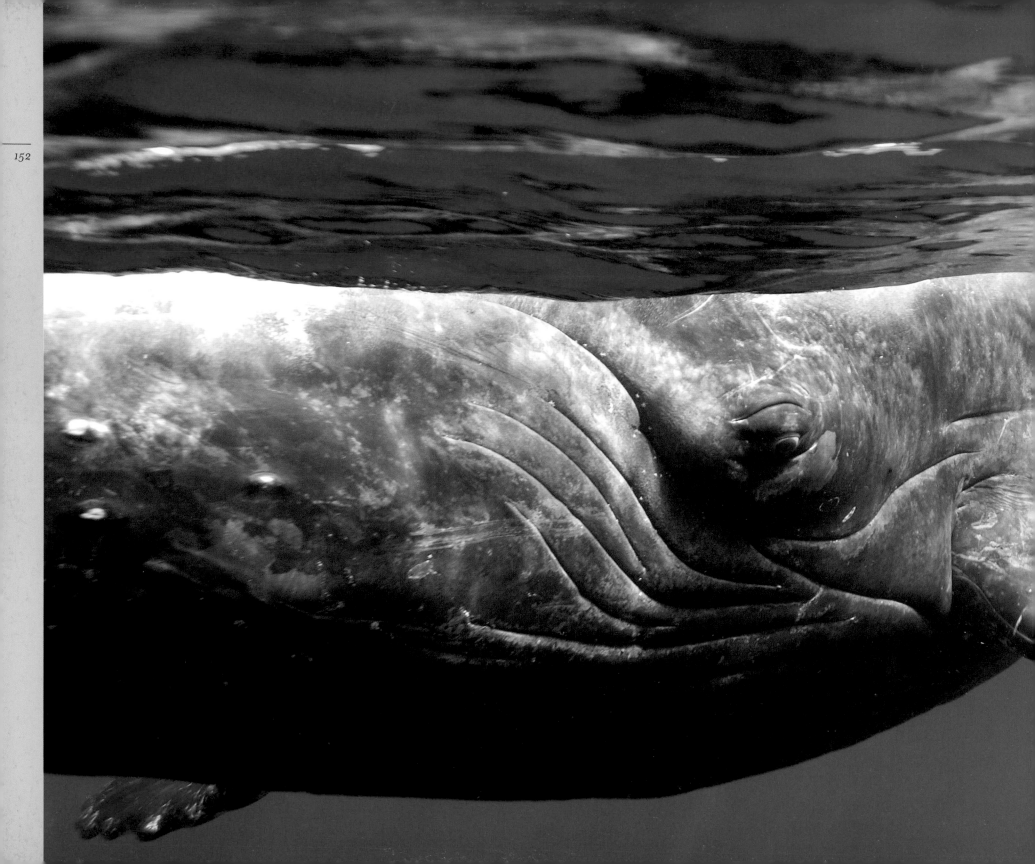

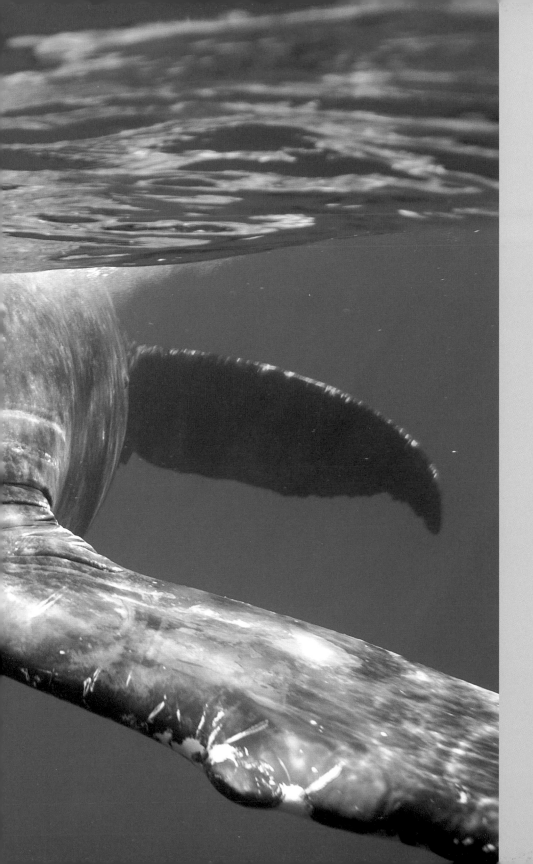

Imaging the Future

HUMPBACK WHALE (*Megaptera novaeangliae*) MAUI, HAWAII 2006
*A very assertive escort male humpback guards a nearby female in the
Au Au Channel between Maui and Lanai. The escort forced the researchers
and me away—a tap with a pectoral is like getting hit with a baseball bat.*

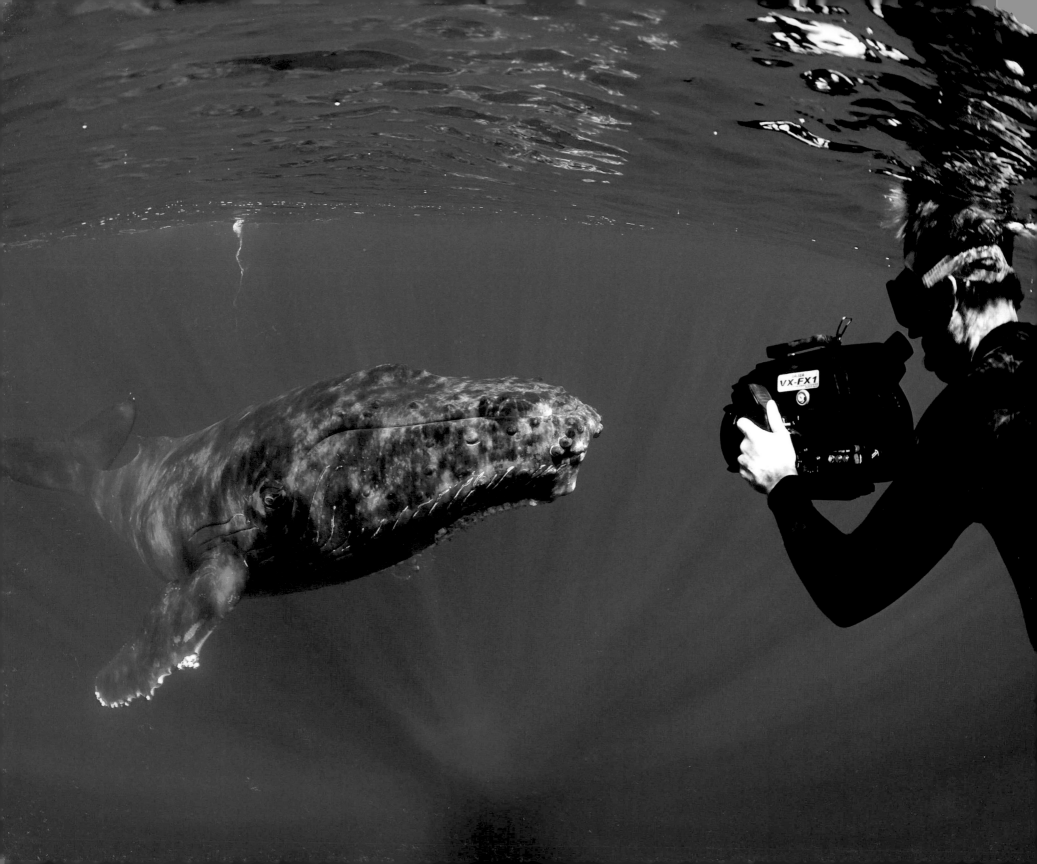

"We've barely begun to figure out how to study the world's largest mammals, and the future is all about expanding our view of them."

SINCE RETURNING TO HAWAII in the mid-1990s I've been making the transition from going out and covering the "guys who know" to being one of those guys. At least here and in Alaska, I've become part of the research effort myself, as well as finding ways to support other people's research. In 2001 Jim Darling, Meagan Jones, and I founded the non-profit Whale Trust. Our mission is to promote and conduct research on whales and the marine environment and to develop education programs based on that research. I put up some of the seed money for this, but the National Geographic's Grosvenor Council members and many others have provided most of the funding.

In Hawaii we have a perfect living laboratory for whale research. During the winter season the islands have over 10,000 humpbacks passing through. We don't know exactly why they like it here, but for us, the warm, clear protected waters make this an ideal place for research. On the west side of Maui the waters just offshore are in the lee of the mountains, so they're usually dead calm from sunup until one or two in the afternoon, even when the trade winds are blowing. In that kind of water we can keep our boat in one place and see better. And the healthy, growing whale population here exhibits all kinds of behaviors that we're interested in.

Over the decades Jim has continued his efforts to find out why whales sing. Specifically, he has looked into the social function of song. We already

HUMPBACK WHALE *(Megaptera novaeangliae)* MAUI 2006
Jason Sturgis films a friendly young female humpback that spent hours around our boat.

Jim Darling listening to a singer, Maui 2004

knew from our work in the late '70s and early '80s that only the humpback males sing. Were they trying to attract mates? Or were they signaling status or something else to each other? It was generally assumed the males were singing love songs, but it turns out they weren't. Males appear to be singing only to each other, then going off in pursuit of females.

Generally, a female, with or without a calf, will have a primary male escort. But periodically this primary male will be challenged by other males. These challenges can last for hours. Instead of a free-for-all, it may be more like the Tour de France. There are a number of possible primary escorts, often with affiliates (wingmen) that team together. Sometimes you'll see half a dozen males following a female without any apparent competition at all.

These kinds of whale studies can take years. Meagan has spent over a decade with us investigating the behavior of female humpbacks.

She recently finished her doctoral dissertation with Antioch University on the influence of reproductive status on female humpback behavior patterns. Though I don't want to scoop her research before it comes out, I'll just say that she has some intriguing theories about female behavior.

We operate three boats at a time. Typically, Jim runs the "singing boat," while Meagan handles the "female boat," and I operate the "video and still-photo boat" with my research assistant, Jason Sturgis. We use high-quality digital photography and video to systematically document the behavior patterns of humpbacks.

Jason came to us as a young man back in 2001, and I like to think of him as the future of this business. A fisherman friend called me one evening back then and told me he knew this nice young guy who was a good free diver. My friend said Jason's family had been in Hawaii a long time and Jason wanted to work for us and I'd be an idiot if I didn't use him. So I said, "Okay, send him over." For the first couple of years I gave him every dirty job I could think of. And he kept coming back. He's very good in the water and excellent with a camera. He can free dive down at least a hundred feet, something I could pretty much do in my prime. Two years ago I told him that from now on I was going to be *his* assistant. Which basically meant he would load the heavy stuff in the boat, and I would get the sandwiches and the coffee.

But, in all seriousness, Jason is the kind of guy we were. We came and stayed, whether it made any sense financially. Sometimes we paid big prices for our choices, both economically and socially. The people who are not just looking for the best pay but have a passionate curiosity are the people that

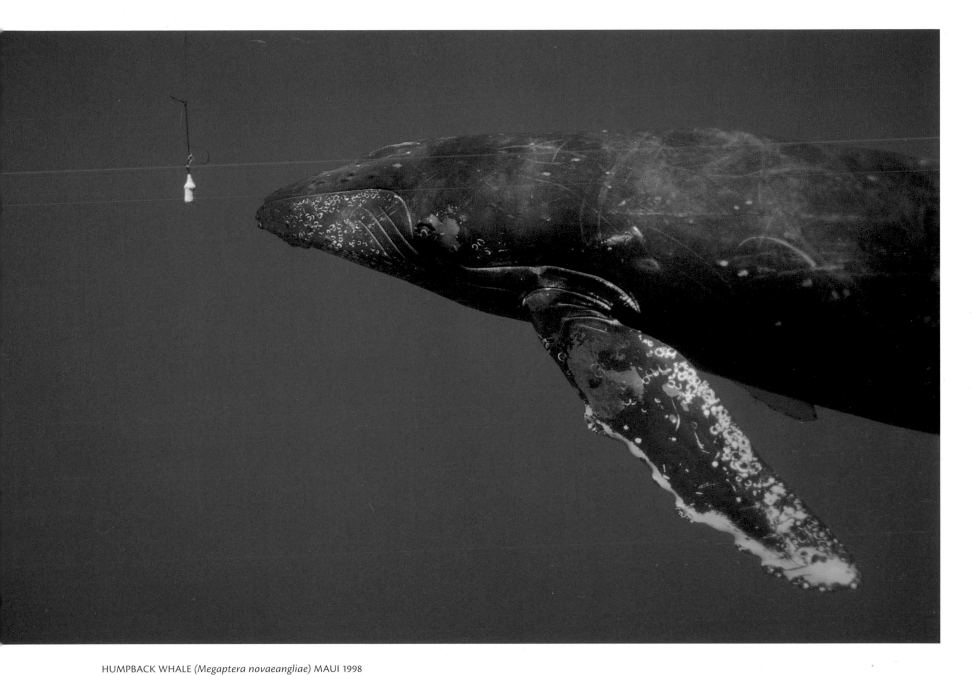

HUMPBACK WHALE (*Megaptera novaeangliae*) MAUI 1998
*A cooperative humpback sings into a hydrophone, each of his songs lasting up to 14 minutes. He swam
and rolled around the hydrophone line, wrapping his pectoral around it and nearly pulling Jim into the water.*

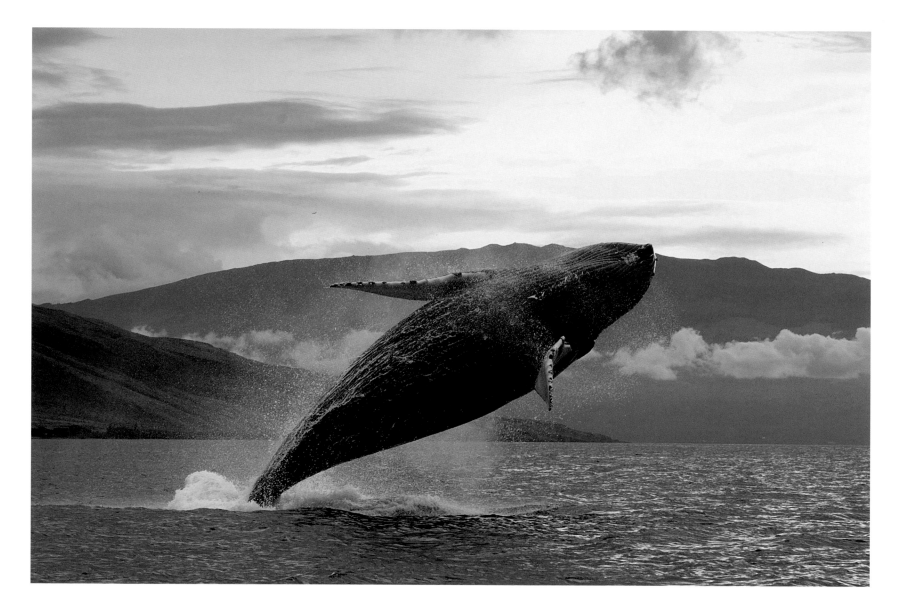

ABOVE: HUMPBACK WHALE (*Megaptera novaeangliae*) MAUI 2004
*Dr. Ed Lane, a volunteer assistant from Virginia and longtime dive buddy,
took this great breach shot with a brand-new digital Nikon.*

OPPOSITE: *A remote-controlled photo blimp in southeastern Alaska offers a glimpse
of future ways to study whales—though this 1998 effort didn't work out very well.*

I believe will carry this work forward. I have moments of doubt that those people will show up, but then they've always been rare. I remember when I was first at the *Geographic*—the older generation had plenty of doubts about me.

Another photographer who has made a name for himself doing marine mammal work is Paul Nicklen. He started writing to me when he was a teenager in the 1980s. He asked if he could tell people he was my nephew, even though he spells his name differently. He was persistent, and I began hearing good things about him. I finally met him and worked with him for a couple of years. I introduced him to the people at *National Geographic,* and he's doing great stuff for the magazine with new gear, new approaches, and great passion.

In my fourth decade of working with whales, I still do a lot of what I did in my 30s, though it takes much more preparation. Mostly I swim and snorkel. My father always said the best way to train for diving was to dive, so I'll go out into the water and sit on the bottom for longer and longer periods, starting with 30 seconds and working up to 2.5 minutes. I'll spend weeks training for a dive that used to be a matter of just jumping off a boat. And I've never lost my respect, awe, and, yes, fear of what's down there.

The great thing that has changed for us, and research groups everywhere, is that we can capture whale behavior on video. In the old days you had to just hope that somebody was there with a 16-millimeter TV camera. It was very expensive and cumbersome. Now just about everybody has cameras that shoot with high production values. In the future, we'd like to

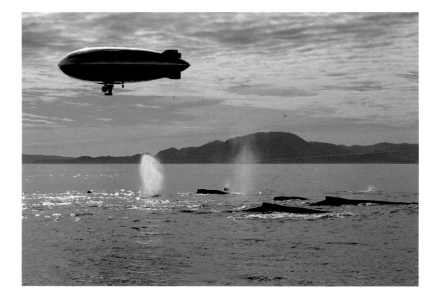

use unmanned drones in our research. From 2,000 feet up, drones could show us what's going on all around the boat. It's well beyond our means right now, but I hope we'll get there eventually. Jason has also been working with people who operate two-man submarines. Though it would be a logistical challenge, we would like to be able to follow a humpback group and observe it for a long time underwater.

If you're studying land animals, you can sit on a hillside with binoculars. With whales, we have no binoculars and our vision is cloudy. A photographer can shoot one-fifth of the distance he can see underwater, and that distance is limited to a hundred feet or so in the best conditions. We've barely begun to figure out how to study the world's largest mammals, and the future is all about expanding our view of them. We're still only getting glimpses, not a whole picture. You see a tail or a blow and you have to make surmises about what you *aren't* seeing.

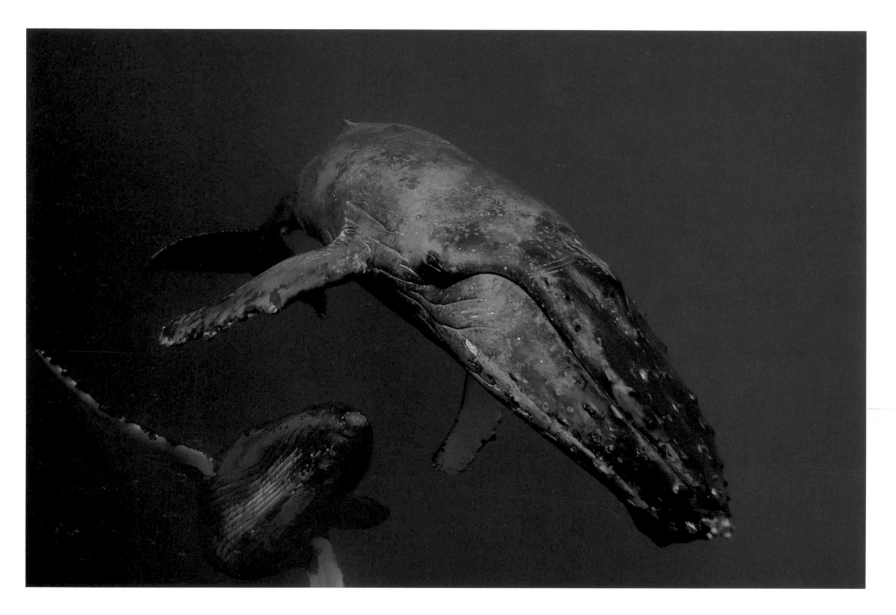

ABOVE: HUMPBACK WHALE (Megaptera novaeangliae) MAUI 2006
This female hung quietly in the water column for a half hour at a time, 60 feet deep; her male escort below wasn't nearly as relaxed. The whales off Maui in the winter live on their fat reserves, some staying for just days, others for up to three months.

OPPOSITE: A humpback feeds through a cloud of small bubbles it has made to trap small fish called sand lance, Stellwagon Bank, Massachusetts, 1997.

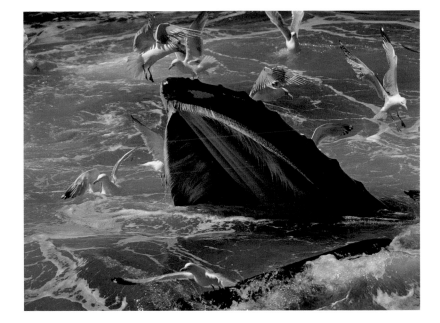

Underwater acoustics can help with this, and that kind of work is being done now. Scientists are shooting suction-cup tags onto the backs of whales that record not just whale sounds but the sounds of ships and other things in the area. Using these tags, researchers discovered that the largest concentration of blue whales was right in the shipping lane of California's Santa Barbara Channel. If the lane is moved, the whales might be saved. In recent years a lane in the Great South Channel off Boston has been moved to accommodate northern right whales.

What else is in store for the future? We've used satellite transmitters for decades and they keep getting better. Bruce Mate, at Oregon State, continues to develop new and better satellite telemetry to track whales. I've worked with Bruce on blue whales, and it's amazing how he can attach a tiny transmitter to a whale, and it will beam information to orbiting satellites, giving data not just on the whale's location but on how deep it dives and how frequently. This kind of tagging can also monitor heart rates and other physiological data while a whale is diving, swimming, feeding, or mating. It's potentially a very sophisticated world of above- and below-water biotelemetry, with endless possibilities. It just takes money and a will to know.

DNA analysis is yet another tool we've been using. Most of what we know from cetacean skin samples now is gender identification. But we could also be getting kinship and evolutionary links, species-specific genetic fingerprints, and all kinds of other information. This is not futuristic stuff— the technology is available now, it's just very expensive and hard to do.

The new generation of divers is also going to have better equipment.

Smaller and smaller rebreathers will mean photographers won't have to free dive and hold their breath forever. (Rebreathers are tanks that recycle your own air, scrubbing out the carbon dioxide so that you don't produce bubbles and alarm the marine life.) Jason is also working with jet boots—little propellers with a battery pack that strap onto your legs and let you go about four knots. They're quirky and don't always work, but when they do, you can swim along with whales at cruising speeds while running a camera. The National Geographic's Crittercam system actually attaches a camera to an animal so you can experience the world it's experiencing.

The cameras photographers use are changing, too. I couldn't be doing any of what I'm doing now without the latest cameras: As I get older and slower, cameras are getting better and faster, so I have more of a shooting life than I ever dreamed.

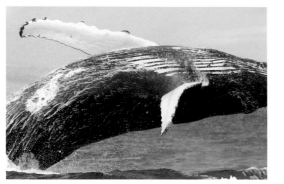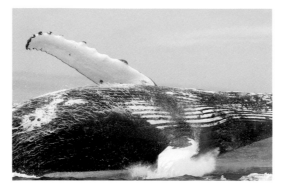

We keep pushing the technology because when it comes to whale research we have barely started. There are still many, many questions about how whales live their lives, how they find food, how they find each other, and what the larger relationships among them are. In Alaska researcher Fred Sharpe has worked with nonrelated groups of humpbacks that come together in cooperative feeding groups to do pretty amazing stuff. One of them will make a ring of bubbles about 20 feet below the surface, then the other whales go deeper to a school of fish and corral the fish into the bubbles above. The amazing thing is that this group effort can involve lots of whales cooperating in a learned behavior that gets passed on and refined to adjust to different situations.

Blue whale groups are another intriguing and mysterious phenomenon we don't know much about. These creatures—Earth's largest animals—live in a world of sound; they can make sounds that travel across ocean basins. Could members belong to the same group, even if they are thousands of miles apart? As Ken Norris once said, "We knew much more about whales before we looked at them closely."

We know quite a bit about the social structures of killer whales, including the fact that some of them form family pods that reliably stay and hunt together in the same places day after day and year after year. But until recently, we didn't know as much about migrating, or transient, killer whales. Now there's breaking news about groups of hundreds of transient orcas coming together to hunt gray whales off the Aleutians every spring.

Then there are humpbacks, the whales I'm most familiar with. We know a good deal about their behavior superficially, but we don't know why they do what they do and relatively little about their group structures. The thousands of whales that come through Hawaii every year, are they coming through together? Or do they form family or social groups that travel together at different times and from different places? These questions become important when you want to look at historical migration patterns.

One question that especially intrigues me is exactly when humpbacks started coming to Hawaii and why. In artwork and oral histories of ancient Hawaiians there is no record of humpback whales being there, and there is no evidence that humpbacks were there in large numbers in the mid-1800s during the heyday of whaling. The whalers who provisioned in Hawaii in the winter couldn't have overlooked the numbers of whales that are in Hawaii now. We really don't know what happened, but everything points to a recent colonization of humpbacks.

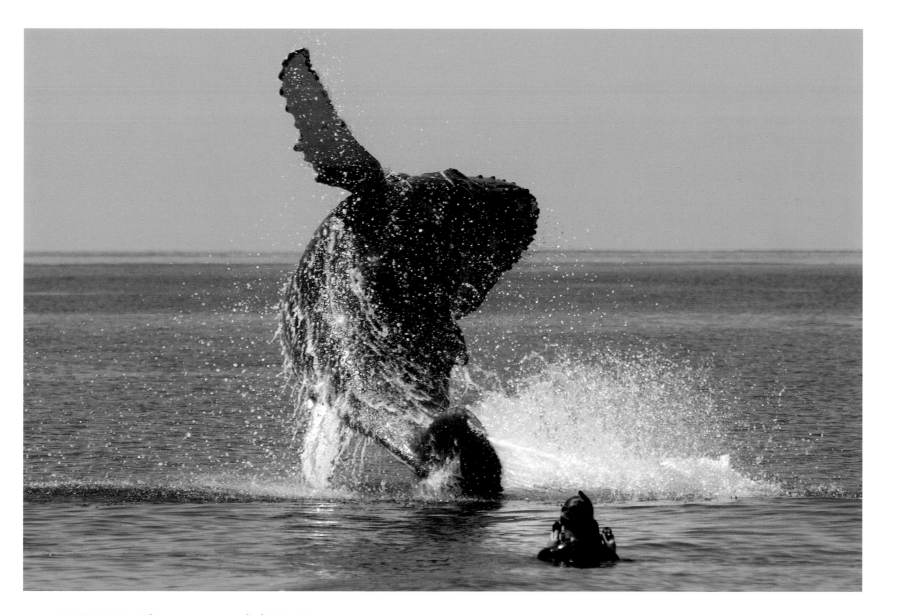

ABOVE: HUMPBACK WHALE (*Megaptera novaeangliae*) MAUI 2007
A yearling humpback breaches almost directly over Jason Sturgis. Whales have damaged boats during breaches but haven't landed on swimmers—a very good thing.

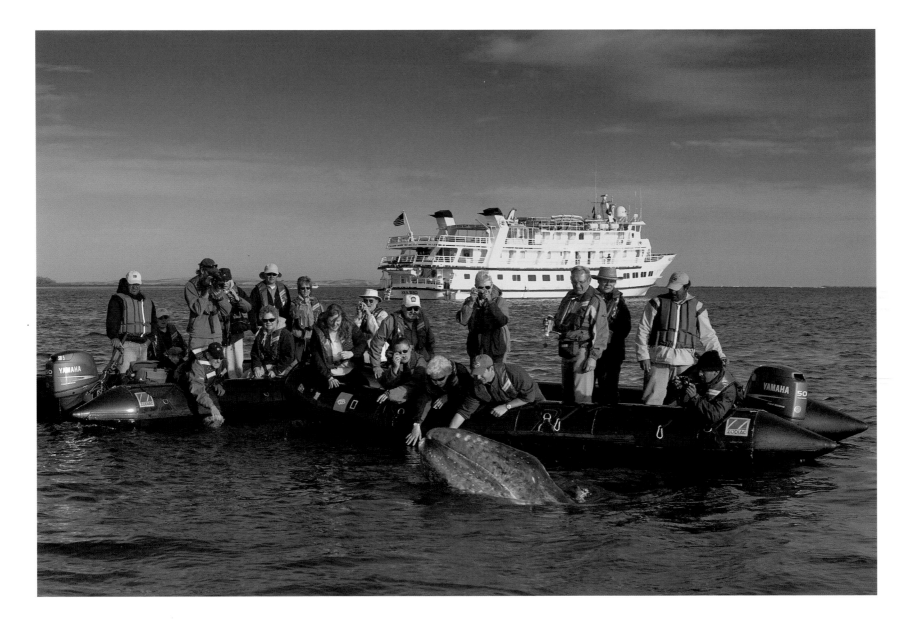

A baby gray whale (Eschrichtius robustus) greets guests from a National Geographic Expedition trip to Baja California in 2007. Grays are still sometimes hunted by indigenous peoples in the north Pacific. They're easy to locate because their migration routes are close to shore. Protection by the International Whaling Commission has taken their population from near extinction to around 20,000.

OPPOSITE: Bottlenose dolphins encounter guests at Dolphin Quest on the Big Island of Hawaii, 1991. How we will choose to live with cetaceans is still an open question.

The future of whale research and of the marine environment as a whole lies in the hands of people who are children now. Every time we invite local elementary and junior high schools to participate in marine education programs in Hawaii, we see how enthusiastic the kids are and what the future could hold. We routinely work with organizations such at the National Geographic Society, the National Oceanic and Atmospheric Administration, and the Jason Project to make our research accessible to classrooms around the world. And we try to educate the public through radio and TV programs, books and popular publications, so that the research we do can have an immediate impact on public awareness. Without public support, the efforts of researchers to study and protect our marine resources would go nowhere.

I spend about two months of the year traveling around the world with National Geographic Expeditions, giving talks about whales, photography, and life in Alaska. I never thought it could be so much fun to teach other people how to make pictures, but helping others see what I see and learn what I've learned has been tremendously rewarding.

I mentioned earlier that the life of a whale researcher and photographer can take a toll. When you're avidly pursuing something that requires a nomadic lifestyle, it's hard to keep relationships going at home. When the choice was keeping a relationship going or spending a year traveling the world to find out about dolphins, I always wanted to go find out about dolphins. I know other photographers who try to arrange their schedules to get home on a regular basis, but I wasn't very good at balancing that. I've spent two months on a floe edge with an Inuit waiting for something to

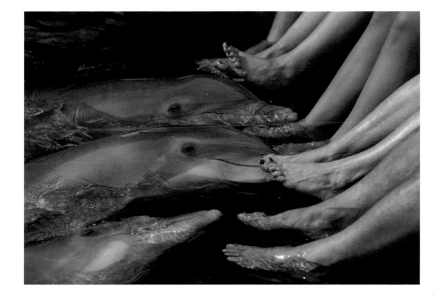

happen just because I was allowed to and because it seemed like a good thing to do. I have no regrets.

Ten years ago I met my wife, Linda. We were both on a National Geographic Expedition cruise ship in Alaska as guest experts and lecturers, she as a biologist and I as a photographer. We had both tried to do everything we could to get out of the trip, but there we were, stuck together for two weeks. She had some preconceptions about what a *Geographic* photographer was going to be like, and they weren't so flattering. And I liked her as soon as she told me this. Following her home to Alaska was a wonderful move. She's a Stanford-educated biologist and more like my researcher friends than I am. She's smart, tough, and has more bear stories than I do, and it has all worked out in a way that I wouldn't change.

I'll close with a snapshot of our life: In Maui Linda and I share a three-bedroom cottage with Jim in the first condo village built in Hawaii.

The houses all around us are now multi-million-dollar homes, but our place was inexpensive when we bought it in 1997, and it's near the beach. You can sit on our furniture in a damp bathing suit with sand on your feet, and nobody worries about it. Our research area is strewn with Pelican cases full of cameras, and computers and recording gear is piled up everywhere. The walls and shelves are filled with whale pictures and sculpture. At times I feel a little bit like the Beverly Hillbillies. We're always moving gear back and forth, building odd things. The neighbors at one point wondered what we were up to; now they're a part of it and they seem to like what we do.

In the summer Linda and I migrate back up to our real home in Juneau for the humpback-feeding season in southeast Alaska. We live in Auke Bay, about ten miles north of town, just past the last store. We're situated on a tidal flat that's underwater at high tide, and right out our front window we can see eagles, seals, sea lions, and even killer whales and humpbacks.

I like to think of humpbacks as living and working—that is feeding—

in Alaska and other places in the North Pacific, and vacationing, mating, and giving birth in Hawaii, Mexico, and Japan. Though thousands go through Hawaii every season, they're not all there at once, and some seem to skip the trip altogether. We'd like to study and photograph the whales in Alaska in winter. Before, with the technology we had, it was just too hard to photograph them in the low light and harsh conditions of winter. Now with more light-sensitive cameras we can get a better view. We'd also like to know what the whales are doing between Alaska and Hawaii. The journey takes a month, but what are they up to? Doing satellite telemetry late in the year could give us some answers, and I bring this up with Bruce Mate every time I see him. One thing is certain: The methods and technologies we're using now let us study whales in places we couldn't in the past.

My life has been an adventure beyond anything I ever would have dreamed possible—filled with whales and science and good stories. Following whale research has taken me to places I never imagined I'd go and introduced me to some wonderful people. It has been the most satisfying part of my life, and I encourage all my readers to dive in and join the adventure. Take a whale-watching trip, go to a lecture, or just contact one of the sites in the back of this book. You could discover a lifelong passion, and your efforts could make a huge difference to our world.

Mornings in Maui often find me talking to Jim over the first coffee, before any projects have begun. We seldom talk of where we have been but instead of where we might go. Years and sunburn disappear and all the things we might see suddenly become very clear. We just have to keep looking for them.

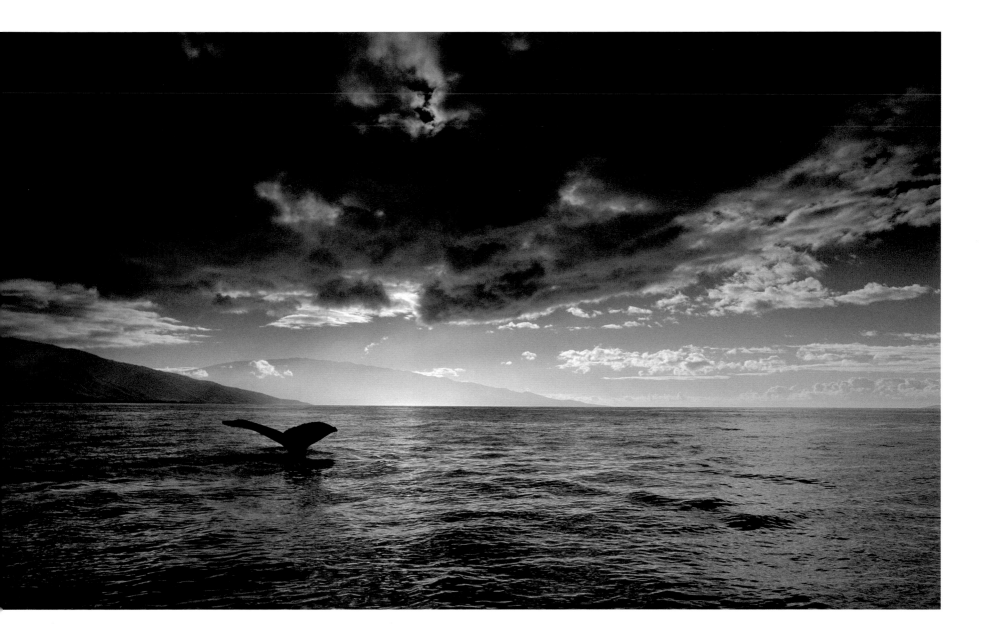

Suggesting mysteries yet to be solved, a humpback whale tail catches early morning light in Au Au Channel.

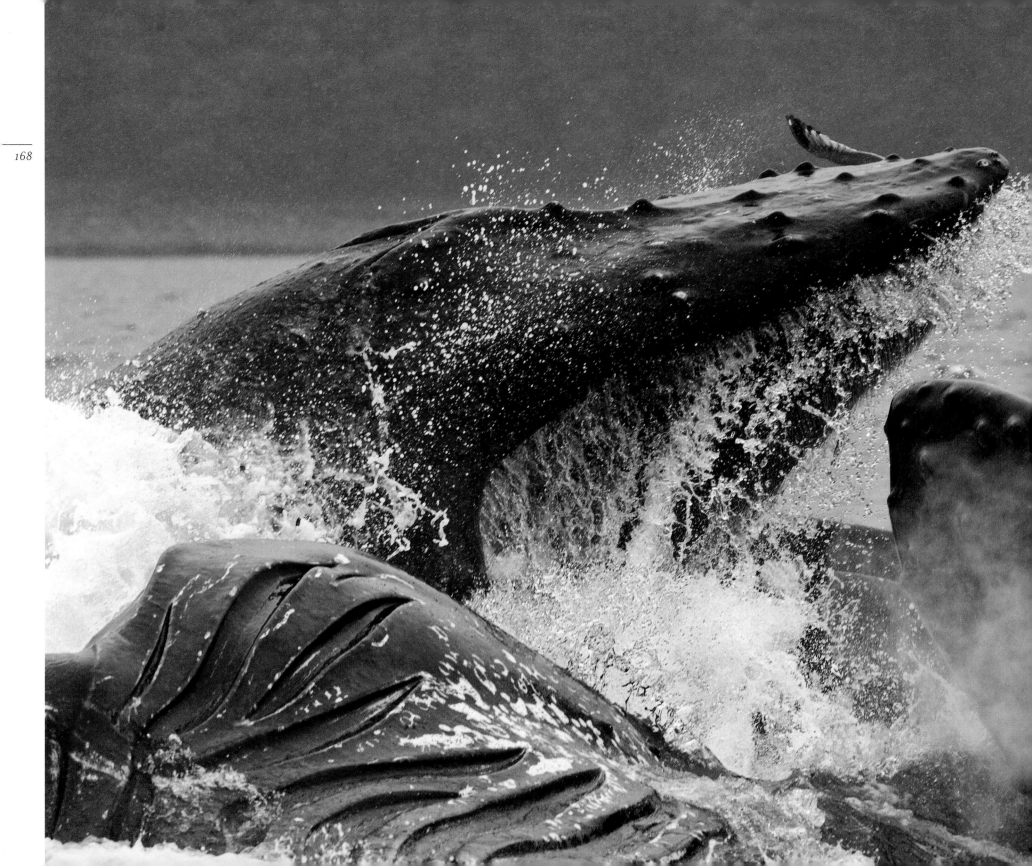

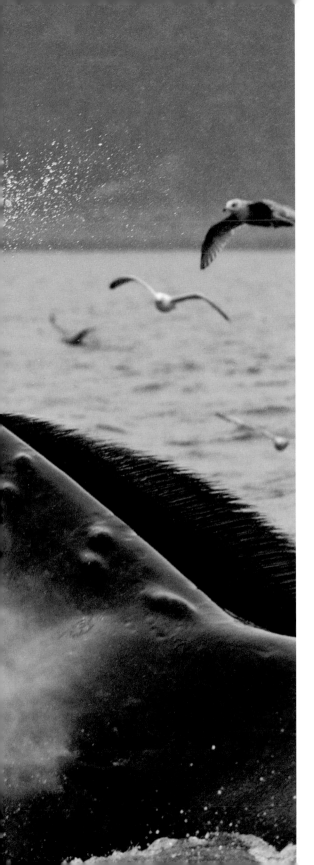

HUMPBACK WHALE *(Megaptera novaeangliae)* AUKE BAY, ALASKA 2009
*Humpbacks feast on herring near Auke Bay, Alaska, 20 minutes from my house. In this
cooperative feeding behavior, one whale blows a bubble net, while other whales corral fish
below. Then one of the group dives deep and screams, driving the corralled fish up into the net.*

HUMPBACK WHALE *(Megaptera novaeangliae)* MAUI 2010
A female diving near a cooperative male group

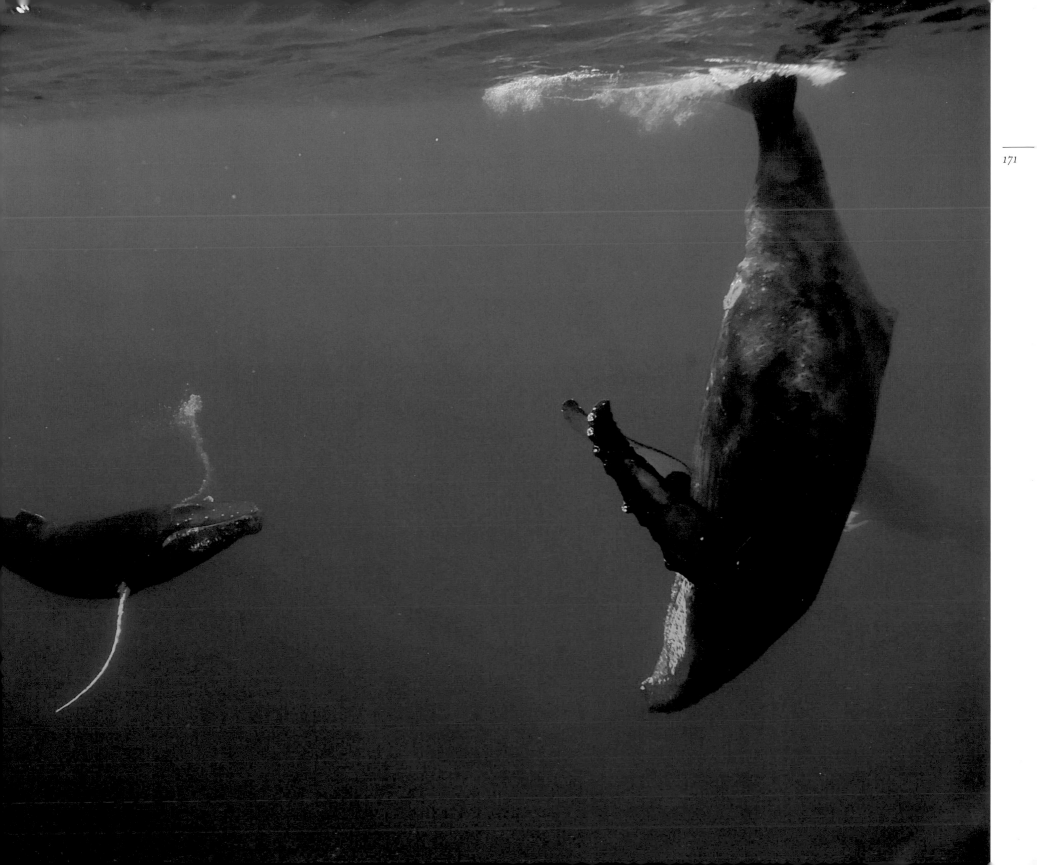

HUMPBACK WHALE (*Megaptera novaeangliae*) MAUI 2005
A humpback calf cavorts along the surface of the Au Au Channel,
as patterns of sunlight play over its skin.

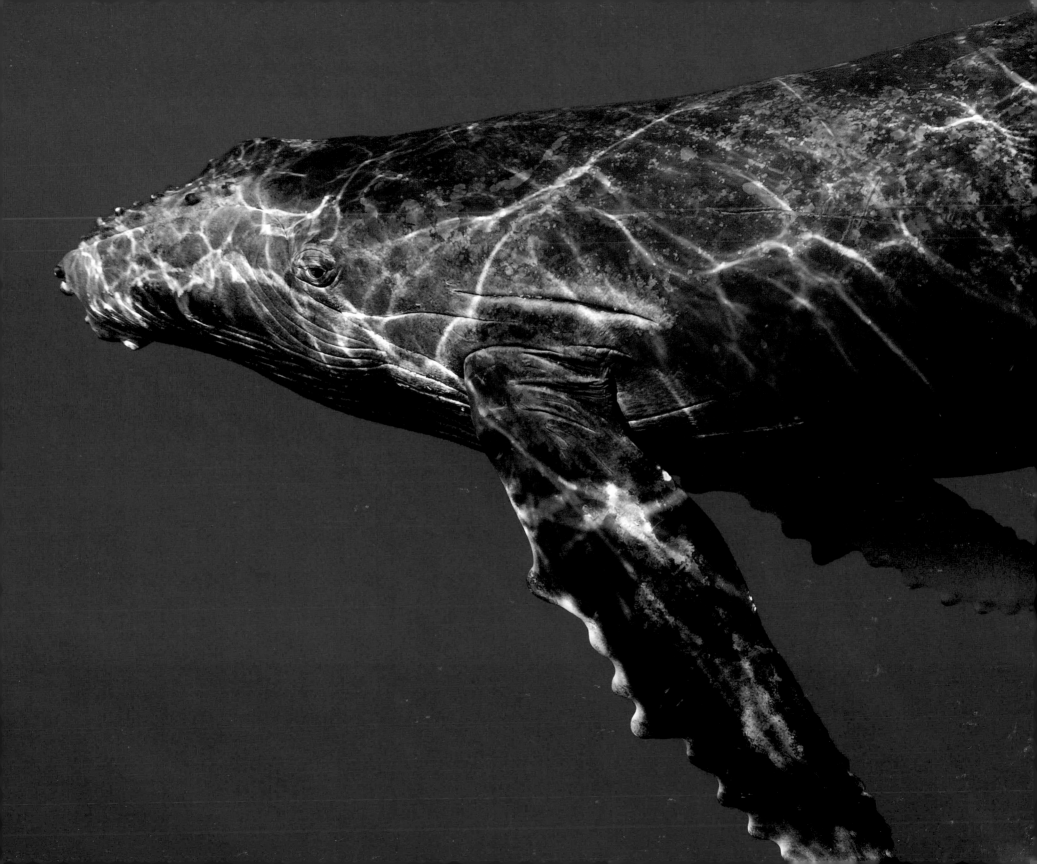

GRAY WHALE (*Eschrichtius robustus*) MAGDALENA BAY 2007
Like an aerial landscape, the eye of a whale off Baja California
opens on another world in this close-up taken from a boat.

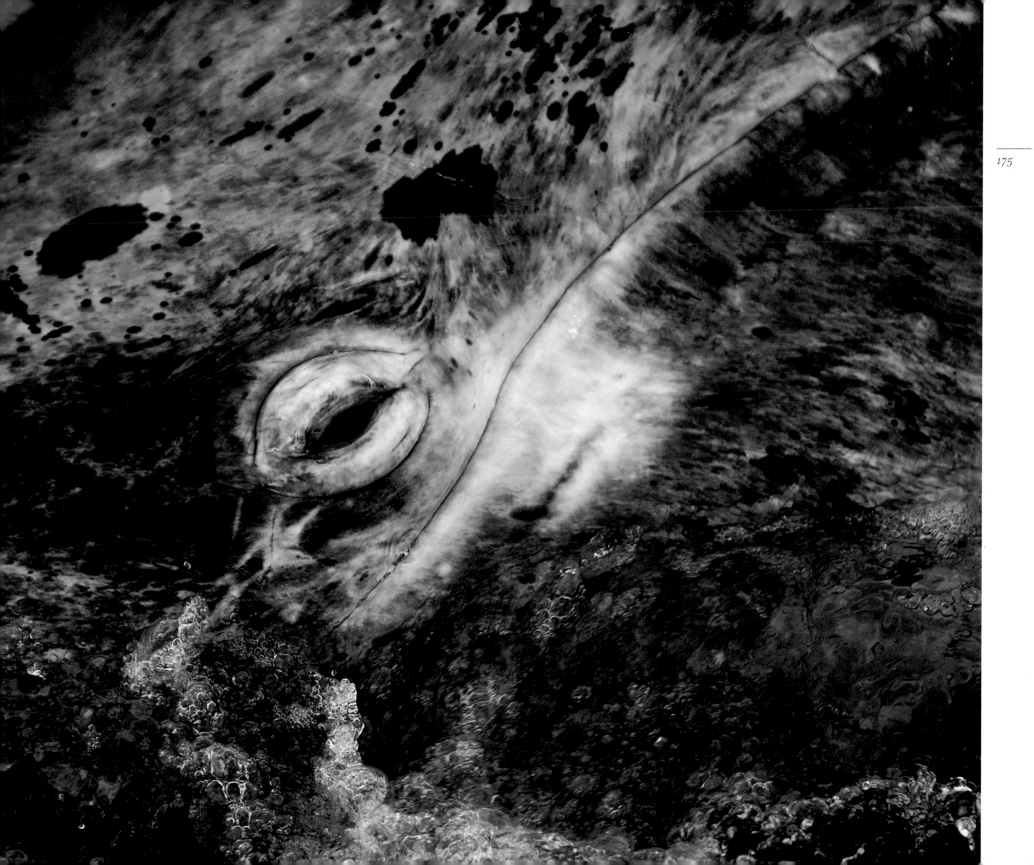

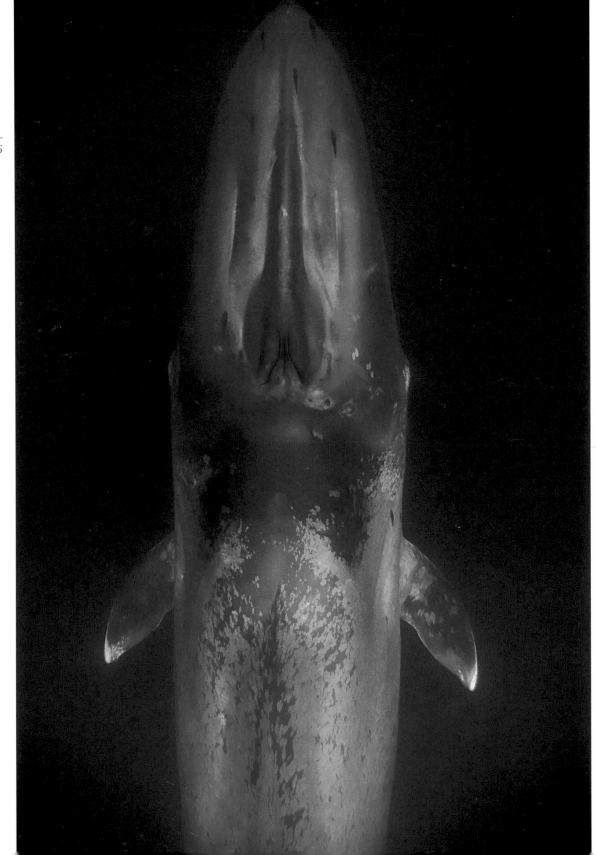

BLUE WHALE (*Balaenoptera musculus*)
COSTA RICAN DOME, 500 MILES WEST OF COSTA RICA
*A very young baby blue—certainly the youngest I have
seen underwater—passes below me. Over the course of
a month, we got only 20 minutes underwater with these
elusive creatures.*

BRUCE MATE ON TECHNOLOGY

DIRECTOR, MARINE MAMMAL INSTITUTE, HATFIELD MARINE SCIENCE CENTER, OREGON STATE UNIVERSITY

THE FIRST TIME I worked with Flip was in the mid-1980s. We were in the High Arctic, trying to get satellite-monitored radio tags on bowhead whales. The tags then were too large to be projectile, so we had to deploy them with a pole—if we could get close enough. But with all the ice up there, that was pretty difficult. An engineer and I came up with a way of building the tag and its applicator onto the base of a six-inch, remotely controlled helicopter that could land on a whale's back, where it would automatically deploy.

Since then Flip and I have worked together often, and he's just incredible to work with. His approach is always, "What can I do to help?" He'll set his camera up off to the side, and 80 percent of the time he's just doing whatever you want him to do. Periodically, he takes the shot he needs—he's really good at anticipating when those opportunities are coming up. He's looking not only for scenes that are taken during research but other things that provide novel perspectives.

In our field, researchers used to try to judge whale behaviors from what they could see when the animals came to the surface to breathe. But basically these days we can put our eyes and ears on whales when they're in the depths, where they spend most of their time. We can put tags on sperm whales that dive over a mile deep and stay down for an hour, and we can track them for up to twenty months. We've tagged fifteen different populations of seven different species of endangered whales, covering every ocean in the world. There hasn't been a single one of those deployments that didn't supply a radical change in the paradigm that we had going into the experiment.

Every three to four years we see tremendous advances in the technology for studying animals. I'm sure there'll be a time when this era is looked back on as the day of the Model T. But right now the questions that we need answered are very basic: Who, what, when, and where. Some of these animals are still hunted, so if we're killing whales in one place, are we taking them all from the same reproductive group? And where there's oil and gas development, naval exercises, fishing, or shipping, what's that doing to the seasonally "resident" animals?

If depleted whale stocks are to recover, we have to find ways to share the ocean with other creatures, and technology will be a key to this. If we are not proactive in identifying the important issues and finding solutions to the problems, we will lose species from benign neglect.

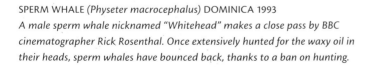

SPERM WHALE *(Physeter macrocephalus)* DOMINICA 1993
A male sperm whale nicknamed "Whitehead" makes a close pass by BBC
cinematographer Rick Rosenthal. Once extensively hunted for the waxy oil in
their heads, sperm whales have bounced back, thanks to a ban on hunting.

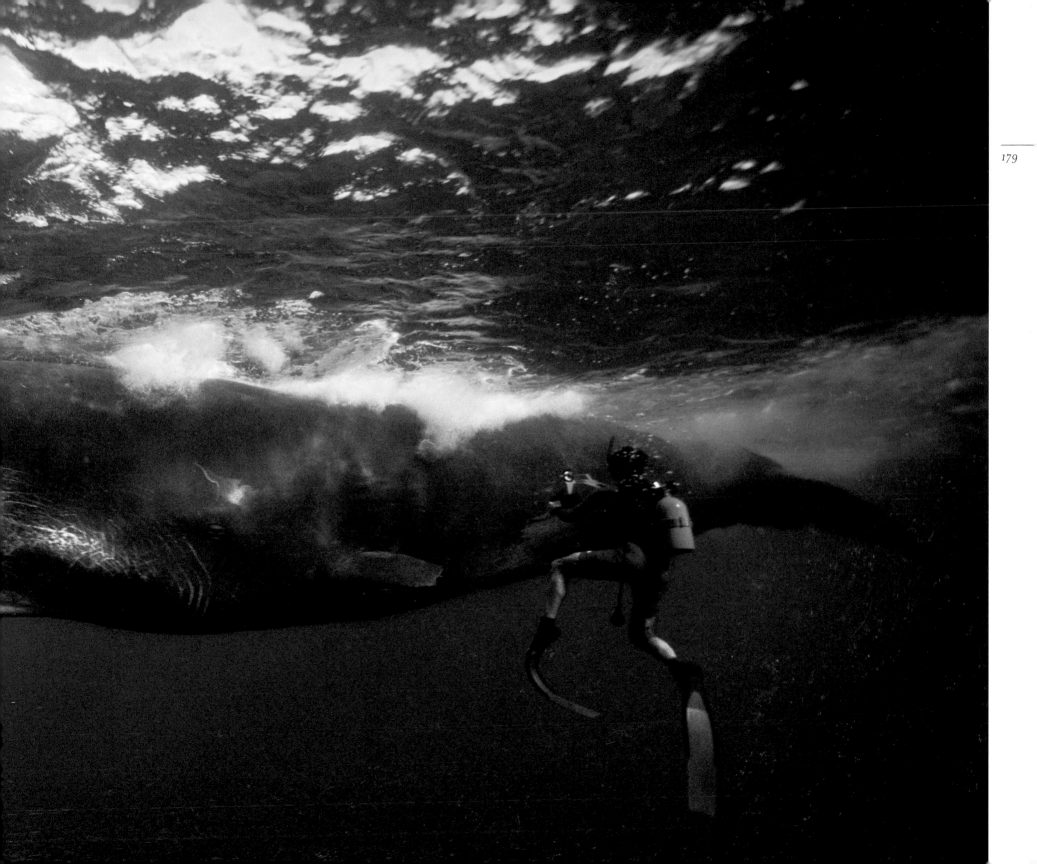

SPERM WHALE *(Physeter macrocephalus)* KAIKOURA, NEW ZEALAND 1993

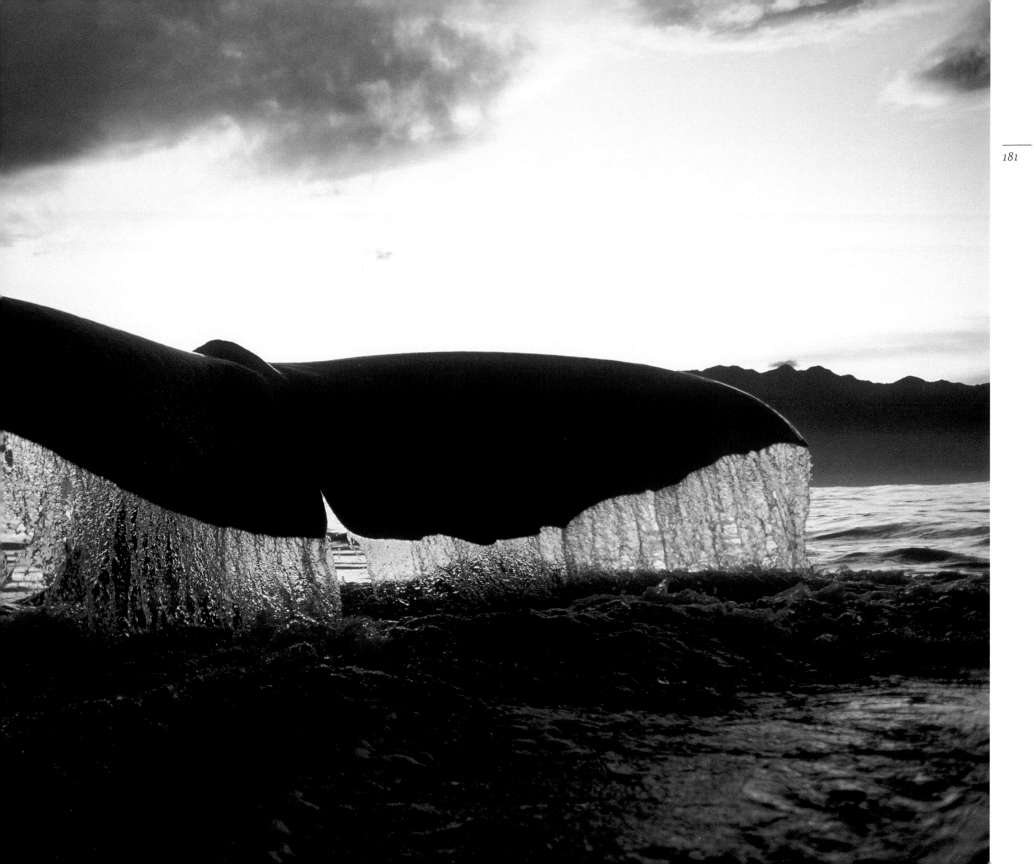

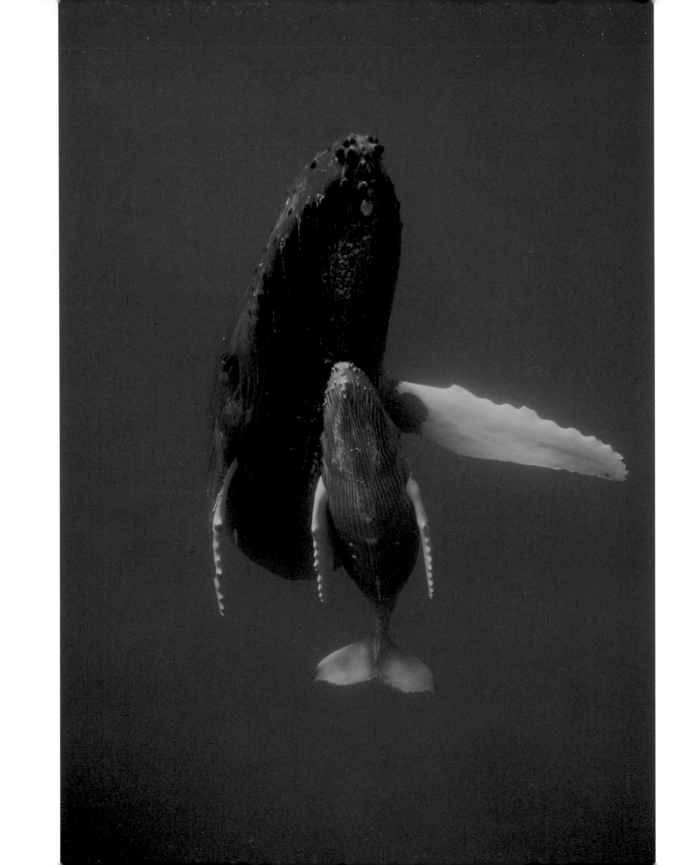

HUMPBACK WHALE
(*Megaptera novaeangliae*) MAUI 1996

KATHY MORAN ON FLIP NICKLIN

SENIOR EDITOR, NATURAL HISTORY, *National Geographic* Magazine

I FIRST MET FLIP in his early days working with the *National Geographic*. I was a photo assistant then, and he was a diver and self-taught naturalist who'd worked with *Geographic* photographers as their dive assistant. When he decided he wanted to try photography himself, he approached it with the same sort of careful prep that went into his diving. He really did his homework before he went on an assignment, learning about the researchers he was covering, the work they were doing, the animals he was assigned to shoot, and the location he was visiting. He'd even storyboard his assignments before heading into the field, sketching out every picture he hoped to take. He knew it was just "pie in the sky" to think he'd get them, but he wanted a clear idea of what the researchers hoped to find and how he could show that, as well as getting those groundbreaking new images of the whales.

His greatest asset was that he could free dive, so he was able to get in close, to shoot things that people had never seen before. The researchers were blown away with what he brought back. At that time, very few of them knew how to dive, and without the technology we have now, all they could do was observe what the animals did on the surface, which was only a small part of the time. Flip truly became the lens, the eyes of the scientists.

Because he could adjust to whatever the assignment called for—to make himself at home on the ice or on a boat or on a beach—he covered all kinds of marine mammals in all kinds of situations. Most photographers get type cast as warm-water or cold-water guys, but we could send Flip anywhere. And he had an instinct about when to shoot. I've been on boats with him, and he'd say, "Nothing's happening, I'm going to sleep." Then suddenly he'd sense that things were about to come together, and he'd be up and ready to shoot. Both he and the researchers could tell by the tiniest change on the surface that something was going on underwater, and that's when Flip would slip in with his camera.

Over the years, he has documented all kinds of marine mammal behavior, what's happening to these animals in a changing environment, and what the conservation concerns are. He has created the path that photographers since him have followed if they want to do serious underwater storytelling.

PHOTO NOTES

All of my early photography was aimed at getting published in *National Geographic*. When I needed ideas on how to handle a new situation, I looked at old issues of NGM. These ideas were enhanced by a few key people: Bob Gilka, the director of photography; David Doubilet and Bates Littlehales, both master photographers who specialized in underwater work; my father, Chuck Nicklin, a pioneering underwater photographer; and Kathy Moran, now Senior Editor, Natural History, at NGM.

I had very few rules:

• Shoot something new, or something old in such
 an original way that it was new again.

• Get close to the action.

• Tell a story.

• Shoot fast enough to stop the action.

• Keep trying new things.

 (I never wanted to hear Bob Gilka say, "Nothing new here.")

At the beginning of my career almost any close-up picture of a whale underwater was a good whale picture. The one thing I wanted to do differently, though, was to look whales in the eye, to shoot them as I would land animals—not just as big shapes underwater but real portraits of spectacular animals. That was my first goal. I also knew I was in on a world of groundbreaking ideas and opportunities in cetacean research, and I wanted to show that. Then, as time went by, I learned the craft of photography.

Photography, especially underwater photography, is very dependent on equipment. New pictures are often the result of new gear—wider lenses or ones with a greater zoom capacity. I was never very methodical about testing gear—if Bates or David (and later NGM's photo equipment expert Joe Stancampiano and Koji Nakamura of Japan Underwater Films, the company I worked for in Japan) were happy with something, I knew I would be very happy.

As much as I could, I tried to travel light. My best opportunities were few and far between. As a general rule, if I spent a hundred days in the field, I'd only get four or five chances at something significant. During those moments of opportunity I tried to keep focused, keep it simple, and get something new. Often my decision about gear was easy—I used whatever I hadn't broken yet. I found that I could really get creative when I had the wrong lens for a situation.

These days I still try to travel without excess baggage, taking only as much as the average traveler. On assignment, "light" might mean three or four extra bags carried or shipped. I love the new digital cameras and zoom lenses. The high ISO ranges now available (which have a greater sensitivity to light) have really kept me in the game. I get a great kick out of the fact that as I get older and slower, cameras get faster and more forgiving. Shooting at very high speed and great depth of field opens the door to shooting new situations and using new approaches. I think photography has never been so welcoming, but at the same time the bar has never been so high.

I've changed systems five times since going digital in 2003 and I'm probably not done yet, but here's my current list of day-to-day tools:

Nikon D3 camera body

Nikon D700 camera body

Nikon 14-24mm zoom lens

Nikon 24-70mm zoom lens

Nikon 70-200mm zoom lens

Nikon 300mm f4 lens

Panasonic LX3 pocket camera

Nikon SB900 Speedlight

Pelican 1520 waterproof box

Lowepro Flipside 200 backpack

Sea and Sea underwater housing with large dome

and spacers for the Nikon D3

My most important tool hasn't changed in the past 30 years—a researcher who wants to share new discoveries and is willing to put me in the right place at the right time. It's amazing how long you can wait for great situations and how easy photography is when those situations are happening in front of you. The researchers know where to look for those moments, and, luckily for me, they've let me tag along with them.

Something new for me has been travel photography with National Geographic Expeditions. It has been great fun so far and I learn more on each trip. Teaching people how to see has kept photography fresh for me.

ACKNOWLEDGMENTS

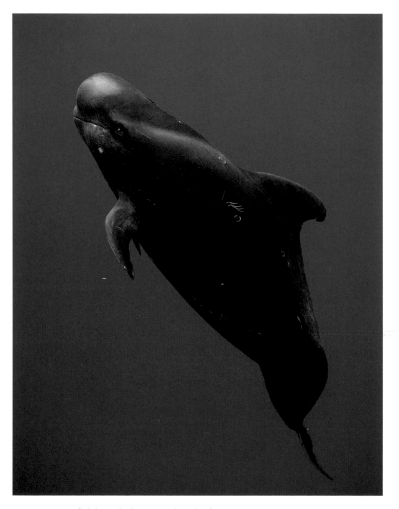

PILOT WHALE (*Globicephala macrorhynchus*) HAWAII 1987

WITHOUT THE SUPPORT OF *National Geographic* Magazine, none of the work reflected in this book would have been possible. Becoming the National Geographic "whale guy" opened the door for me to many possibilities and adventures. Thanks to all my NGM friends and colleagues, and especially to Bates Littlehales, Kathy Moran, Gill Grosvenor, Mary Smith, Bob Gilka, Jonathan Blair, Bill Garrett, Bill Graves, Bob Patton, David Arnold, Chris Johns, Steven Uzzell III, Bill Douthitt, and Grosvenor Council members Margaret Sears, Darlene and Jeff Anderson, Karyn and Pat Cochran, and Garry and Donna Weber.

This book was made possible by the tremendous patience and tenacity of Lisa Lytton. I am also deeply grateful to the team—Karen Kostyal, John Thompson, and Kathy Moran, and the University of Chicago Press— for taking pictures and memories and turning them into a book.

My work was built on the shoulders of a great group of people— the researchers and others who made room for me on small boats and in crowded camps. I am completely in their debt, and I wish I could have told all their stories. I still work with the first researcher I ever worked with, Jim Darling, and he is still full of new things to do, see, study, and photograph. Working with experts like Jim, Hal Whitehead, Jon Stern, Bruce Mate, and Glenn Williams has really been a chance to work among giants.

My sincere thanks to all those listed, and my apologies to anyone I inadvertently left out.

Seeglook Akeeagok	Mark Ferarri	Tad and Cindy Luckey	William Scott
Gay Alling	Kerry Finley	Jim Luckey	Richard Sears
Peter Arnold	John Ford	Ian MacAskie	Carlos Javier Navarro Serment
Ken Balcomb III	Jason Gdampke	Mary Lou and Bruce Mate	Greg Silber
Pierre Béland	Craig George	Beth Mathews	Chuck and Connie Southerland
Mike Bennett	Astrid van Ginneken	Monique Mathews	Liz Slooten
Per Bergren	Debbie Glockner-Ferarri	Craig Matkin	Tom Smith
Mike Bigg	Carlos Garcia	Tadahiko Matsui	Jonathan Stern
Jim and Mary Bird	Rick Geisller	Dan McSweeny	Jan Straley
Alister Birtles	Jonathan Gordon	Godfrey Merlin	Jason Sturgis
Jim Borrowman	Joann Hay	Peter Metcalfe	Jim Sugar
Eugene Brower	Craig Hayslip	Robert Michaud	Art Sutch
Ken Brower	Denise Herzing	Karen Miller	Jay Sweeney
John Calambokidis	Sacha Hooker	Koji and Miuki Nakamura	Andrew Taqtu
Debbie Cavanaugh	Russ Hozel	National Geographic Expeditions	Peter Tyack
Doug Chadwick	HTO Arctic Bay	Terry Nicklin	Kim Urian
Bud Clark	Lad Irvine	Ken Norris	Gunars and JoRene Valkirs
Richard Conner	Hiran Jayawardena	Rodger Payne	Randy Wells
Jenny Crystal	Meagan Jones	Héctor Pérez-Cortés	Whale Trust Board
Brad and Frances Dawe	Ian Kerr	Richard Petricig	Whale Trust Supporters
Steve Dawson	Barbara Lagerquist	Andy Read	Doc White
Volker Deeke	Ed Lane	Mark and Jeri Robinson	Hal and Lindy Whitehead
David Ellifert	Jim Lee	Ron and Diane Roos	C.C. Williams
Graeme Ellis	Brian Lorenz	Eva Saulitis	Glenn and Rebekah Williams

RESOURCES AND BIBLIOGRAPHY

HECTORS DOLPHIN (*Cephalorhynchus hectori*), NEW ZEALAND 1991

Note: The images in this book were collected from many bona fide research efforts over the past 30 years. Hawaii humpback photographs were collected under National Marine Fisheries Service permit numbers 987, 753, and 587.

CETACEAN RESEARCHERS AND RESEARCH ORGANIZATIONS

BELUGA WHALES
NATIONAL OCEANIC AND
 ATMOSPHERIC ADMINISTRATION
 (NOAA), Alaska
www.fakr.noaa.gov/protectedresources/
 whales/beluga/research.htm

BLUE WHALES
RICHARD SEARS
Mingan Island Cetacean Study (MICS)
www.rorqual.com

DOLPHINS
DENISE HERZING
www.WildDolphinProject.org

RANDY S. WELLS
www.sarasotadolphin.org

HUMPBACK WHALES
JIM DARLING, MEAGAN JONES,
 AND FLIP NICKLIN
www.whaletrust.org

MARK FERARRI AND
DEBBIE GLOCKNER-FERARRI
www.centerforwhalestudies.org

ED LYMAN
*Hawaiian Islands Humpback Whale
 National Marine Sanctuary*
http://hawaiihumpbackwhale.noaa.gov/
 about/overview.html
Also:
www.whaledisentanglement.org

DAVID MATTILA
*Science and Rescue Coordinator,NOAA
 Hawaiian Islands Humpback Whale
 National Marine Sanctuary*
http://hawaiihumpbackwhale.noaa.gov/
 science/splashinfo.html

NATIONAL OCEANIC AND
 ATMOSPHERIC ADMINISTRATION
 (NOAA), Hawaii
www.hawaiihumpbackwhale.noaa.gov/
 science/splashinfo.html

DAN R. SALDEN
www.hwrf.org/Hawaii_Whale_
 Research_Foundation/Aloha!.html

JAN STRALEY
University of Alaska Southeast
www.alaskahumpbacks.org
Also: www.sitkawhalefest.org

KILLER WHALES
KEN BALCOMB III
www.whaleresearch.com/contact.html

VOLKER B. DEECKE
www.marinemammal.org/MMRU/
 volker.php

GRAEME ELLIS AND JOHN K. FORD
*Cetacean Research Program, Fisheries
 and Oceans Canada*
www.pac.dfo-mpo.gc.ca/science/
 species-especes/cetacean-cetaces/staff-
 personnel-eng.htm
Also:
http://wildwhales.org/?page_id=44

CRAIG MATKIN
www.whalesalaska.org/team.html

MINKE WHALES
ALASTAIR BIRTLES
Cooperative Research Centre for the
 Great Barrier Reef World Heritage Area
www.reef.crc.org.au/discover/
 plantsanimals/minke/index.html

JONATHAN STERN
San Francisco State University
http://biology.sfsu.edu/people/
 jonathan-stern

SPERM WHALES AND
HECTOR'S DOLPHINS
STEVE DAWSON AND LIZ SLOOTEN
University of Otago
www.otago.ac.nz/marinescience/
 mammals/home.htm
Also:
NEW ZEALAND WHALE AND
 DOLPHIN TRUST
www.whaledolphintrust.org.nz

WHALE SOCIAL STRUCTURE
HAL WHITEHEAD
Dalhousie University
http://whitelab.biology.dal.ca/hw/hal.htm

FOR INFORMATION
ON A VARIETY OF SPECIES:
International Union for
 Conservation of Nature (IUCN)
 Red List of Threatened Species
www.iucnredlist.org/apps/redlist/
 details/13006/0

DOUGLAS H. CHADWICK
Natural History writer who follows
 developments in whale research and
 conservation biology
www.vitalground.org

ROGER PAYNE
Pioneering whale researcher
www.oceanalliance.org/rogerPayne.html

ARCTIC ISSUES
TOM G. SMITH
www.wildlifedetectiondogs.com

CRAIG GEORGE
Study of the Northern Alaska Coastal
 System (SNACS)
www.arcus.org/arcss/snacs/whales/
 projectmembers.php

TRACKING TECHNOLOGIES
BRUCE MATE
Oregon State University,
 Marine Mammal Institute
http://marineresearch.oregonstate.edu/
 assets/page_folders/faculty_page/
 mate_hp.htm

UNDERWATER PHOTOGRAPHY
International League of
 Conservation Photographers
www.ilcp.com

KOJI NAKAMURA
Filmmaker
http://homepage3.nifty.com/juf/english/
 english%20top%20.htm

SELECTED BIBLIOGRAPHY

Among Whales
By Roger Payne
Delta, 1996

Cetacean Societies: Field Studies
of Dolphins and Whales
Ed. by Janet Mann, Richard C. Connor,
 Peter L. Tyack, and Hal Whitehead
University of Chicago Press, 2000

Dolphin Societies:
Discoveries and Puzzles
Edited by Karen Pryor and
 Kenneth S. Norris
University of California Press, 1996

Face to Face with Dolphins
Flip and Linda Nicklin
National Geographic Children's Books,
 2007

Face to Face with Whales
Flip and Linda Nicklin
National Geographic Children's Books,
 2008

Hawaii's Humpbacks:
Unveiling the Mysteries
By Jim Darling
Photographs by Flip Nicklin
Granville Island, 2009

The Grandest of Lives
By Douglas Chadwick
Sierra Club Books, 2006

Killer Whales (second edition)
By John K. B. Ford, Graeme M. Ellis,
 and Kenneth C. Balcomb III
University of Washington Press, 2000

Killer Whales of Southern Alaska
By Craig Matkin, Graeme Ellis,
 Eva Saulitis, Lance Barrett-Lennard,
 and Dena Matkin
North Gulf Oceanic Society (Alaska),
 1999

Men and Whales
By Richard Ellis
Alfred A. Knopf, 1991

An Observer's Guide to the Killer Whales
of Prince William Sound
By Craig Matkin
Prince William Sound Books, 1994

Sperm Whales: Social Evolution
in the Ocean
By Hal Whitehead
University of Chicago Press, 2003

Whales and Dolphins in Question
James G. Mead and Joy P. Gold
Smithsonian Institution Press, 2002

Whales, Dolphins, and Porpoises
By Jim Darling, Bernd Würsig, Kenneth
 Norris, Hal Whitehead, and Flip Nicklin
National Geographic Society, 1995

INDEX

Bold page numbers indicate photographs.

HAWAIIAN SPINNER DOLPHIN *(Stenella longirostris)* HAWAII 1990

Abyss, The, 25
Amazon River dolphin, **144–45**
Atlantic spotted dolphin, **126**, **146–47**

Balaena mysticetus, 102, 104, **105**, **106**, 107, **114–15**, 131, **134**, 135
Balaenoptera acutorostrata, **16–17**, **130**, 131–32, 148, **149**
Balaenoptera edeni, **22**, 23, **24**, 25, **26–27**
Balaenoptera musculus, 69, 70, **82–83**, 162, **176**
Balaenoptera physalus, **8–9**
Béland, Pierre, 127, 128, **129**
beluga whale, 102, 104, **108–9**, **116**, **118–19**, 128, **129**
Bennett, Michael, 69, **74**

Bigg, Michelle, **62**, 63
Bigg, Mike, 61-62, 63
Bird, Jim, **43**
Bird, Mary, **43**
Birtles, Alistair, 133
Blair, Jonathan, **32**, 33, 34
blue whale, 69, 70, **82–83**, 162, **176**
bottlenose dolphin, **14–15**, **120–21**, **125**, **137**, **138-39**, **142–43**, 164, **165**
bottlenose whale, 135–36, **136**
bowhead whale, 102, 104, **105**, **106**, 107, **114–15**, 131, **134**, 135
Brower, Harry, Sr., 135
Bryde's whale, **22**, 23, **24**, 25, **26–27**

Cavanaugh, Debbie, **62**, 63, **100**, 101
Chadwick, Doug, 131–32
Clark, Chris, 135

Clark, Eugenie, 43
Colombo, Gustavo Alvarez, **72**
common dolphin, 140, **141**
Crosthwaithe, Philip, 31

Darling, Jim, **37**, 38, 39–40, 43, **55**, 69, 70, **72**, 73, **75**, 102, 155–56, **156**, 165, 166
Deep, The, 25, 37
Delphinapterus leucas, 102, 104, **108–9**, **116**, **118–19**, 128, **129**
Delphinus delphis, 140, **141**
dusky dolphin, **122**, 123, **150–51**
dwarf minke whale, **16–17**, **130**, 131–32, 148, **149**

Ellis, Graeme, 42, 61–62, 63, 65
Endangered Species Act, 34, 135
Eschrichtius robustus, **18**, **84–85**, **164**, **174–75**
Eubalaena australis, **72**, **88–89**

fin whale, **8–9**
Finley, Kerry, 104, **105**, 107
Ford, John, 61–62, 63, 65, 96, **97**, 98, **100**, 101

Garcia, Carlos, 73, 75
Geissler, Rick, 98, 100
Gilka, Bob, 37
Gilliam, Phil, **68**
Gordon, Jonathan, 70
gray whale, **18**, **84–85**, **164**, **174–75**
Grosvenor, Gil, 37

hammerhead shark, **41**, 43
harbor porpoise, **124**, 125
Herzing, Denise, 124, **126**, 127
humpback whale, **10–11**, 19, **20**, **28–29**, **30**, 31, **38**, 40, 42, 43–44, **45**, 46–47, 48–49, 50–51, 52–53, **54**, 55, **56–57**, **152–53**, **154**, 155–56, **157**, **158**, **160**, **161**, **162**, **163**, 166, **167**, **168–69**, **170–71**, 172, **173**, **182**
Hyperoodon ampullatus, 135–36, **136**

Inia geoffrensis, **144–45**
International Union for Conservation of Nature Red Book, 114
International Whaling Commission, 131, 148, 164

Jason Project, 165
Jaws, 43
Jones, Meagan, 155

killer whale, **36**, **58–59**, **60**, 61–62, **63**, **64**, **76–77**, **78–79**, 136, 162

Lagenorhynchus obscurus, **122**, 123, **150–51**
Lane, Ed, 158
Larsen, Dottie, 70
Littlehales, Bates, 32, 34, 37

Marine Mammal Protection Act, 34
Martin, Tony, **128**
Mate, Bruce, 21, 161

DALL'S PORPOISE (*Phocoenoides dalli*) SOUTHEAST ALASKA 1998

Mathews, Beth, 38, **39**
McCarthy, Cormac, 73
McIntyre, Joan, 39
Megaptera novaeangliae, **10–11**, 19, **20**, **28–29**, **30**, 31, **38**, 40, **42**, 43–44, **45**, **46–47**, **48–49**, **50–51**, **52–53**, **54**, 55, **56–57**, **152–53**, **154**, 155–56, **157**, **158**, **160**, **161**, **162**, **163**, 166, **167**, **168–69**, **170–71**, 172, **173**, **182**
Melville, Herman, 66
Miller, Karen, 43
Mind in the Waters: A Book to Celebrate the Consciousness of Whales and Dolphins, 39
minke whale, **16–17**, **130**, 131–32, 148, **149**
Monodon monoceros, **90–91**, 94, **101**, 104, **112–13**, 117

Moore, Chris, 129
Moran, Kathy, 75

Nakamura, Koji, 96, **97**, 100
narwhal, **90–91**, 94, **101**, 104, **112–13**, 117
National Geographic Society, 37, 44, 65, 155, 165
National Oceanic and Atmospheric Administration, 165
Nicklen, Paul, 159
Nicklin, Charles "Flip," 19, 20, 21, **32**, 33, **96**, **166**, 167
Nicklin, Charles R., Jr. "Chuck", 19, 20, **22**, 23, **24**, 25, 26, 30, 31, 32, 33, 37–38, 40, 62, 65, 70, 73
Nicklin, Linda, 165, **166**, 167
Nicklin, Terry, 66, **68**, 69, 70

Nomads of the Deep, 39
Norris, Ken, 123, 127, **128**, 162, **192**

Orcinus orca, **36**, **58–59**, **60**, 61–62, **63**, **64**, 76–77, **78–79**, 136, 162
Orr, Jack, **128**

Payne, Roger, 39, **72**, 73, **75**
Philbin, Regis, 25
Phocoena sinus, 126, **127**
Physeter macrocephalus, 6–7, 12–13, 65–66, **67**, **68**, 69, 70, **71**, **80**, 81, **86**, 87, **178–79**, **180–81**
polar bear, **95**, 110, **111**, 117

Read, Andy, **124**, 125
Rice, Margo, **43**
right whale, **72**, 73, **74**, 75, **88–89**
Rosenthal, Rick, 178, **179**

San, Hosano, **133**
San Diego Union-Tribune, 25
Save the Whales, 25
scalloped hammerhead shark, **41**, 43
Scott, Peter, 69–70
Scott, Philippa, 69–70
Scott, Robert Falcon, 69
Scripps Institute, 32
Sea World, 34, 37
Sharpe, Fred, 162
Silber, Greg, **37**, 38, 39
Smith, Mary, 44, 65
Smith, Tom, **128**
Songs of the Humpback Whale, 39

sperm whale, **6–7**, **12–13**, 65–66, **67**, **68**, 69, 70, **71**, **80**, 81, **86**, 87, **178–79**, **180–81**
Sphyrna lewini, **41**, 43
Stenella frontalis, **126**, **146–47**
Stern, Jon, 131
Sturgis, Jason, 10, **11**, **154**, 155, 156, 159, 161, **163**

Taqtu, Andrew, **92**, 93, 96, **97**, 100, 102
Taqtu, Judah, 96, **97**, 100
To Tell the Truth, 25
True's porpoise, **132**, 133
Tursiops truncatus, **14–15**, **120–21**, **125**, **137**, **138–39**, **142–43**, 164, **165**

Ursus maritimus, **95**, 110, **111**, 117
Uzzell, Steve, **32**, 33, 34

vaquita, 126, **127**

Wells, Randy, 123, 124
Whale Trust, 155
Whales, Dolphins, and Porpoises, 128
Whitehead, Hal, 65, **66**, 69, 86, **87**
Williams, Ben, 102
Williams, Glenn, 96, **97**, 98, 100, 102, **103**, 104, 116, **117**
Williams, Rebekah, 97
World Wildlife Fund, 69

IN MEMORIAM: KENNETH NORRIS 1924–1998
Ken Norris was a world-renowned expert on cetaceans and was legendary for his ability to inspire students. Much of what is known about whales and dolphins, particularly about their social patterns and echolocation abilities, comes from groundbreaking investigations by Norris and the researchers he motivated.

Widely regarded as the world's leading cetacean photographer, Flip Nicklin grew up around his father's small dive shop on the California coast. He went on to become National Geographic's premiere whale photographer and marine mammal specialist. Over the last quarter century Flip has photographed more than thirty species of whales and dolphins, some so endangered their very survival is in question. In 2001 he co-founded Whale Trust, a non-profit organization dedicated to research and public education.

The mission of Whale Trust is to promote, support, and conduct scientific research on whales and the marine environment and develop public education programs based directly on results of scientific research. Whale Trust is committed to promoting and fostering Maui as a unique living laboratory for whale research and the marine environment. For information, please visit www.whaletrust.org.

For more information about Flip Nicklin and his work, upcoming lectures, exhibitions, and stock photography, or to purchase fine-art prints of the images in this book, visit www.flipnicklin.com.

LISA LYTTON, *Project Editor*

KAREN M. KOSTYAL, *Writer and Text Editor*

KATHY MORAN, *Photography Advisor*

JOHN THOMPSON, *Writer*

JENNA PIROG, *Photography Assistant*

REBECCA BARNS, *Release Editor*

THE UNIVERSITY OF CHICAGO PRESS:

CHRISTIE HENRY, *Editorial Director, Sciences*

LEVI STAHL, *Publicity Manager*

The University of Chicago Press, Chicago 60637
The University of Chicago Press, Ltd., London

All photographs © Flip Nicklin/Minden Pictures, with the exception of the following:
pp. 6–7, 33, 34, 35, 41, 64, 68, 72, 88–89, 100, 105, 106, 112, 116, 118–119, 125, 126, 128, 146–147, 178–179, 186 © National Geographic Society; Back cover (image of Flip Nicklin) © Linda Nicklin; p. 22 © Bill DeCourt, San Diego History Center, San Diego Union-Tribune Collection; p. 24 © Bill DeCourt; pp. 26, 32 (two images upper left) © Chuck Nicklin; p. 32 (two Images upper right) © Steve Uzzell; p. 158 © Dr. Ed Lane; p. 166 © Jason Sturgis; p. 183 © David Griffin.

Color separations by Prographics, Rockford, IL
Printed in Hong Kong by Sing Cheong Printing

20 19 18 17 16 15 14 13 12 11 1 2 3 4 5

ISBN-13: 978-0-226-58099-9 (cloth)
ISBN-10: 0-226-58099-7 (cloth)

Library of Congress Cataloging-in-Publication Data

Nicklin, Flip.
 Among giants : a life with whales / Charles "Flip" Nicklin with K. M. Kostyal ; foreword by James Darling.
 p. cm.
 Includes bibliographical references and index.
 ISBN-13: 978-0-226-58099-9 (cloth : alk. paper)
 ISBN-10: 0-226-58099-7 (cloth : alk. paper) 1. Whales. I. Kostyal, K. M., 1951– II. Title.
 QL737.C4N475 2011
 599.5—dc22
 2010029430

♾ The paper used in this publication meets the minimum requirements of the American National Standard for Information Sciences—Permanence of Paper for Printed Library Materials, ANSI Z39.48-1992.